THIS BOOK BELONGS TO:

IF FOUND, PLEASE CONTACT:

REWARD

This book is meant to be sketched in, remixed, and made your own!
Start immediately by adding some flare to this page, personalizing
it with whatever doodles, colors, or images inspire you the most!

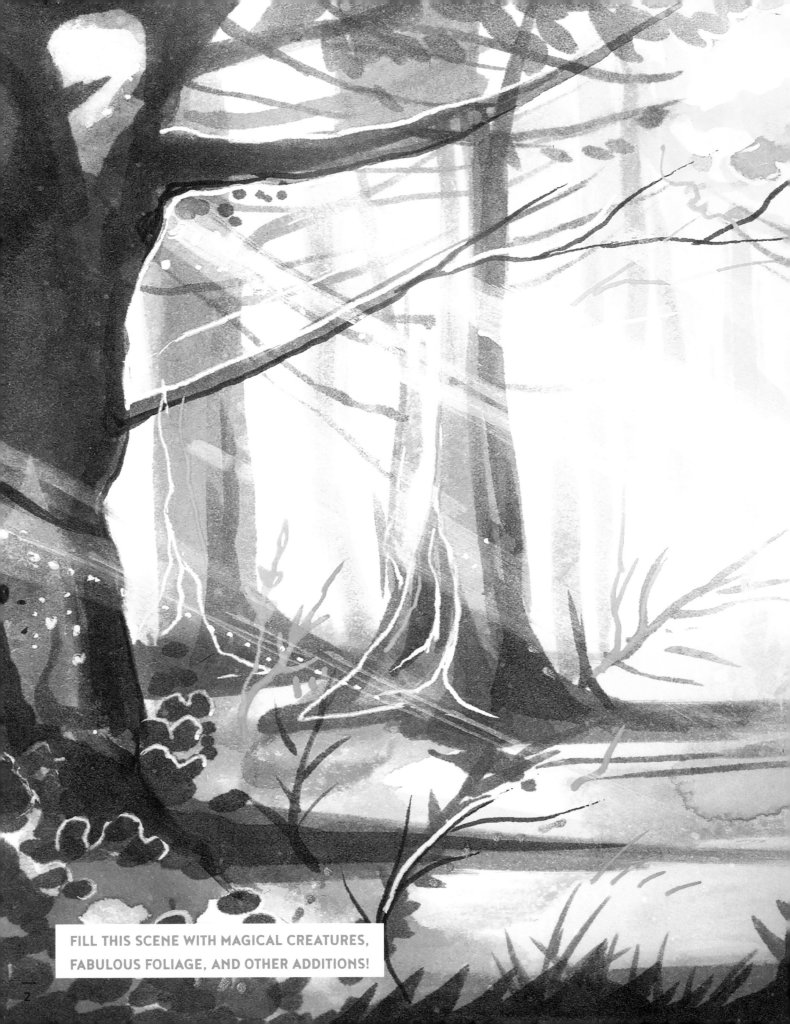

FILL THIS SCENE WITH MAGICAL CREATURES, FABULOUS FOLIAGE, AND OTHER ADDITIONS!

THE ARTIST'S DRAWING BOOK

Easy exercises, activities, and guides to inspire your inner artist

Illustrated, written, and designed by
KATY LIPSCOMB & TYLER FISHER

Blue Star Press.

Copyright © 2023 Blue Star Press
PO Box 8835, Bend, OR 97708
contact@bluestarpress.com
www.bluestarpress.com

Illustrated, written, and designed by
Katy Lipscomb LLC and Tyler Fisher LLC

ISBN: 9781941325810

10 9 8 7 6 5 4 3 2 1

We dedicate this creative endeavor to you because it's not about us – it's about your amazing potential! We'd also like to thank everyone who has supported us through the crazy journey to becoming full-time professional artists. We draw inspiration from so many different people around us and would not be who and where we are today without the love and support of our friends, families, and communities.

We'd love to know who or what drives you to create. Give a quick shout-out to them below:

Contents

INTRODUCTION

In this Chapter:

Intro To The Authors
–
Guide To The Workbook
–
How To Set Up Your Creative Space
–
Making Your Mark
–
Essential Tools And Materials

LET'S GET TO KNOW WHO YOU ARE AS A DESIGNER:

WHAT IS YOUR NAME, NICKNAME, OR ALIAS?	
WHAT ARE YOUR FAVORITE COLORS?	
WHAT IS YOUR FAVORITE SUBJECT MATTER?	
WHAT ARE YOUR FAVORITE MATERIALS?	
WHAT ARE YOUR BIGGEST STRENGTHS?	
WHAT ARE YOUR BIGGEST WEAKNESSES?	
WHAT DO MOST PEOPLE KNOW YOU FOR?	
WHAT DO YOU WISH PEOPLE KNEW YOU FOR?	
WHAT ART DO YOU USUALLY ENJOY THE MOST?	
WHAT ART DO YOU USUALLY ENJOY THE LEAST?	

About the Authors

In August of 2011, a sweet girl named Katy sat next to a new kid named Tyler in art class, and they fell in love at first sight. Now after having formed a successful design firm and established an international creative brand, Katy and Tyler continue to stretch the limits of each other's creativity while expanding their own personal aesthetics. This book solidifies much of what they've learned about creativity and the design process, capturing years of practice, study, teaching, and experimentation.

Katy Lipscomb

Katy Lipscomb is an author, illustrator, and designer whose watercolor creatures have sprung, soared, and shuffled their way around the globe. Seen in *TIME* Magazine, heard on NPR news, and viewed millions of times on her social media accounts, Katy's works combine artful skills with opulent imagery to create unforgettable masterpieces.

FIND MORE OF HER WORK AT WWW.KATYLIPSCOMB.COM

Tyler Fisher

Tyler Fisher is a creative jack-of-all-trades, having formed sculptures shown in the High Museum of Art, published books that demystify the creative process, and worked with brands on countless designs for marketing, packaging, and more. Tyler's work focuses on the boundary between memory and myth, blending his own personal history with carefully crafted narratives and archetypes to form works that are deeply personal yet universal.

FIND MORE OF HIS WORK AT WWW.TYLER-FISHER.COM

You'll learn more about us and see more of our experiments as you continue through this workbook.

Hello there!

We wrote and released our first instructional art book in 2017, immediately after receiving our fine art degrees. In art school, you are supplied with the resources to create almost anything you can imagine, surrounded by a large group of like-minded peers to bounce ideas off of, and are provided a constant stream of professors, guest speakers, and exhibitions to spark new areas of development. While this environment is magical and genuinely helps to enable prolific creation, it can blind you to the realities of making art in the real world. Outside of school, you rarely find your work being analyzed so deeply, are not given prompts that are open to your exploration, and rarely have a captive audience on tap. Instead, it is your responsibility to develop a routine, build your audience, and form your support system. Without the resources to make whatever you wish, you either adapt to sustain your creative process or are doomed to watch it die.

We've found that art books are usually on one of two sides. Many beginner art books are so basic that you can rarely gain noticeable growth. Others are so specific that you need a college education just to understand them. When we looked back at what we wrote after leaving art school, we were stunned by what we had neglected to include. Initially, many sections of our book were far too analytical, preventing beginners from accessing information. At the same time, other areas were too minimal, providing only a passing glance at broad and complex subjects. Now, after having gained so much more real-world experience and having taught classes to students of all skill levels, we holistically reworked our approach, striving to make a book in the middle of this scale. We used wording that is easy to understand, making the content approachable and beginner-friendly while also attempting to be more comprehensive so that a proper understanding can be gained of the topics, materials, and subjects. In addition, we have included our students' interests, hang-ups, and questions in order to proactively tackle misconceptions, fears, and desires. Through hands-on practice, we have learned the things that we believe matter most and wrote a book that easily encapsulates the most essential elements of the creative process. We will teach many different techniques and principles through various subjects – from humans to animals to cityscapes. Throughout all these, we will focus on breaking your subject into its Lines, Shapes, Forms, Values, and Colors. Once you have learned these principles, you should be able to draw anything you want!

We believe that art is for everyone and that no one can create exactly the way that you do. We hope this book helps spark your creativity and excites you about the limitless possibilities. We can't wait to get started!

What You'll Find in this Book

In this interactive workbook, we'll help you hone your creativity in an easy, inspiring, and fun way! We've made this book with artists of any skill level in mind, whether you're a beginner or are further along in your creative journey. If you approach this book with patience, excitement, and determination, you'll gain lifelong skills that can be applied to just about any artistic medium!

We'll cover an enormous range of topics, with each section's skills building on the last. With each lesson, we'll provide tons of inspiration, prompts, tutorials, and worksheets. Once you complete this workbook, you will have gained the skills and confidence to create almost anything you can imagine!

LESSONS WILL TEACH YOU HOW TO:

- START MAKING ART (AND NEVER STOP)
- **SKETCH ANY SUBJECT THROUGH EASY STEPS**
- USE THE ELEMENTS OF DESIGN TO YOUR ADVANTAGE
- **AVOID MANY OF THE MOST COMMON BEGINNER MISTAKES**
- UNDERSTAND SHADING AND VALUE LIKE NEVER BEFORE
- **SEE THE WORLD AROUND YOU IN NEW WAYS**
- USE COLOR TO ITS FULL POTENTIAL
- **GAIN, SUSTAIN, AND EXPAND YOUR IMAGINATION**
- INTERPRET AND DISCUSS WORKS OF ART
- **PURSUE YOUR CREATIVE PASSION**

As you complete the activities inside, we encourage you to post your work on social media and tag us with #artistsdrawingbook.

How to Use this Book

All the lessons contained in this book have been **STUDENT-TESTED** and **ARTIST-APPROVED**. We have refined these lessons over our years of teaching, learning, and making to be approachable, exciting, and engaging. Every activity should push you to reach new creative heights and expand your craft.

If possible, **GO IN ORDER**. While it can be tempting to skip around or jump right into color theory, your work will be better if you allow the lessons to build on one another. We've provided a mix of step-by-step tutorials, prompts, and deep dives so your growth can be well-rounded.

MAKE A HABIT out of this book. That means setting aside a little time each day so that we can develop your skills together. Open the book every morning during breakfast, set a reminder on your phone, place the book in a visible location, or work through the book with a friend so that it's easy to keep going.

That said, **BREAKS ARE IMPORTANT** to gain perspective into your creations and recharge your creative energy. Don't be upset if you have to take a hiatus from your artwork for a few days. Just be sure to add a form of accountability so a break that started as a few days doesn't turn into a few months.

BE PATIENT with yourself. The creative process takes time, patience, and devotion. Some things are bound to come easier to you, while others will be more of a struggle. We have provided tips and tricks to expedite your learning, but it's up to you to allow yourself the time needed to grow.

SKETCH IN THE MARGINS, in the spaces we provide, or in your sketchbook with your own notes and ideas. This will help to cement each of the lessons in your mind. Then, once you've completed the lessons, allow yourself to return to this book as often as you need for a refresh, to reflect, or for a burst of inspiration.

These lessons can be completed by **DIGITAL ARTISTS** as well! If you prefer to work digitally, know that you can complete almost any activity with software like Procreate ™ or Photoshop ™. We've designed each lesson to work with various mediums so anyone can grow from each exercise. Experiment, test your limits, and push yourself to try new things!

Setting Up for Success

Creating art should be rejuvenating, exhilarating, and addicting. Here are a few simple tips for setting up a more productive, sustainable, and enjoyable creative environment.

ERGONOMICS can play a massive role in the effectiveness of your space. First, find a comfortable chair that can adjust to your unique height. Then, if possible, use a drafting table to angle your drawing surface toward your body, as leaning over your work can strain your neck over time. You can jury-rig a drafting table by propping up one side of a drawing board with a few books. Your neck and back will thank you!

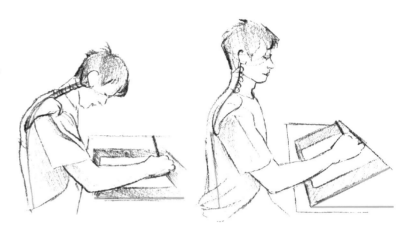

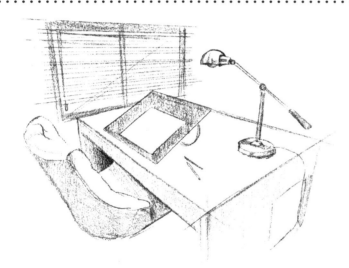

PROPER LIGHTING is essential to making art. Ensure that the lighting in your space is bright enough to avoid unnecessary eye strain and is diffused to prevent hard shadows. Your lighting can also affect your perception of color, so we recommend using a light bulb with a temperature of around 4500K and a color rendering index (CRI) of at least 90. Diffused natural light is also great if you're lucky enough to have a window in your space.

PERSONALIZE your space. First, ensure that you are warm enough by keeping a soft blanket nearby. Next, consider adding a perfumed candle or diffuser to the area for a subtle scent boost. Place a live plant nearby to help add some life to the space. Whatever will make you feel physically comfortable yet mentally excited is the best. Remember, when you feel good, your work will follow.

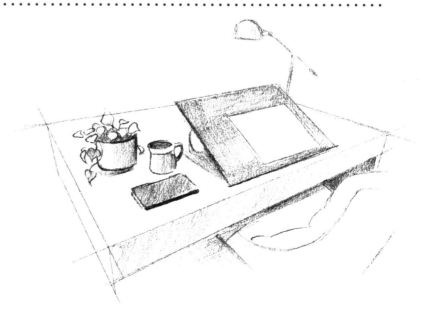

MINIMIZE DISTRACTIONS while keeping any essentials within arm's reach. Stay organized by removing clutter and putting materials away each time you finish a sketching session. It can be hard to bring a new creation into the world if the items around you make you feel claustrophobic. Curate objects in and out as you work in the space, prioritizing the items that provide inspiration and comfort without adding unnecessary distraction.

DEDICATE A SPACE that best helps you to focus. Even if you don't have a separate room, take steps to ensure your work area is private. If noise can't be avoided, invest in a quality pair of headphones and play whatever music gets you in the mood to create. Some people work best in a coffee shop with constant hustle and bustle around them, while others work best in a sterile studio. It's all about finding your fit so you can start creating!

BE FLEXIBLE in both your setup and your creative mentality. While working in a controlled environment can feel ideal, you should be prepared to create wherever and whenever inspiration strikes! Organize a portable "go" bag with the minimal supplies necessary to create amazing art wherever you go. To the right is an example of what our travel studio looks like with the materials and tools we need.

Artistic Improvement

The most common question that we get asked is, "How do I become a better artist?" Our answer is simple:

CREATE AS MUCH AS POSSIBLE!

It might not be the answer you were hoping for, but it's true. The best way to improve at almost anything is to practice. As artists, we practice our craft and experiment with new ideas by **SKETCHING**.

Each time you sketch, you train your brain to think more creatively, build essential habits and hand-eye coordination, and expand your ability to experience the world around you. While many artists sketch by doodling or drawing, you can "sketch" in just about any material or process you can imagine, from welding to writing. It's a great way to quickly test multiple ideas or compositions without being overly concerned about producing a fully refined result. This allows you to create without hesitation or inhibition, leading to increased experimentation and innovation. It can be a bumpy road at the beginning, but if you keep it up and practice, you will be blown away by the improvement over time!

PROGRESS HAPPENS OVER TIME.

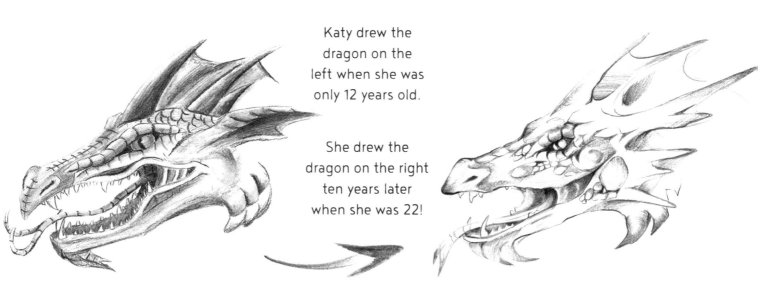

Katy drew the dragon on the left when she was only 12 years old.

She drew the dragon on the right ten years later when she was 22!

Don't worry – this practice really, truly, honestly can be fun! Throughout this book, we'll guide you through exercises, tips, and activities to build and sharpen your creative skills. We can't wait to see what you create!

Start Your Art

We know the feeling: You've got an idea and are so excited to make it that you just want to grab the brush and get painting. But we are telling you – from too much experience – if you take a moment and sketch your idea out first, your work will vastly improve. A simple series of sketches can help you problem-solve, practice, and experiment in a way that nothing else can.

Key reasons for starting with a sketch:

Sketching is loose, spontaneous, and exciting!

If you were to jump right into a big piece without sketching first, it could feel like trying to perform a magic trick in front of a crowd without practicing first. Not only does the sketch help prepare you for the real thing, but the experimentation involved can result in surprising innovations that you might never have thought of otherwise!

Mastering what you want to create can take practice!

Perfection is a process, and it can take time to build your skills. So don't be afraid if you start a piece that doesn't look exactly like you imagined. Instead, recognize where you might be struggling and put in the time to research and practice that part of your process.

Your first idea isn't always your best idea!

Before committing to a time-consuming project, ensure you are working with your favorite iteration of your concept. Remember, a sketch can take as little as a few minutes, whereas a finished piece can take hours, days, or weeks! This little step can help you spot potential issues and may be the difference between a "show-stopper" and a "stop-showing."

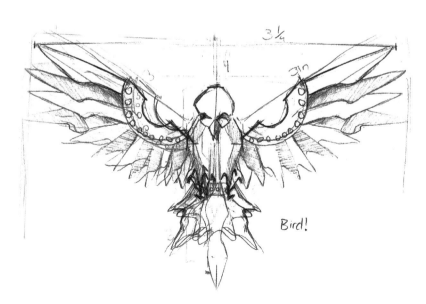

Bird!

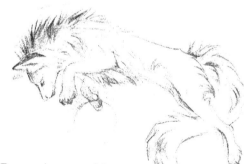

PRO TIP – Even when working on commercial projects or a commission, we always start with a sketch for the client to approve! Not only is this step helpful, but it's also required to ensure all parties are satisfied.

Avoid Any Excuses

Finding the time to create artwork can seem impossible between chores around the house, that new TV show you've heard about, and all the other endless excuses.

OFTEN, JUST STARTING SOMETHING NEW IS THE MOST CHALLENGING PART!

It's crucial to remind yourself that your art is important and your perspective is valuable. There will always be doubt in your mind, other uses for your time, and obstacles in your way. Identifying and strategizing how to tackle these hurdles is vital to spark your creativity and keep the art flowing.

AVOID THESE COMMON THOUGHTS THAT LEAD TO SELF-SABOTAGE BEFORE YOU EVEN BEGIN:

"I DON'T HAVE ENOUGH TIME."

Blocking out time for activities you find enriching is healthy and necessary. We know life is busy; if you are overwhelmed with a packed schedule, try scheduling 15-30 minute blocks into each day for art time. You will see huge improvements, even from sketching for only a few minutes at a time.

"I DON'T HAVE THE NECESSARY MATERIALS."

Try starting with just a pencil and paper. Artists usually build their tool kits over time. As you and your process grow, so will the tools you use. This book focuses on core concepts that can be studied and practiced with just a few simple materials, which we've listed on page 20 of this book.

"THERE ARE SO MANY BETTER ARTISTS OUT THERE."

Comparing ourselves to others is inevitable but ultimately not productive. The only person you should be comparing yourself to (especially when starting out) is you. Try to measure your progress over time, and rather than getting discouraged when you see something you think of as "better," try to view it as inspiring.

...

If you remove these mental blocks early on and try to approach your creativity with clarity and focus, you will get the most out of each art session. Our most important tip is this:

DON'T HESITATE, JUST CREATE!

Making Your Mark

Have you ever sat down to start a new piece only to find that making the first mark seems nearly impossible? When starting with a pristine new sketchbook or expensive canvas, there can be a lot of pressure to create the perfect artwork. After all, materials are costly, and a sketchbook seems like such a commitment.

This feeling, known as "**BLANK PAGE SYNDROME**," is a paralyzing hesitation that can lead to making nothing at all, despite the desire and motivation to do so. If you find yourself staring blankly at your sketchbook, here are a few tips to help combat Blank Page Syndrome so you can get started:

Go through your sketchbook and write a prompt on every page. This will force you to put marks on the paper and fill your sketchbook with ideas!

Spill your tea, coffee, or ink! These abstract shapes might be the perfect source of inspiration, and the pages will feel less precious!

Let someone else make the first mark! Ask a friend or family member to make a few random marks on the pages. Their scribbles could be just the push you need to get started.

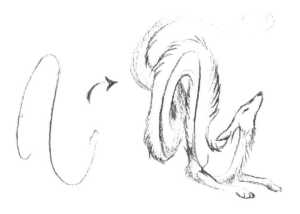

Some people are timid about starting the first page of a sketchbook since that is what viewers will see when they first open it. If you struggle with this, why not skip the first few pages and start on page ten? You can always return to the beginning later once you've gained more confidence.

LET YOUR SKETCHBOOK BECOME AN UNFILTERED JOURNAL WHERE YOU CATALOG YOUR THOUGHTS, EXPERIMENTS, AND EXPERIENCES.

What You'll Need

If you've ever walked into an art store, you know that there are countless different supplies, tools, and materials to choose from – each catering to a different process with its own complexities and nuances. Narrowing down which items are worth investing in can be daunting. We've provided a brief overview covering some of the most essential items below:

RULER. A ruler can help draw straight lines, take measurements, or divide your space.

ERASERS. You'll want one standard white eraser for general marks, one kneaded gum eraser for lifting layers, and one fine-tip eraser for details.

GRAPHITE PENCILS. Look for a set with a range of hardness from at least 6B to 6H. (More info about graphite grades on page 24).

SHARPENER. Any pencil sharpener with a sharp blade will work, but an angle-adjustable style is best.

MECHANICAL PENCIL. Available in varying sizes and colors, but a standard 0.7 is a good start.

WHITE CHARCOAL. A white pencil is really helpful in making bright white highlights on toned paper.

SKETCHBOOK. Get a hardcover sketchbook with thick, unlined, acid-free paper, stitch-bound so it can lay flat. An elastic band around the exterior can help to prevent smudging. You may want to consider finding one with toned paper as it allows you to work additively and reductively, such as in the activity on page 119.

BALLPOINT PEN. These are a cheap yet effective medium. Ideally, you'll want to have ones with different colored inks, such as black, blue, and red.

FINELINER PEN SET. Technical pens in a variety of sizes with archival, waterproof inks.

GEL PENS. We love white gel pens for details and highlights, but bright colors are fun, too.

COLORED PENCILS. A set of 12 wax-based, artist-grade pencils is a good start.

COLORLESS BLENDER & BURNISHER. These translucent pencils make blending a breeze.

REFERENCE PHOTOS. It's always nice to have a few references to pull from. You can take your own photos, collect vintage stills, or search free-use websites.

PAINTERS TAPE. A low-tack tape is helpful to stretch your paper, mount ephemera, mask areas, and more!

WE RECOMMEND USING THE MATERIALS LISTED ON THIS SPREAD FOR THE EXERCISES AND ACTIVITIES IN THIS BOOK, BUT YOU ARE WELCOME TO EXPERIMENT WITH SUBSTITUTIONS!

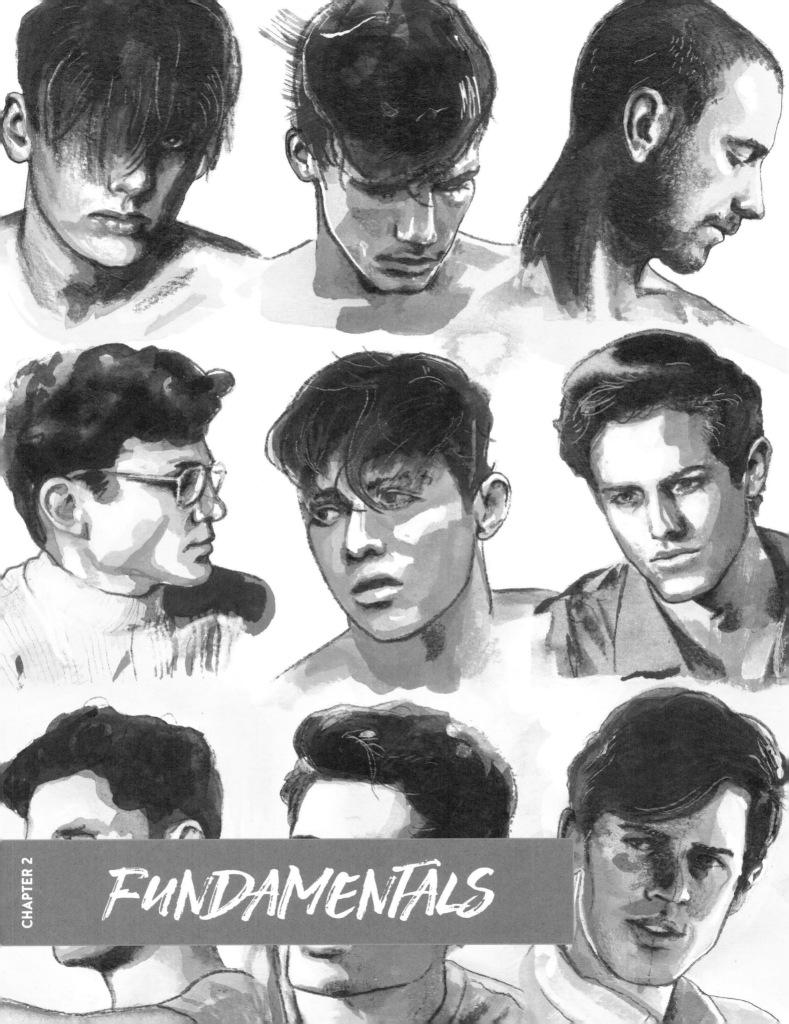

FUNDAMENTALS

In this Chapter:

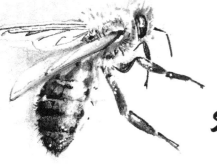

Materials Required:

Pencils

A set of graphite pencils in various hardnesses from 6B to 6H.

Eraser

Helpful to erase any mistakes or to work reductively.

Sharpener

A pencil sharpener will ensure you're always on point.

Sketchbook

Have your sketchbook on hand to take notes and practice as we go.

Graphite: MASTER THE POWER OF THE PENCIL

Graphite is one of the most versatile drawing, sketching, and writing tools. Pencils have been used for thousands of years, with ancient Romans using a metal stylus to leave light marks on papyrus. Other styluses included ones made of lead which is why we continue to call the core of our graphite pencils the "lead." This toxic material was eventually replaced by graphite.

The modern pencil allowed people to create more detailed and varied works of art. By sharpening the end, you can achieve a fine point for accurate details, use the side for broad shading, or anywhere in between for an enormous range of possible marks.

DON'T OWN A SET OF PENCILS?

Most standard #2 pencils found in any school or office are an HB, or medium hardness. Fancy materials aren't required to make a great work of art (but they do help).

GRADE

Graphite pencils are classified with an alphanumeric value into their hardness or softness, with 9B being the softest and 9H being the hardest. Think of **H** standing for **HARD** and **B** standing for **BLACK**, as the softer the lead, the darker the mark will be on the page.

SOFTEST / DARKEST	HARDEST / LIGHTEST
←	→

... 6B | 5B | 4B | 3B | 2B | B | HB | F | H | 2H | 3H | 4H | 5H | 6H ...

2B

HOW TO HOLD A PENCIL

When starting a drawing, hold the back of the pencil with a looser grip, like a magic wand. Movements should use the entire arm, radiating from your elbow and shoulder, to have a full range of motion.

When drawing detailed areas, hold the pencil closer to the tip with a tighter grip. Use your whole arm but focus movements closer to your fingers.

Play with your grip until you find what feels the most comfortable.

Pros & Cons

Pencils of different hardness are not built the same! Below are three subjects you can practice shading:

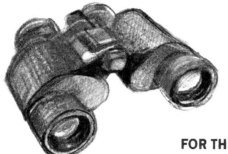

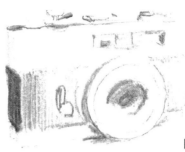

FOR THE BINOCULARS, try to shade using only your softest pencil (6B).

FOR THE CAMERA, try to shade using only your hardest pencil (6H).

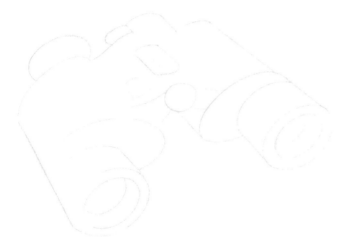

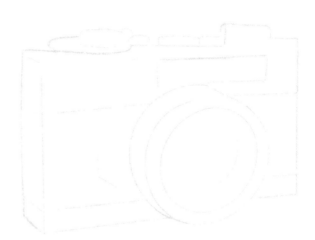

Graphite can have a distractingly shiny appearance if not used correctly. To avoid this, use harder pencil leads, such as 6H, for the lighter areas of the drawing, and use softer pencils, such as 6B, for the darker areas. By starting with lighter and harder leads and then gradually moving to darker and softer leads, you can avoid most of the shine, keeping the viewer's focus on your drawing, not the material.

NOW USE THE FULL RANGE OF PENCILS TO SHADE THESE FOXES:

Sketching Basics

These techniques will help you form good sketching habits, helping you to avoid many beginner mistakes.

Start Big, then Narrow Your Focus

A good sketch should start loose and large, with emphasis on the major shapes of your subject. Once the overall form has been established, you may gradually work smaller, but always leave the details for the end. Imagine drawing a face: It can be tempting to immediately start with the eyes (they are "the window to the soul," after all), but if you haven't taken the time to first measure and work out the major angles of the head, then you'll likely find that the eyelashes you rendered so beautifully are actually in the wrong location. Resist the temptation to jump right to the little stuff, and your work will be better because of it!

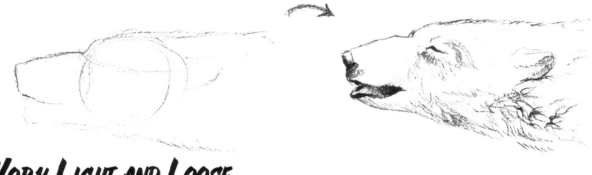

Work Light and Loose

Try to sketch with a light touch and gradually darken areas as you refine them. Think of the sketching process like a developing photograph – your page should start blank and full of possibilities, and then the most important areas should gradually darken as everything comes into focus. A common beginner mistake is to tightly grip the pencil, resulting in a thick, dark line that cannot be cleanly erased. Remember, it is way easier to darken your drawing than it is to make something lighter.

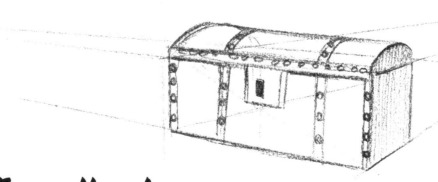

Always follow a "push and pull" pattern with your work. Pull out darker, tighter values with your pencil while pushing back errant lines with your eraser.

Extend Your Lines

When drawing, **EXTEND YOUR LINES** past where they might typically end to enforce directionality, and overlap edges until you are confident with where they lie. As long as you work lightly, you'll be able to erase any unnecessary details later, but this step REALLY helps you be accurate and confident in your work.

Tips and Tricks

BLEND BETTER

Blending is a contentious issue when using graphite. Many beginners are tempted to use their fingers to smudge their drawings to create blended areas from light to dark. Try to avoid this temptation. Not only does smudging prevent you from practicing proper pencil control, but the oils on your fingers can ruin your paper. Blending chamois or stumps can help you achieve certain textures in some cases, such as creating realistic skin pores. Still, try to avoid using these unless absolutely necessary and instead focus on controlling your pencil pressure and application to create smooth blends.

PREVENT SMUDGING

If you're right-handed, always try to fill up your sketchbook and drawings from left to right and top to bottom. (Lefties, do the opposite!) This simple habit prevents smudging your work. Of course, you may not always be able to work this way. In these instances, place a clean piece of paper below your hand so you don't smudge your sketch. This can also prevent the oils from your skin from affecting your work surface.

PROTECT YOUR PAPER

Whether working in a sketchbook or this workbook, remember that there are sheets of paper beneath the page you're working on. These pages can be damaged if you press too hard with your pencil or use a material that bleeds through. Therefore, we recommend placing a scrap of paper behind your page before working to prevent scoring, bleed-through, or other unintentional marks on your surface.

FIX YOUR ARTWORK

Once you have completed a piece made with dry materials, such as pencil, pastels, or charcoal, we recommend spraying your art with a workable fixative! This product is an aerosol sealant that "fixes" or stabilizes your materials to the surface to preserve your finished work. Spray fixative should be used in several light passes and only when you have proper ventilation.

The Sketching Formula

Many people are overwhelmed with sketching at first. Young artists often lack the knowledge gained through experience, causing them to dive right in with a dark outline or simplified symbol. Older artists will often stumble about, unsure of the right moves as they struggle to sort out the "right" methods of approach. We believe that, no matter how complex a subject may seem, you can tackle your sketch using a simple series of steps in what we call "The Sketching Formula."

THE SKETCHING FORMULA:

LEAD WITH LINE

SHAPE COMES SECOND

FORM IS WHAT FOLLOWS

EVENTUALLY ADD VALUE

TOP IT OFF WITH TEXTURE

These processes represent the different **ELEMENTS OF DESIGN**. Consider them unique tools to add to your creative toolbox, each allowing you to quickly build a strong sketching foundation. Once you gain more experience, you can selectively mix and match these elements to customize your artistic process.

Formula in Action

Every sketch starts with a **LINE,** in what we refer to as a gesture.

These **LINES** guide our development of **SHAPE.**

Each **SHAPE** can be extruded into a three-dimensional **FORM.**

 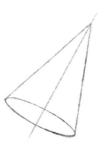 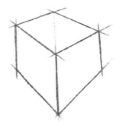

Once the **FORM** has been established, **VALUE** comes next.

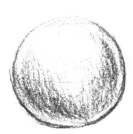 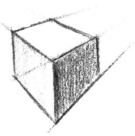

Finally, we render **TEXTURES**, transforming simple forms into finished subjects.

WE WILL BREAK DOWN EACH STEP OF THIS PROCESS IN THE FOLLOWING PAGES.

Learn Your Lines

Formed by connecting any two points with your drawing utensil, a line is the most basic element of any drawing. Despite its apparent simplicity, properly creating this stroke can be a major hurdle for many new artists due to a lack of line confidence, consistency, or control. If a beginner lacks line confidence, they often use a series of short strokes to create a long line. This absence of fluidity is caused by using joints too close to the pencil end, using the wrist or fingers instead of the elbow and shoulder. Remember that drawing is best done with the whole body in mind.

Another common problem is a lack of line consistency, or the ability to repeat a desired stroke. An artist struggling with consistency may have difficulty creating repetitive strokes, such as when hatching. Similarly, many artists struggle with line control. This causes them to lack the sensitive touch required to make light or dark lines with intention. Luckily, all these problems can be fixed with proper practice.

LET'S IMPROVE YOUR LINE CONFIDENCE, CONSISTENCY, AND CONTROL IN THE SPACE BELOW. START BY WORKING ON TOP OF THE GUIDES AND THEN MOVE TO FREEHAND.

Sharpen Your Circles

It's so simple that it might sound silly, but a great exercise before starting a sketching session is to draw as many circles as possible for five minutes, trying to make them as perfect as possible. To increase your accuracy, focus on moving from your elbow and not from your fingers, working to enter a rhythm. This practice will help loosen up your hand, sharpen your eye for detail, and build muscle memory. In the space below, we've made a few guides to practice on. Don't worry if your circles are not perfect initially – this exercise requires practice but will vastly improve your skills!

WORK ON PERFECTING YOUR CIRCLE SKILLS IN THE SPACE BELOW:

Gesture Study

A SKETCH OF FORM & MOTION THROUGH LINE

The best way to start a sketch is with an initial series of lines capturing the motion of your subject in what is known as a **GESTURE STUDY**. A gesture is the foundation of a sketch. It is the simplest possible representation of your subject, expressed through line and focused on capturing the story more than the exact likeness. These lines will serve as pathways for establishing shape and form. Start with a gesture when drawing any subject from observation – whether a person, plant, or plane.

A gesture study starts by capturing the **LINE OF ACTION**. This first mark should capture the action of your subject through a broad, gracefully flowing line. For subjects in motion, start with a curved line along the longest axis, such as the line formed from the head, down the spine, and to the tip of the toes. For perfectly still items, focus on capturing the line of symmetry which divides the subject in half along the longest axis.

Next, add **DEFINING LINES**. These strokes should focus on the most prominent curves to capture your subject's story. At this point, you can add pivot points at the locations of the active joints or develop the lines that support your line of action.

Finally, use **MEASUREMENT LINES** to determine the proportion of your subject. Use these marks to establish the endpoints of your subjects, such as the top of the head, bottom of the feet, or tips of the fingers.

WHEN WORKING ON A GESTURE DRAWING, TRY TO KEEP THESE TIPS IN MIND:

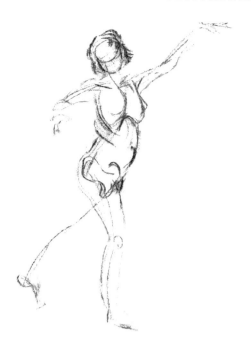

The primary purpose of a gesture drawing is to capture a subject's energy, gravity, and motion rather than the outline or exact details. Therefore, refrain from capturing detailed features like eyes, fingers, or hair, as those will come later. Instead, we should understand the essence of the subject just from a few simple lines.

Gestures are meant to be fast, often limited to just 30-60 seconds. During this time, drop all preconceived notions about your subject and just capture what you see!

Even without carefully rendered features, we can still tell that the gesture to the right is meant to capture a bee in flight.

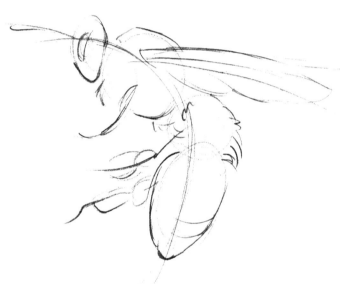

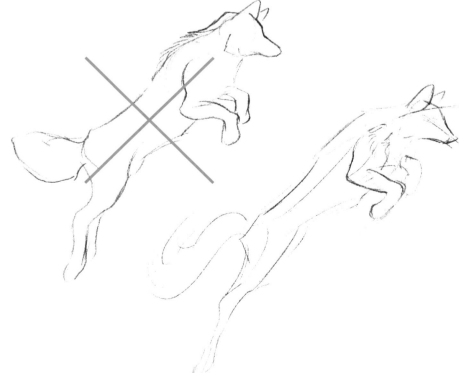

Notice the subject's movement and selectively exaggerate your gesture to communicate your character's motivation. For example, you can stretch limbs that are in motion or tense the muscles to capture a mood of anxiety. To emphasize a tired subject, drop the extremities, rotating the gaze downward and the focus inward.

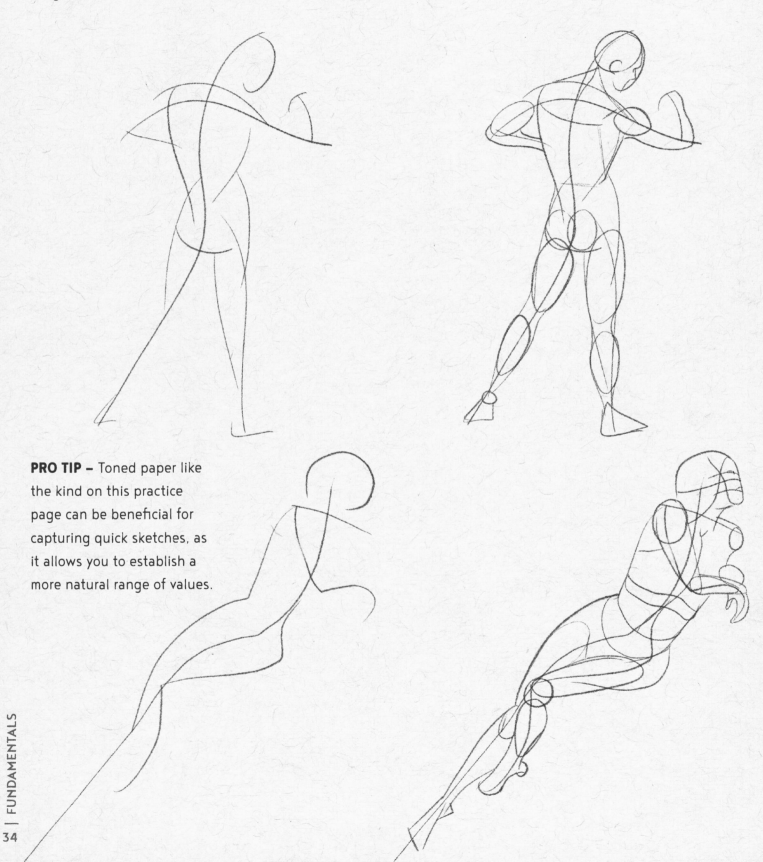

Gesture Practice

In the step-by-step below, we've rendered our subjects using the Sketching Formula to show how a gesture can continue to be developed.

PRO TIP – Toned paper like the kind on this practice page can be beneficial for capturing quick sketches, as it allows you to establish a more natural range of values.

A true gesture should embody the raw form, like that shown in our first step. In the space below, view our finished subjects and then try to show their movement and form in a gesture study. Begin by establishing the line of action, then gradually move tighter. Remember that the purpose is to capture the energy of your subject as simply and elegantly as possible. You can come back and add detail later if you like.

CAPTURE A GESTURE OF THESE SUBJECTS IN THE SPACE BELOW.

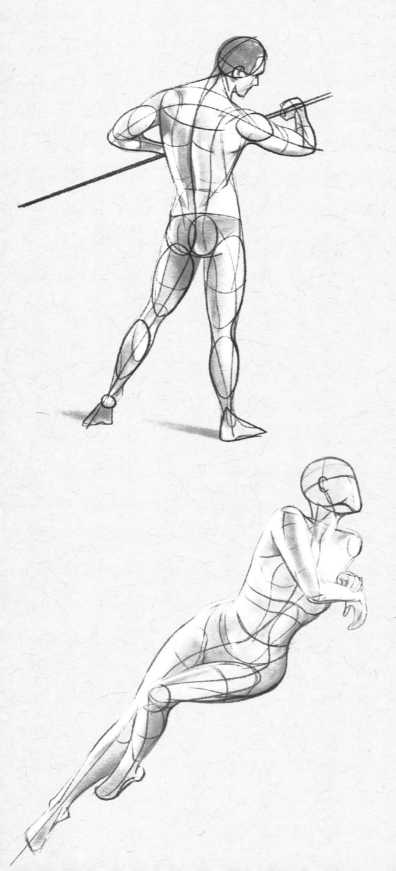

Shape is Second

Any subject can be simplified into different **SHAPES**, such as circles, rectangles, and triangles.

These are the basic building blocks of any subject, and each of these shapes can be squished, stretched, bent, and merged to fit the unique nature of your subject. Understanding simple shapes can help you to comprehend and simplify a complex form, like a face or hand, into more manageable components.

Round shapes can be circles, ovals, or ellipses. Circles are perfectly round. Ovals are circles that are distinctly longer in one dimension and are often found when drawing natural forms, such as animals and people.

Ellipses are circles that are shown in perspective. For example, several ellipses are visible when viewing a glass of water: one at the rim, one at the water line, and one at the bottom. In reality, the glass has a perfectly circular edge; however, our vantage point causes the perfectly round form to become squished the closer it gets to our vanishing point. We'll talk more about perspective a little later in this workbook.

 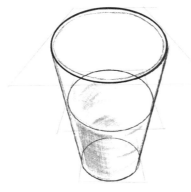 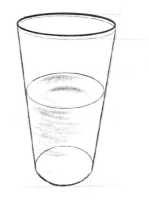

TOP RIM **ANGLED VIEW** **SIDE VIEW**

Blocking In Shapes

You can view any subject as a series of interconnecting lines, circles, triangles, rectangles, and polygons. This process is known as **BLOCKING IN** your subject. When blocking in with shapes, try to match each component with the shapes it's composed of, such as the top of the skull as a circle. These shapes might not be perfect – a circle might be squished and elongated, a triangle might have very random angles, and a rectangle might be closer to a rhombus. Be careful to observe these nuances and capture them as best as possible. Remember to skew your shapes to fit your subject – don't skew your subject to fit perfect shapes.

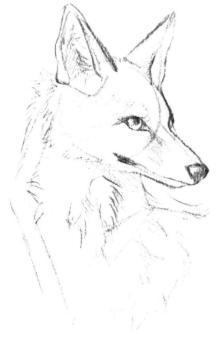

This fox can be broken down into circles, triangles, and rectangles.

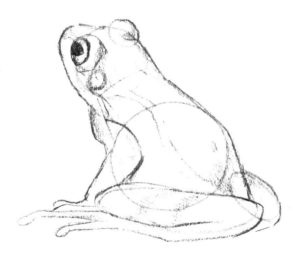

This frog is made with different circles, some stretched or warped.

You can also focus on the negative space around the subject to determine the silhouette or **ENVELOPE**. With this method of blocking, you can capture the true form instead of the assumed shape. Start by enveloping the most prominent areas, almost as if a sheet is covering your subject. Once that large form has been established, gradually move inward, focusing on the nuanced facets of the silhouette. As you work smaller and tighter, your subject should come more and more into focus.

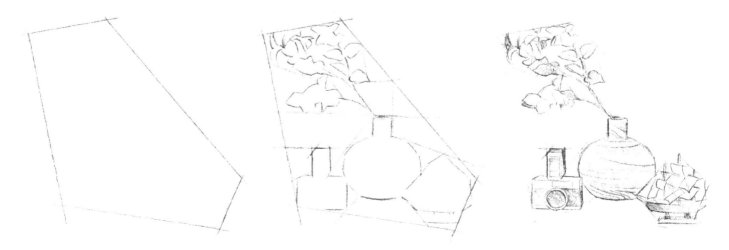

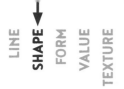

Shape to Something

Some people have trouble envisioning their subjects as shapes at first. In this activity, we will turn simple shapes into quick drawings. To start, all you need is a pencil and a timer.

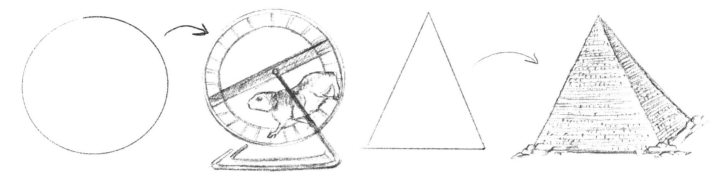

Set your timer for ten minutes. Then, turn each of the following nine circles into a rapid drawing or idea. That's only a little more than a minute per drawing, so try not to overthink it!

Take a look at what you made with the circles. Which ones worked best? Which ones worked the least? Now, set your timer for another ten minutes to transform each of the following nine triangles. These can be a bit trickier, but anything's possible when you think out of the box!

You can repeat this activity in your sketchbook. Use squares, parallel lines, or more complex forms like cubes and cylinders. You can also adjust the time limitation to see how your creations change.

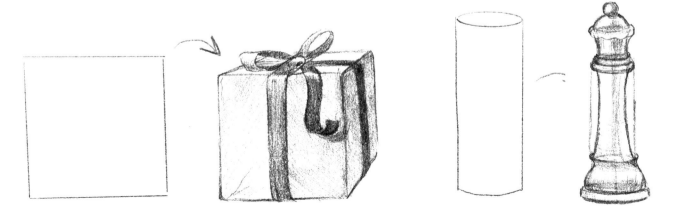

Shape Selection

Now let's try that same principle but in reverse. We've provided a few finished sketches along with examples of shapes. This time, simply draw over our sketches to identify the shapes that make up each subject.

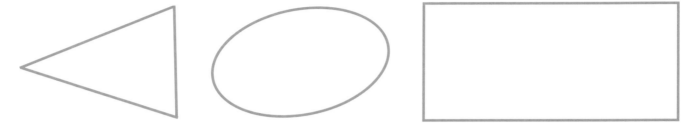

DRAW THE MAJOR SHAPES OVER EACH OF THESE SKETCHES:

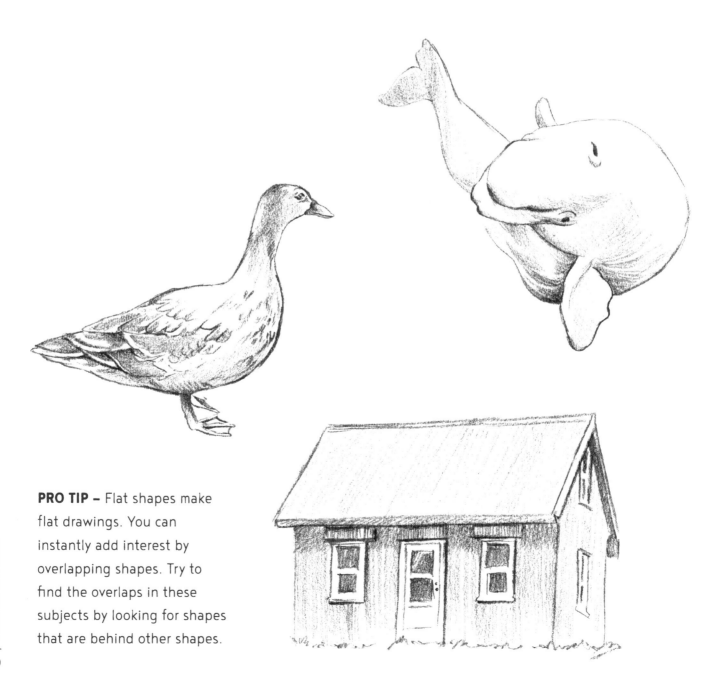

PRO TIP – Flat shapes make flat drawings. You can instantly add interest by overlapping shapes. Try to find the overlaps in these subjects by looking for shapes that are behind other shapes.

Gesture Guides Shape

So how does shape work in our formula? First, start with a gesture to capture the motion of a subject. Then, observe and analyze the shapes that fall along the lines of action. Carefully observe the various sections of your subject and try to match them with their corresponding shapes, such as circles, squares, or triangles, then place them along the lines of your gesture study. Focus on scale and proportion to determine the relative size of each shape. Then analyze how the shapes connect to capture their combined area. This set of steps can help you refine your subject's contour.

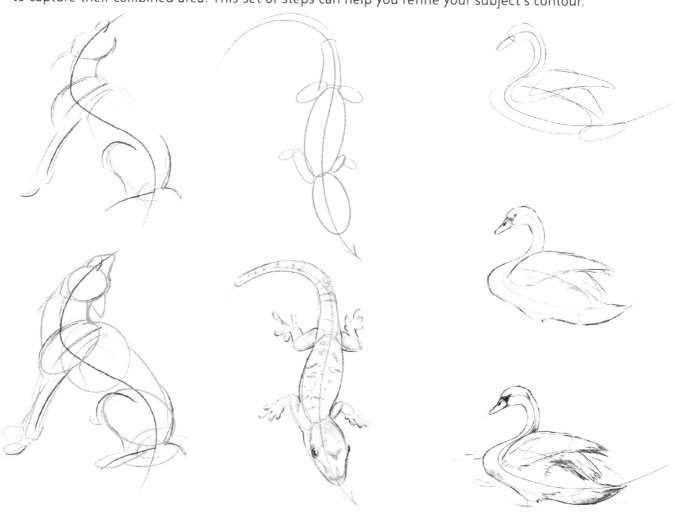

TRY TO REPLICATE THESE SUBJECTS IN THE SPACE BELOW:

Foundations of Form

Once you have established the **SHAPE** of a subject through these outer contours, you can start to develop the **FORM**. Shape is a flat representation of your subjects' perceived area through height and width, while form represents the subject's volume by adding depth. Figuring out form allows you to determine how your subject exists in space and relates to other items.

The simplest way to express volume is by adding **CROSS-CONTOURS** to indicate a subject's dimensionality, instantly turning any flat shape into a three-dimensional form. Cross-contours are like slicing your subject with an invisible knife. Their direction will be relative to your viewpoint, so they will rarely be perfectly straight.

Start with the shapes of your subject and then observe how their forms bulge and bend. Capture this by adding cross-contour lines, starting with a simple curved line in the center of each shape.

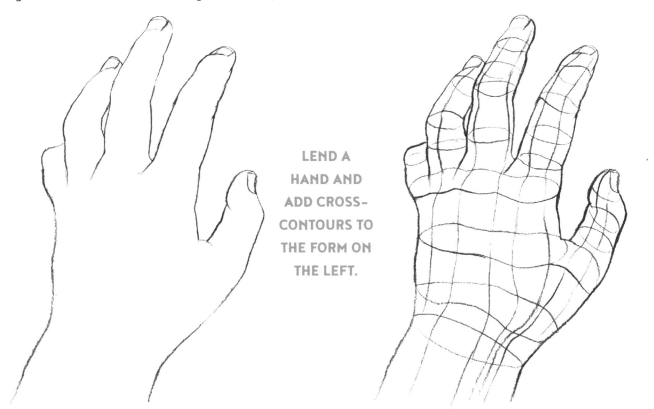

LEND A HAND AND ADD CROSS-CONTOURS TO THE FORM ON THE LEFT.

Look carefully at your subject and refine any areas where the cross-contour should be distorted to better mesh to your subject, such as by adding dimples, wrinkles, and mounds. These subtle changes help us understand how each shape's forms are bent, squished, and distorted. Focus on any places where shapes connect into one another, and then mark these transitions with cross-contours as well.

With cross-contour lines, you can create a map of your subject, focusing on the major areas and gradually moving to the smaller ones but waiting to add details. Moving from simple to complex, you can check your scale, proportions, and directions before committing to a final drawing.

When adding cross-contours, start by indicating the longest side. Unless your shape is a perfect sphere, this distortion in one dimension will help to determine a top and bottom. Draw one contour curving around the form from the north to south poles, then make an equatorial line by establishing a contour perpendicular to that vertical line.

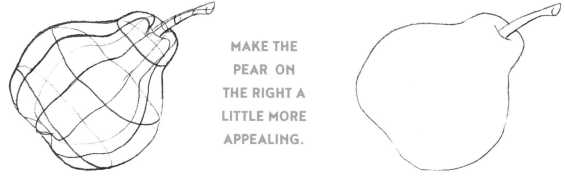

MAKE THE PEAR ON THE RIGHT A LITTLE MORE APPEALING.

See how an ambiguous shape becomes volumetric once cross-contours have been added? Cross-contours should allow you to still understand the shape even if there were no outline at all.

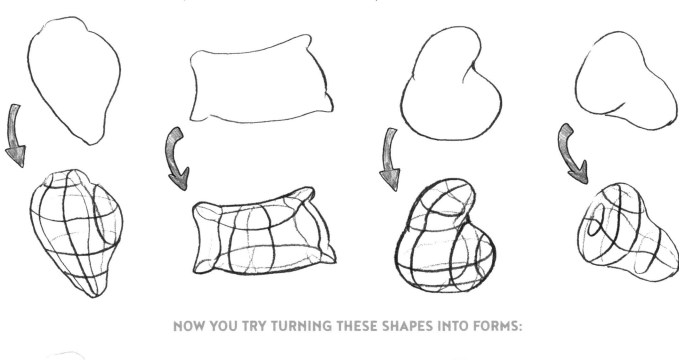

NOW YOU TRY TURNING THESE SHAPES INTO FORMS:

TAKE IT FURTHER – Imagine wrapping a string around your object in a crisscrossing fashion. Now, try to draw the contours of your subject by only drawing the strings. You should be able to capture the forms through the curves of the contours alone.

43

Informed Forms

When we use cross-contours to turn a shape into a form, we trick our minds into perceiving our drawing as a 3D form instead of a 2D shape. In the space below, we've explored another way cross-contour lines can form optical illusions. First, create your shape and add cross-contours. Then, you can erase the outside shape and extend your cross-contours. By using selective overlap, we can make it seem like the forms are not solid at all but actually cut into pieces or made of ribbon.

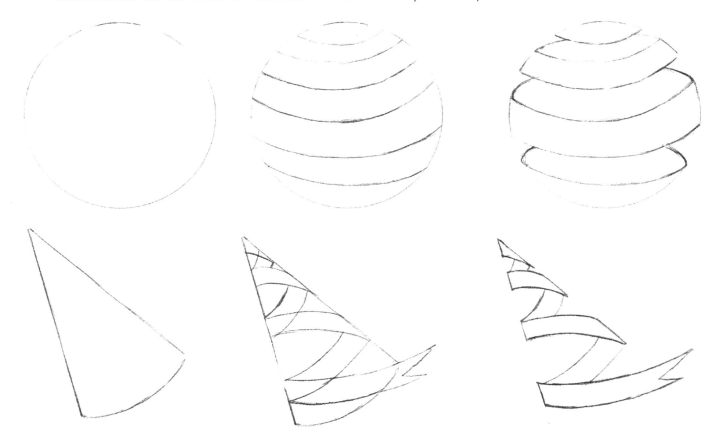

TRY BREAKING DOWN YOUR OWN FORM IN THE SPACE BELOW:

Sometimes form is visible in the texture or pattern of a subject, such as in the stripes of a tiger. These lines should curve around the body just like a cross-contour.

USE WHAT YOU KNOW ABOUT FORM TO ADD STRIPES TO THIS TIGER:

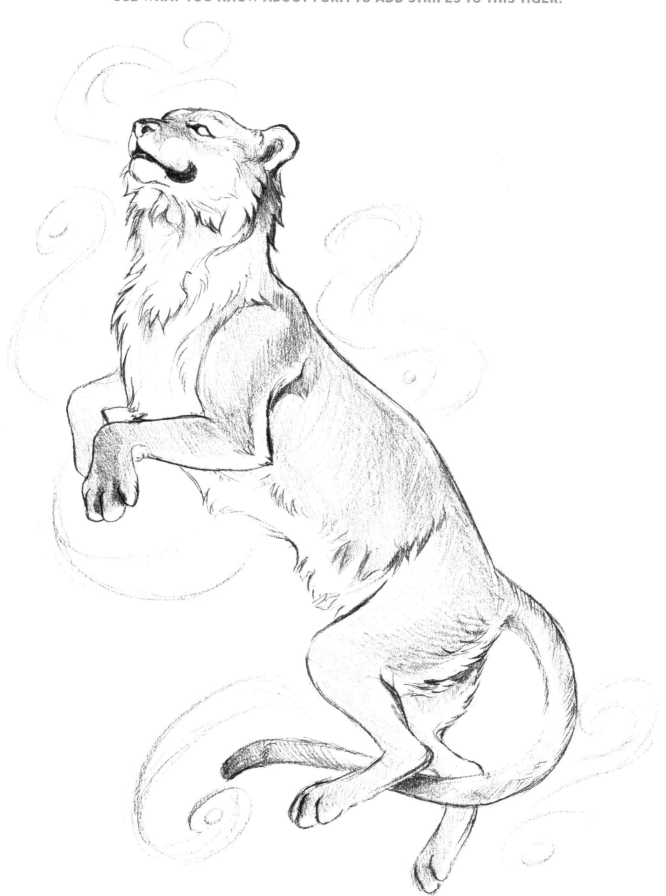

Value Scale

Once **SHAPE** and **FORM** have been figured out, the next step is to establish **VALUE**.
Value is the determination of how light or dark an area of a subject is perceived.

WHAT IS A VALUE SCALE?

A value scale shows the full range of shades available to the artist. To the right, you can make a value scale of your own! First, use pencils of varying hardnesses to make a gradient from light to dark. Then, use only a standard #2 pencil, varying your pressure and density to make a value scale. Observe how the results differ.

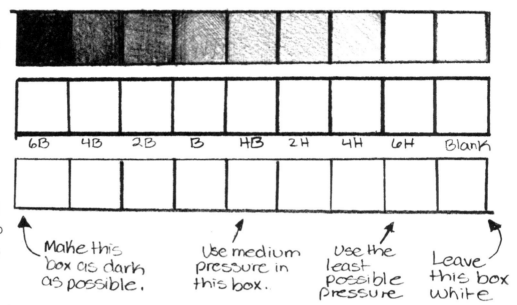

6B 4B 2B B HB 2H 4H 6H Blank

Make this box as dark as possible.

Use medium pressure in this box.

Use the least possible pressure

Leave this box white

TIPS FOR CREATING VALUE:

Start your shading with a limited value scale containing the lightest areas, the darkest areas, and the mid-tone areas. Then shade everything according to how these interact with one another.

It can be helpful to block in your values first by focusing on the separation between the lightest and darkest areas. Sketching this invisible line can help you to plan the more subtle gradations.

Be mindful of a subject's local value or how light or dark a subject is in relation to a perfect scale from light to dark. For instance, the value of a black shirt may only range from 100% to 80%, while a white shirt might only go from 40% to 0%. Keeping these relative values in mind can help to add realism.

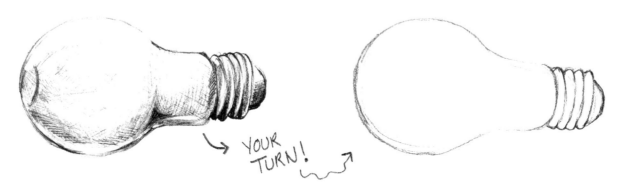

YOUR TURN!

Ways to Shade

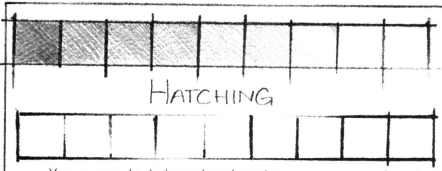

HATCHING

HATCHING:
Using a series of parallel lines to create the illusion of light and shadow.

You can create darker values by using more pressure, by using a softer pencil lead, or by using both. You can lighten values by decreasing pressure and using a harder pencil lead.

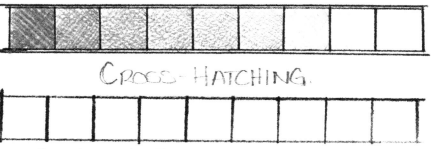

CROSS-HATCHING

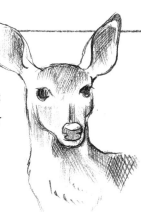

CROSS-HATCHING:
Using perpendicular lines to create the illusion of depth through value.

Consistency is key. Try to keep your lines somewhat evenly spaced and perpendicular, or change the angle of the lines to match the direction of your subject.

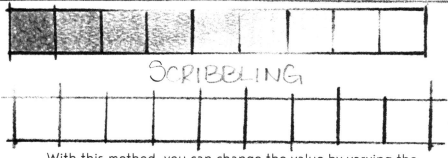

SCRIBBLING

SCRIBBLING:
Using tight circles or random lines to build up tone and imply texture.

With this method, you can change the value by varying the pressure you use, utilizing a harder or softer lead, or changing the density between the scribbles.

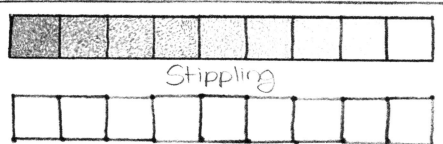

Stippling

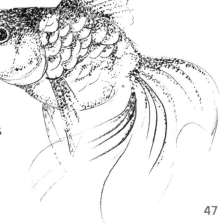

STIPPLING:
Varying the spacing of dots to create tone and texture.

Space the dots very tightly together for a darker value or space the dots farther apart to create a lighter value.

Value from Light

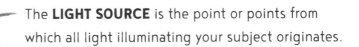

Value relies on understanding how your form interacts with the light sources of your scene. Keep in mind the direction, brightness, and color of your light source while also paying attention to any light that is reflecting onto your subject.

The **LIGHT SOURCE** is the point or points from which all light illuminating your subject originates.

The **LIGHT DIRECTION** is the path light takes to reach your subject. Does the light pass through a window before hitting your subject or bounce off of a wall? These can affect the properties of the light.

The **FORM SHADOW** is the darkened area on your subject, caused by the object's contours almost entirely blocking the light source.

The **HIGHLIGHTS** are the areas where the light source directly hits your subject, creating the lightest value.

The **OCCLUSION SHADOW** is the total absence of light seen in the space where the subject meets the ground.

The **REFLECTIVE LIGHT** is the illumination caused by light that has bounced from a surface back onto an object's edges.

The **CAST SHADOW** is the darkened area opposite the light source caused by an object blocking the light.

USING A LIGHT AND A BALL TO VISUALIZE THE LIGHTING, PRACTICE SHADING THE SPHERES BELOW,

Straight from the Source

You can use the cross-contours we have established to understand your subject as a volume with many flat facets. Each plane will face towards or away from our light source, which will indicate that section's value. Any plane that is facing our light source will be the absolute brightest. As the planes gradually angle away from the light source, they will get darker and darker. The plane directly opposite the light source would be the absolute darkest if there was no reflective light.

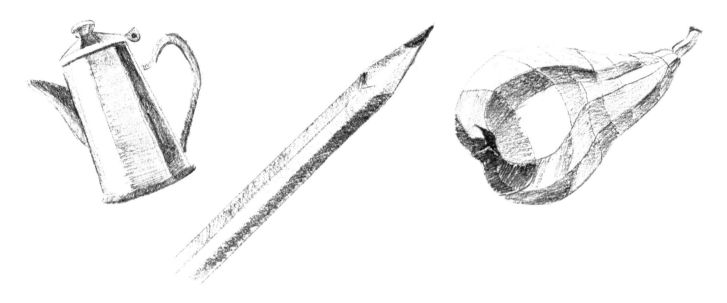

Using what we've learned about lighting and imagining the individual values of each plane, you can better understand how your subject is realistically shaded.

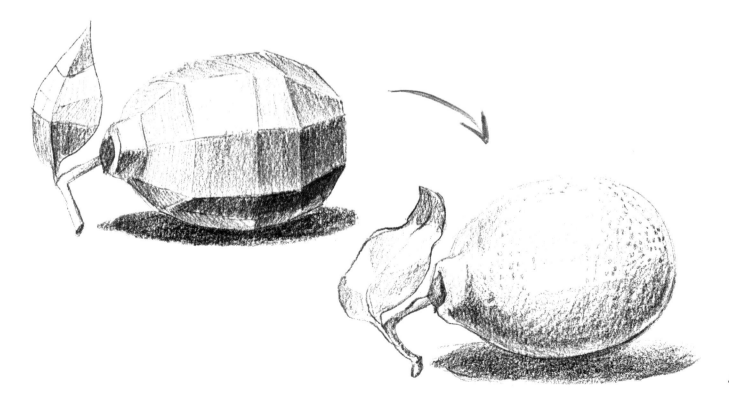

Shading Spaces

Complex subjects follow these same rules of light and shadow. Let's explore some examples below:

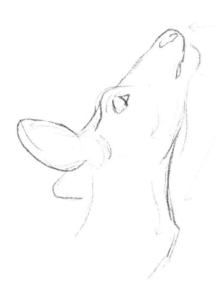
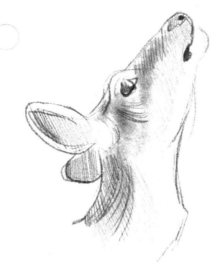
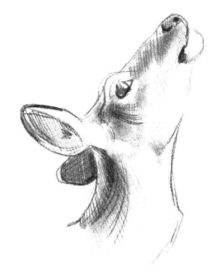

FIRST, sketch the subject and identify your light source. When there are multiple light sources, start with the most prominent.

SECOND, identify the areas most obstructed by light. These will contain the darkest values. Forms that protrude towards the light source will have highlights and will be the brightest.

THIRD, continue to add tone to areas most heavily in shadow so that they recede in space. Lightly shade areas that protrude towards the viewer to emphasize the highlights.

WHEN SHADING A TRANSPARENT OR TRANSLUCENT OBJECT, IT IS IMPORTANT TO PAY ATTENTION TO HOW THE LIGHT MOVES THROUGH THE OBJECT.

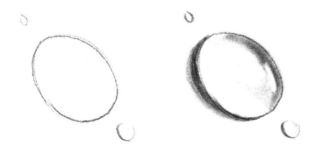
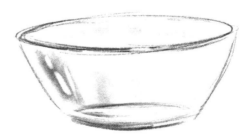

A subject like a transparent water droplet may still have a strong cast shadow, but the object itself will be full of light with strong reflective light! The softly fading edges of the shadows and strong reflective light help our eyes perceive this as a transparent water droplet.

When shading an object, a telltale sign of transparency is that the viewer can see through the object. Notice that the bottom of the bowl is visible to the viewer, immediately making the object's transparency believable.

Shade Study

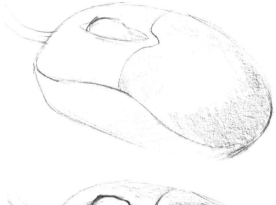

Start by roughing in a base layer of mid tones. Leave the areas where the light source hits the image bright and make your shadows dark. Use the side of your pencil to quickly apply the graphite in light, loose passes.

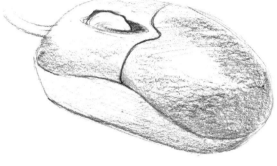

Emphasize shadows wherever the light does not touch by adding darker pencil tones with a 4B or 5B pencil. Refrain from pressing with full hardness so you can continue layering.

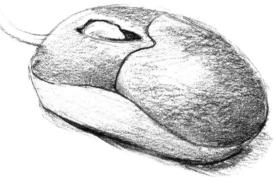

Add more layers with your graphite pencil, building gradually. As more pigment is added, the object will feel more "solid." To ground the object, you can add a cast shadow to the surrounding.

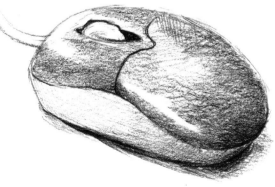

Finish adding your darkest darks with a 6B pencil. This is only necessary for areas that appear almost pure black. You can then use an eraser to bring back any highlights.

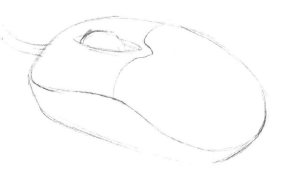

**NOW YOU TRY!
SHADE THE MOUSE SKETCH
THAT WE'VE PROVIDED.**

Working Reductively

Unlike many other mediums, graphite and charcoal are relatively forgiving. If you make a mistake, you can often "knock back" the dark tones with an eraser and work further into the drawing. It also means that you can play with both additive and reductive techniques. **REDUCTIVE PROCESSES** involve removing material from your surface, like carving into wood or sculpting into clay. When drawing, we reduce by using an eraser. Making marks by removing materials can create highlights, lighten tones, or render entire drawings. You can see the reductive process in action in the steps below. First, start with a sketch and then add rough areas of tone. Next, use erasers of different sizes to add areas of light. Finally, use darker tones for the finishing details, resulting in a quick value study!

Drawing by Erasing

NOW YOU CAN TRY WORKING WITH BOTH ADDITION AND SUBTRACTION (NO MATH REQUIRED).

- **FIRST,** find a subject to observe, then create a rough sketch of your subject below.
- **NEXT**, broadly apply a layer of soft graphite or charcoal. Don't worry if the light areas get a little dark.
- **NOW,** work on top of the drawing with an eraser to lighten the highlights. It can be helpful to try using a variety of different eraser types, such as a white eraser for broad marks, a kneaded eraser for subtle shades, and a fine-point eraser for the details.
- **FINALLY,** use darker pencils to render the shadows and final details.
- **BONUS,** you can use Spray Fixative, or even unscented hairspray, to seal it once you're finished.

HAVE FUN AND BE PREPARED TO GET A LITTLE MESSY!

TRY BOTH – Charcoal and graphite are both made of carbon, but their appearance varies significantly due to changes in their atomic structure. Graphite has a very uniform atomic structure which causes a shiny appearance, while charcoal has an irregular structure, resulting in a matte appearance and softer application.

Gesture & Shape

LET'S BUILD A SUBJECT USING ONLY ROUND SHAPES. SKETCH ALONG IN YOUR SKETCHBOOK.

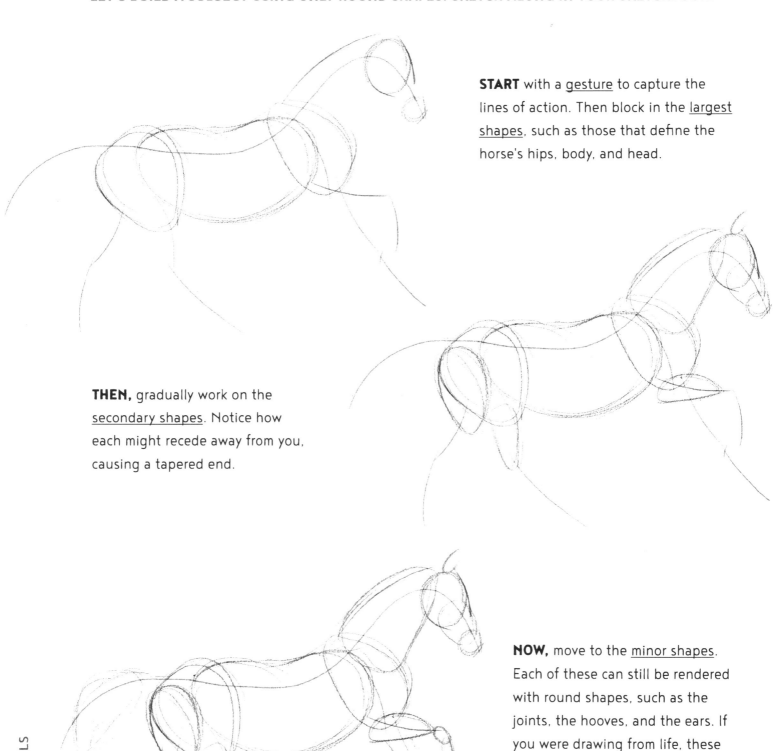

START with a gesture to capture the lines of action. Then block in the largest shapes, such as those that define the horse's hips, body, and head.

THEN, gradually work on the secondary shapes. Notice how each might recede away from you, causing a tapered end.

NOW, move to the minor shapes. Each of these can still be rendered with round shapes, such as the joints, the hooves, and the ears. If you were drawing from life, these elements would move the most, so saving them for last can be helpful.

Form & Value

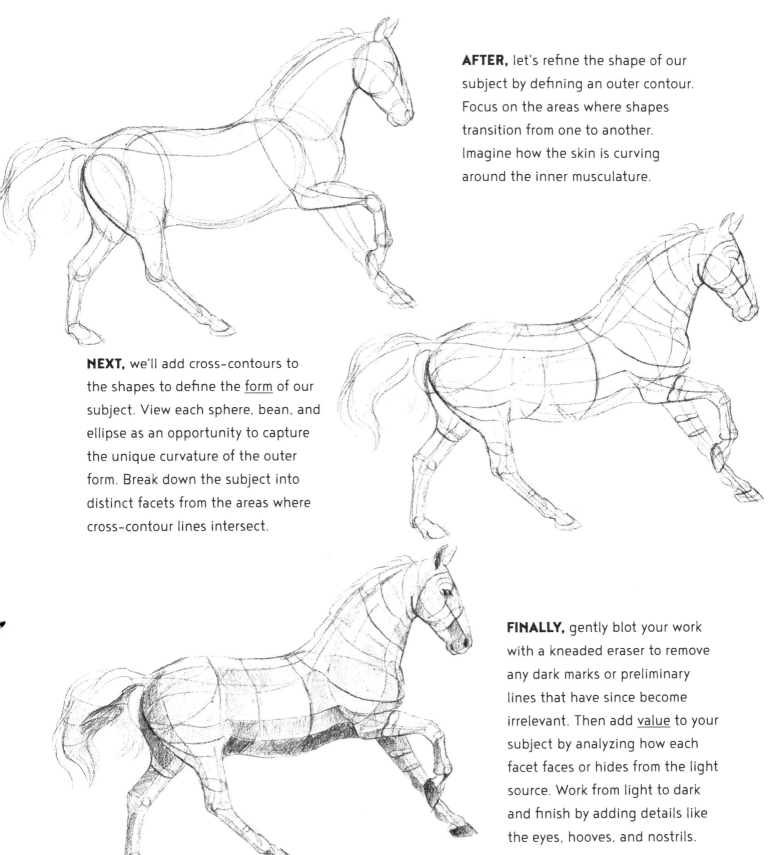

AFTER, let's refine the shape of our subject by defining an outer contour. Focus on the areas where shapes transition from one to another. Imagine how the skin is curving around the inner musculature.

NEXT, we'll add cross-contours to the shapes to define the form of our subject. View each sphere, bean, and ellipse as an opportunity to capture the unique curvature of the outer form. Break down the subject into distinct facets from the areas where cross-contour lines intersect.

FINALLY, gently blot your work with a kneaded eraser to remove any dark marks or preliminary lines that have since become irrelevant. Then add value to your subject by analyzing how each facet faces or hides from the light source. Work from light to dark and finish by adding details like the eyes, hooves, and nostrils.

Texture Expert

Texture expands upon value by showing the surface qualities of an object, such as whether your subject is opaque, transparent, reflective, matte, organic, or synthetic. Here are a few examples from animals:

SCALES

Scales can be on anything – from a fish to a snake to a dragon – and can come in many different varieties. They can be spiky, rough, and bumpy, or soft and smooth.

Rough

Irregular

Smooth

Spiky

FOLLOW THE STEPS SHOWN BELOW TO FILL THIS SWATCH WITH SCALES

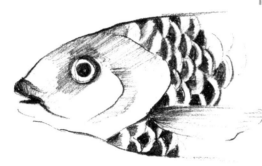

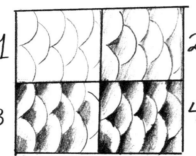

FEATHERS

Feathers are very interesting objects. Individually, they are wonderful studies of the nuances of drawing hair, yet as a whole, they can appear flat and glossy.

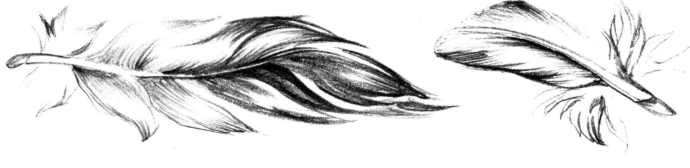

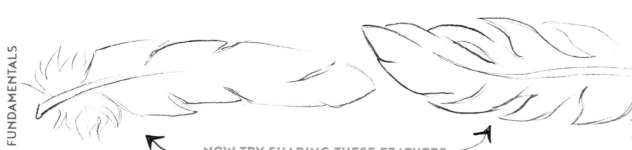

NOW TRY SHADING THESE FEATHERS

Fur and hair are soft, organic materials with distinctive properties. They contort to the shape of a form but can also drape, bounce, curl, etc. Try to observe the characteristics of the hair of your subject.

HERE ARE A FEW HELPFUL TIPS:

- Try to pay attention to the direction of the hair and move your strokes along the same path.
- Don't feel like you need to draw every strand. Instead, pay attention to the highlights and shadows.
- Remember to draw loosely! These organic shapes shouldn't feel stiff.

FUR

Fur comes in so many different lengths, textures, thicknesses, and values. Observe how rigid or flowing the fur appears as it protrudes from your subject.

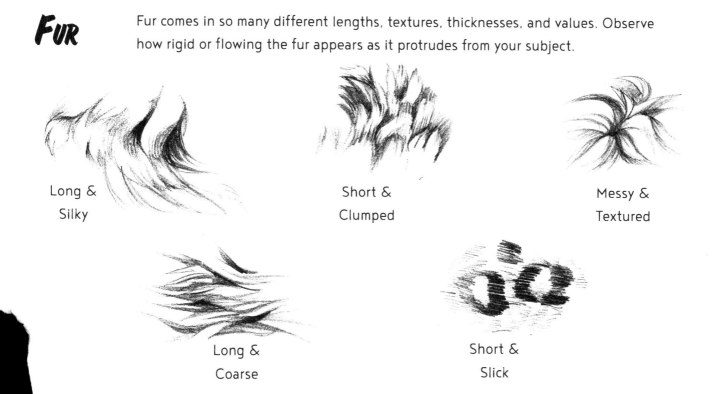

Long & Silky

Short & Clumped

Messy & Textured

Long & Coarse

Short & Slick

HAIR

Shorter hair can be similar to rendering fur, while long hair has its own nuances due to the increased draping.

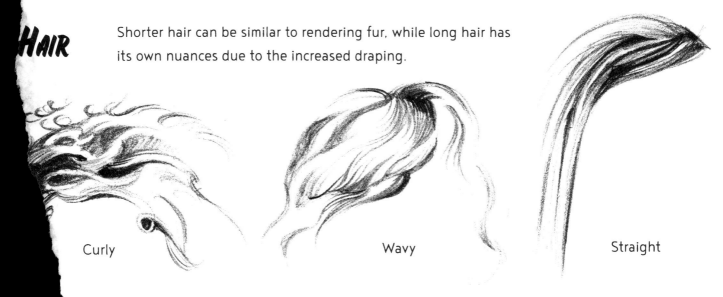

Curly

Wavy

Straight

Surface Types

There are so many more surface types that we could possibly feature. We recommend documenting any new textures whenever you find them. Here are a few additional surface types below:

BARK:
Rigid and flaky. Can be similar to rendering scales.

ROCK:
Textural with deep crevasses and jagged forms.

AGED SKIN:
Fragile with more ripples, wrinkles, and creases.

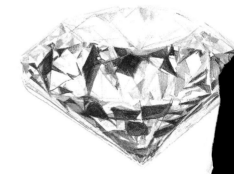

GLASS:
Lots of complex forms through reflection and translucency.

METAL:
Very reflective with many dark darks and stark highlights.

GEMS:
Reflective and multi-faceted with complex shapes

SHINY OBJECTS CAN BE INTIMIDATING. REMEMBER THESE TIPS TO MAKE THE PROCESS OF DRAWING SHINY OBJECTS EASIER:

Reflections may be made up of strange-looking forms. Break down these individual shapes into areas of light and dark rather than getting overwhelmed by the complexity of the overall object.

Create a base tone so that you can work reductively. That way, you can use an eraser for the highlights to make your object pop. Then work in the darker tones from there.

Surface Activity

Now, let's practice adding some texture to different forms. In the space below, you'll find different shapes with different prompts. Remember that texture will curve to follow the cross-contours of the forms. Also, keep in mind how light will affect the values of the textures. Practice on the shapes below:

Cover this sphere with shiny scales.

Cover this sphere with fluffy fur.

Cover this sphere with sharp stone.

Cover this cylinder with craggy coral.

Turn this cylinder into a water glass.

Cover this cylinder with broken bark.

Cover this cube with rugged rope.

Cover this cube with tiny tile.

Cover this cube with slippery slime.

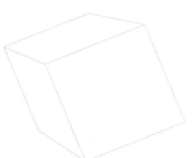

PRO TIP – When rendering these textures, the light source matters. You can imagine the light source for these samples is the sphere in the upper corner of this page.

Sketching Formula Review

Let's go step by step through creating a subject using the sketching formula. Follow along with us and then use the same principles to create your own subject! Remember our tips from earlier: Work lightly and loosely, extend your lines, and focus on the underlying structure of your subject.

Step #1 – Start with a simple <u>gesture</u> drawing using the <u>lines of action</u> to capture the movement and directionality. Add <u>measurement lines</u> to determine the proportion of your subject.

Step #2 – Add the basic <u>shapes</u> by analyzing and adding the shapes that make up your subject. Move from large to small, starting with the most major shapes, such as the head and body.

Step #3 – Now, you can begin to refine the <u>forms</u>, observing the nuances of your subject and molding the contours to match. You can lightly erase areas as they become obsolete or leave traces, known as a "pentimento," or hidden artwork.

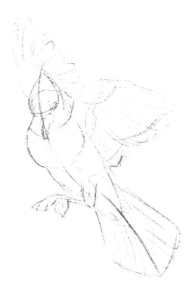

Step #4 – With everything in the right place, you can work on <u>value</u>. We recommend knocking back the drawing beforehand by blotting with a kneaded eraser to lighten any darkened lines. Then build the drawing back up keeping true value in mind.

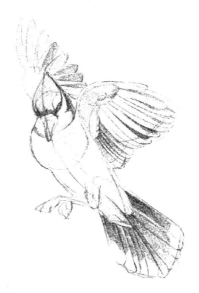

Step #5 – Finally, you can render each of the different <u>textures</u> to create a convincing subject. This is a great time to practice the feather textures we learned earlier in this section.

See what we mean about working from large to small, light to loose? We start with the broad shapes, working lightly with our pencil, and then gradually move tighter with each step.

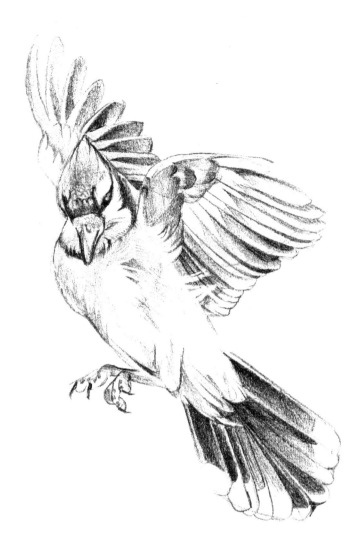

TRY IT FOR YOURSELF:

We've provided our quick gesture study. Work on top of this by following our steps to make your own version of this bird in flight. You're going to do great!

SEEING LIKE AN ARTIST

In this Chapter:

Seeing Like An Artist

–

Creating Compositions

–

Observational Tips And Tricks

–

Principles Of Perspective

–

Creating Cities And Still Lifes

–

People, Animals, and Creatures

Materials Required:

Pencils

A set of graphite pencils in various hardnesses from 6B to 6H.

Eraser

Helpful to erase any mistakes or to work reductively.

Sharpener

A pencil sharpener will ensure you're always on point.

Sketchbook

Have your sketchbook on hand to take notes and practice as we go.

The Eye of the Artist

Artists have a magical superpower that completely changes how they encounter the world. A trained artist experiences the world around them with a vastly heightened spatial and sensorial awareness. How our eyes perceive distances and angles can vastly differ from reality when we translate that information onto a sheet of paper. This is because, while we see three-dimensionally, we are drawing two-dimensionally. This change requires a different way of seeing and relies on a number of techniques in order to truly capture the world around us. Sometimes we must see things as if we have x-ray vision because in order to truly capture our subjects, we must know what is behind, below, or inside of them. Therefore, an artist must always observe, absorbing as much as possible about the people, objects, and environments they pass through.

Much of this training is gained through years of experience, but there are ways to fast-track this education. In fact, your training has already begun. By focusing on the gesture of a subject, you have already started to see the invisible lines that connect and ground each of us. You have flattened your world into a two-dimensional plane by concentrating on shape and then expanded it into three dimensions by exploring form. Hyper-focusing on textures has enhanced your perception of the micro and macro surfaces that always surround you. Let's continue to develop your observational skills.

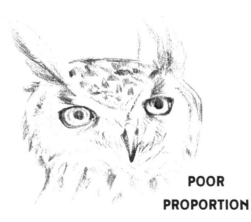

POOR PROPORTION

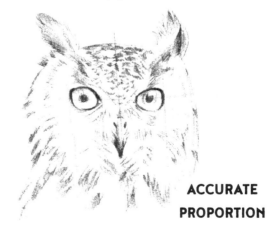

ACCURATE PROPORTION

PROPORTION refers to the size and scale of a subject in relation to its individual parts. For a successful drawing, it is essential to first take the time to establish the correct proportion. Determining an object's proportion is done by measuring and observing your subject. No matter how beautifully rendered, if the proportion is wrong, your resulting drawing will never look quite right. Take the time to measure at the beginning and periodically measure throughout so that you can catch any mistakes in proportion or scale before they've been made irreversible.

Measuring Tips

By holding your pencil out at arm's length, you can use **SIGHTING** techniques to measure your subjects.

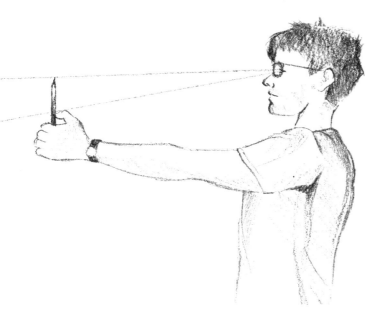

MEASURE THE DISTANCES – Use the pencil's length in relation to the dimensions of your subjects to measure the vertical and horizontal relationships you are observing. First, measure and mark the center of your subject. Then, select an element in your scene, such as the head of a model, to form a point of comparison from which you can determine the relative sizes of the other subjects.

WINDSHIELD WIPER – Adjust the pencil angle until it matches the angle of the subject's tops, sides, etc. Then compare this approximate angle against your drawing.

COMPARE AGAINST A CLOCK – If you use your pencil like the hands of a clock, you can determine the angle as it relates to a time. If the angle you are measuring is perfectly vertical, it would be at 12:00; if you were perfectly horizontal, it would be at 3:00 or 9:00. Use this to help you determine the correct angle of an object.

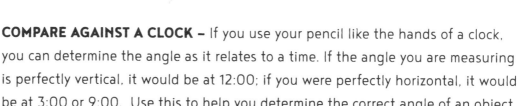

Visual Practice

Learning to connect the movements of your hand with your observations of a subject is essential to creating artwork. Below are a few exercises designed to sharpen your eye while loosening your motions.

A **CONTOUR LINE DRAWING** shows an object's outlines and edges, capturing the curved surfaces with cross-contour curves. No shading is typically added to these drawings, so concentrate on shape and proportion. To create a contour line drawing, select a subject near you and draw the basic shape as a simple outline. Do your best to carefully examine the object or person to create the form using only line.

A **CONTINUOUS LINE DRAWING** focuses on the outlines and contours of a subject, similar to a contour line drawing; however, you are not allowed to pick up your pen from the paper, but you are allowed to look at both your subject and your paper. Because all your lines will be connected, this process can create a more spontaneous interpretation of your subject. This is a great exercise to build strong hand-eye coordination.

A **BLIND CONTOUR DRAWING** is created by drawing without looking at your paper. You must carefully observe your subject, moving your pen as accurately as possible along the contours. Like the continuous line drawing, you are discouraged from picking up your pen since you can easily forget where to put it back down again. The goal of this type of drawing is to learn to trust what your eye sees when it looks at an object. Move slowly so that you can pay very close attention to the nuances of the object you are drawing. This is the most intimidating line drawing technique, but it can also be the most fun!

CONTOUR LINE DRAWING

So many subjects can be good candidates for a contour line drawing. We suggest drawing something with volume and curves, like a plastic toy, so that you can clearly focus on the inner and outer contours!

CONTINUOUS LINE DRAWING

Find a shoe and try to draw its curves, contours, and details without picking up your pen. While working, constantly switch between looking at your subject and at your drawing.

BLIND CONTOUR LINE DRAWING

For this line drawing type, try using one hand to draw the other. Make an interesting pose with your fingers, then use this space to create a blind contour drawing. For an even harder challenge, try a TRULY blind contour by closing your eyes and drawing from memory!

Creating a Composition

In art, "**COMPOSITION**" refers to how various elements are arranged, framed, and combined to form interesting images or provocative relationships. Keeping your overall composition in mind should help guide your creative decisions giving you a map of the overall appearance or impression you want to present to your audience. Here we will discuss a few guidelines to help you create dynamic compositions. Allow these to assist but not limit your creativity; after all, some rules are made to be broken!

Rule of Thirds

The **RULE OF THIRDS** uses a grid formation to help orient your design elements. To start, draw a rectangle and use two lines vertically and horizontally to split your work into nine equally proportioned rectangles. Once divided, the most essential information should be located at the intersecting points on the guidelines or along one of the lines. Following this rule helps create more dynamic, balanced, and intriguing compositions, preventing elements from being placed centrally, which can seem unnatural and uninteresting. Despite its name, this technique is not a steadfast rule. Subjects might fall between two lines, extend along the edge, or can be grouped fully in one section to create a sense of tension.

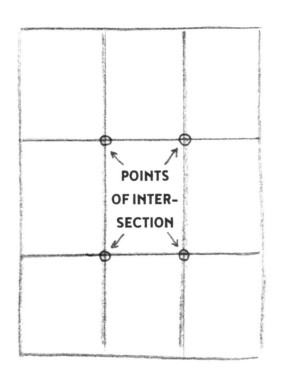

POINTS OF INTER- SECTION

Focal Points

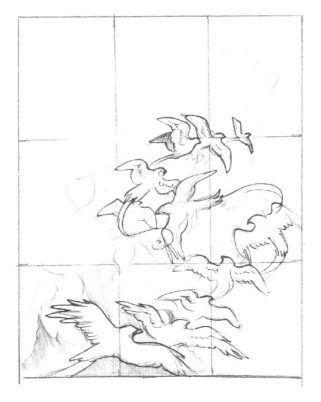

FOCAL POINTS direct the viewer's eye to the most important subjects of composition through placement within the frame, contrast from the other features, or convergence of elements. Convergence means using inferred angles within a work to create invisible lines of action that direct a viewer through a composition. For example, in the piece to the left, diagonal angles are used to enhance the visual interest while drawing our eye through the piece. As a result, our eyes jump from location to location as the front bird forms a focal point, the back bird forms a second, and the white space creates a third.

Golden Guides

The "Rule of Thirds" can work very well as a compositional guide, but our next example has a way cooler name.

Golden Ratio

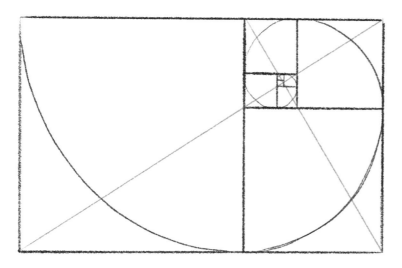

The **GOLDEN RATIO** or "Golden Mean" refers to a grid that results from charting a mathematical proportion. You can create surprisingly dynamic designs using this grid as a compositional tool. In fact, this principle has been used by artists for centuries to guide their compositions. To try for yourself, use the grid to the left as a guide. First, place your most important element in the center of the spiral. Next, place your other compositional elements so that the subjects are centered within each of the rectangles and their focus curves into the spiral interior.

Using these compositional guidelines, you can create more dynamic works of art. For example, imagine a bird sitting on a tree branch. If the bird was centered and the branch flat, there would be minimal action or interest, such as in the first image below. Now view our second image, where we've considered our compositional guides. The bird's head, our primary focal point, is at the center of the golden ratio spiral. We have also used our knowledge of diagonals to place the tree branch at an exciting angle, adding accessory twigs within the smaller rectangles of the golden ratio grid.

LESS EFFECTIVE

MORE EFFECTIVE

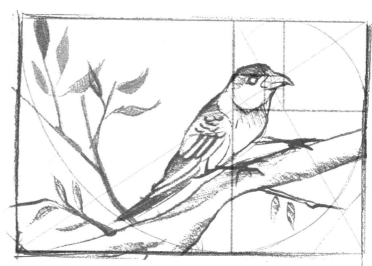

The Thumbnail

A PRELIMINARY SKETCH TO WORK OUT IDEAS

A "thumbnail" is perfect for a mini sketching brainstorming session. These sketches are done fast (usually only a few minutes each) and are small (usually only a couple of inches wide). This process of quickly capturing different compositions allows you to loosen up, test multiple ideas, and prepare for further development. Whether designing a logo for a client, experimenting with a concept for the first time, or just to warm up, providing multiple angles and approaches is a great start.

With our thumbnails of pastries below, can you see how the sketches below are quick and loose?

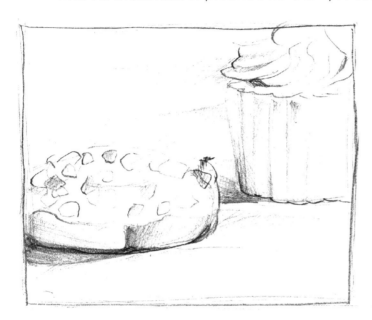

NOW TRY THIS EXERCISE In the frames below, try to create two different thumbnail sketches by observing whatever items are around you. Sketch loosely and have fun!

PRO TIP – The framing of your subject can change how it's perceived. Try drawing your piece with a horizontal frame. How does that differ from a vertical frame or a square frame? How does it look with no frame at all?

Vantage to Your Advantage

When drawing an object from life, your angle, view, or vantage point can help tell the story you are trying to convey, and add visual interest. Rather than drawing a subject straight on, consider these alternatives to add drama and to help to tell a story:

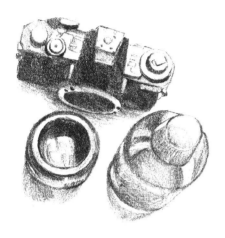

AERIAL VIEW

BOTTOM-UP

EXAGGERATED

Using a Viewfinder

Another tool that helps form a composition when drawing from life is a viewfinder. You can use the camera on your phone or easily construct a viewfinder by cutting a rectangular hole out of a sheet of paper. To use it, hold the viewfinder out from your body and close one eye, moving your frame to find the most interesting composition. This can also help you measure the relative sizes of far-away objects. Just be sure to keep the proportion of your work in mind. For instance, if your viewfinder is a rectangle and your drawing area is a square, you might inadvertently squish your content.

Flip Your View

Drawing complex subjects can seem overwhelming. In a scenario like this, sometimes you just need to look at the object with fresh eyes. Our solution:

FLIP THE SCRIPT AND VIEW YOUR SUBJECT UPSIDE-DOWN!

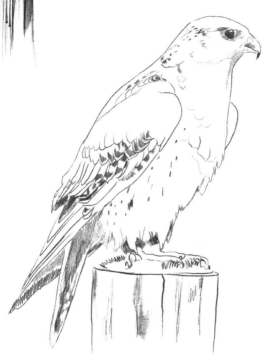

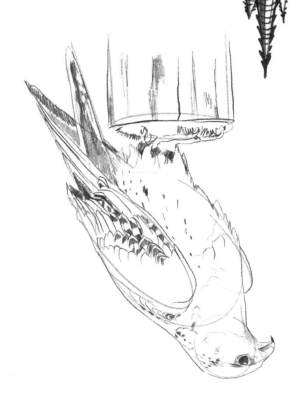

How would you go about drawing this falcon? It can be challenging to separate what we think a subject should look like from how it actually appears. This is because our brains tend to focus on the details, making it hard to see the broader picture.

When we flip our image upside down, the subject becomes less recognizable. This causes our minds to focus more on the lines and shapes. Because of this, we can work free from our assumptions and rely more heavily on accurately capturing what we observe.

FOCUSING ON THE NEGATIVE SPACE CAN BE A POSITIVE! Simply draw the area <u>around</u> your subject instead of the subject itself. Imagine there is a white sheet covering your subject, and it's your job to outline the shape of this sheet. Once the silhouette has been captured, begin to refine the inner forms.

Inverted Exercise

Don't adjust your paper – this page is printed correctly. Below, we've provided a few examples to test your observational skills. Try to view each of these subjects as simple shapes, analyzing the angles of their silhouettes. By drawing upside down, you can better focus on your observations rather than your expectations. Once finished, turn the book upside-down to see how well you did!

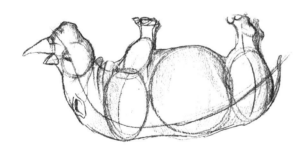

Grid as a Guide

When drawing from a photo reference, a grid can be an excellent method to create a more accurate sketch or to scale a sketch up or down to fit a canvas of any size.

Begin by making a very light pencil grid over the top of your reference photo, using a ruler to evenly space your lines. Next, make a grid of the same ratio but a different size in your sketchbook. Then, translate the content from the photo to the sketchbook by observing how the shapes relate to each other within the squares of the grid. Notice where lines intersect on the axes and focus on the angles of each form, then translate the lines as accurately as possible.

Try to use grids to form a better overall understanding of your subject matter, moving away from the habit as you gain more experience so that it doesn't limit your sketching practice.

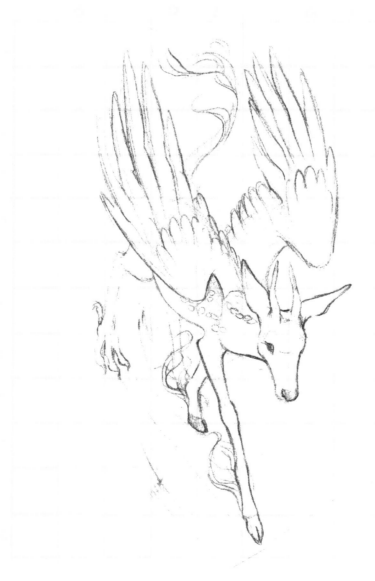

TRY TRANSLATING THE GRIDDED DEER TO YOUR SKETCHBOOK BY MAKING A GRID AS YOUR GUIDE

Super Symmetry

SYMMETRY is how elements are balanced through repetition or tessellation. In the natural world, most living things exhibit mirror or radial symmetry. Mirror symmetry means that elements are reflected across a single line of symmetry, while radial symmetry involves the repetition of elements across multiple lines of symmetry. Objects that lack this type of balance are considered asymmetrical.

MIRROR SYMMETRY

RADIAL SYMMETRY

ASYMMETRY

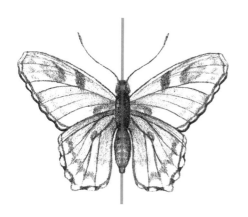

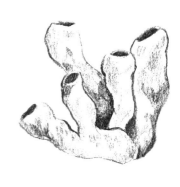

THE SUBJECT BELOW HAS MIRROR SYMMETRY. USE THE GRID BELOW TO COMPLETE THE IMAGE:

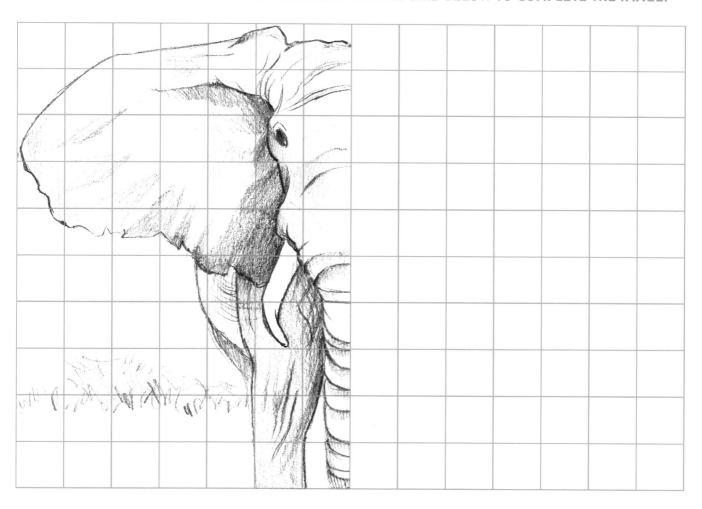

Puzzling Shapes

To help you hone your observational skills, we've divided an image into a grid and then shuffled and numbered the pieces. To solve this puzzle, identify the correct location of each square and recreate the shapes within the grid on the following page. Do this for every square of the grid. Once you finish, you can flip the page upside down to reveal the subject! This exercise separates you from your preconceptions of what a subject should look like, instead allowing you to focus on the subtle changes of each angle & shape.

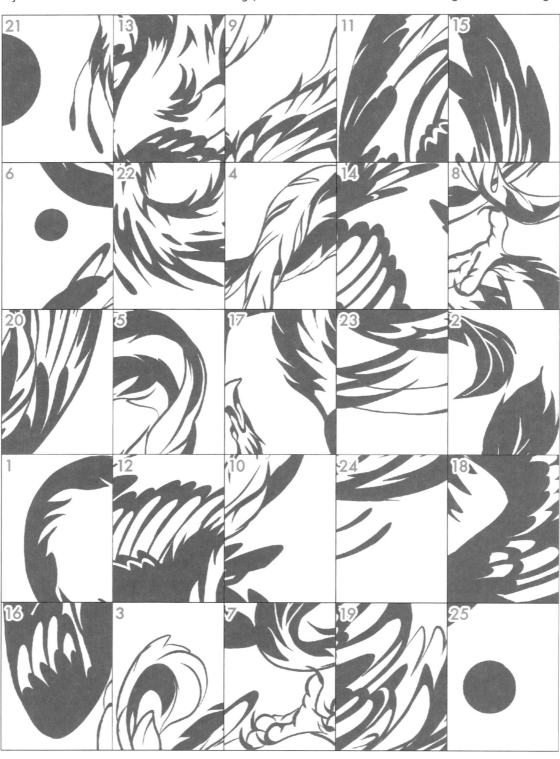

We've given you the first square correctly to start.

1	2	3	4	5
6	7	8	9	10
11	12	13	14	15
16	17	18	19	20
21	22	23	24	25

If you get stuck, we've provided the answer key on page 208.

Gaining Perspective

PERSPECTIVE refers to how we perceive the three-dimensional world around us. Learning the skills, tools, and techniques necessary to create the illusion of perspective on a flat piece of paper is one of the most valuable techniques in creating believable drawings. First, let's learn some important terminology:

The **HORIZON LINE** is an imaginary line that indicates the viewer's eye level.

The **LINES OF PERSPECTIVE** are imaginary lines that extend from the edges of the object you are drawing to the vanishing point.

The **VANISHING POINT** is the spot along the horizon line where all lines of perspective will converge. There may be one or more vanishing points depending on your angle.

Imagine that you are standing on abandoned railroad tracks in a flat desert. You are looking directly out into the distance until the tracks seem to disappear.

The **HORIZON LINE** is the flat line along which the desert seems to meet the sky.

The **VANISHING POINT** is the dot at which the train tracks seem to converge into one point on the horizon line.

The **LINES OF PERSPECTIVE**, in this case, are the train tracks with the sleepers parallel to your horizon line.

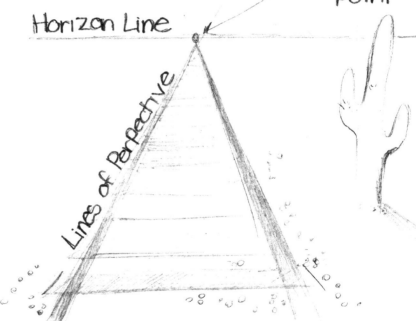

Finding the Horizon

Your horizon line is relative to your eye level, meaning it will change depending on your position. First, hold your head level and look around you to find your horizon line. If you can see the top side of an object, your horizon line is located above that object. If you cannot see the top side of an object, your horizon line is located below that object. Try to find where an object's top appears perfectly flat. This indicates that you have found your relative eye level, indicating where your horizon line should be.

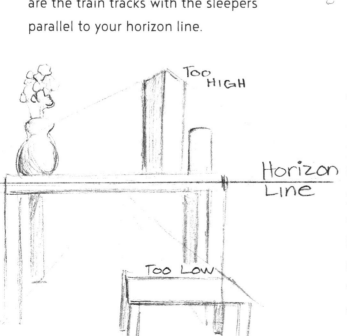

Get to the Point

THIS ILLUSION OF PERSPECTIVE WORKS BECAUSE OF THE FOLLOWING RULES AND TECHNIQUES:

The simplest possible component of a drawing is a **POINT**, a single dot of matter. If you were to place your pencil down on a sheet of paper, you would create a point.

The next simplest component is two dots that are connected. This creates a **LINE**.

A line can go in three definite **DIRECTIONS**, representing our spacial dimensions.

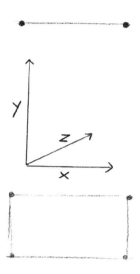

> X is left to right on our page, or "**WIDTH**."
> Y is up and down on our page, or "**HEIGHT**."
> Z is how a line recedes away from us or "**DEPTH**."

One dot is a **POINT**, two connecting dots form a **LINE**, and connecting any three or more dots creates a **PLANE**. Planes make up every shape around us, and their orientation depends on the locations of their points on a three-dimensional axis.

Our angle in relation to a subject determines the **POINTS OF PERSPECTIVE**, or the number of vanishing points along a horizon line that are required to illustrate an object, such as one, two, or three.

ONE-POINT PERSPECTIVE is when there is only <u>one vanishing point</u> on your horizon line and only one dimensional direction recedes from you. In other words, both the width and height are flat to your perception, while the depth of the object recedes in space. This means that you are facing a flat plane.

TWO-POINT PERSPECTIVE is when there are <u>two vanishing points</u> and two dimensional directions are receding from your view. In this example, height is perpendicular while the width and depth both recede from your view. In this situation, you would be facing a line or an edge.

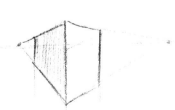

THREE-POINT PERSPECTIVE is when there are <u>three vanishing points</u> as all three dimensions recede from view: width, height, and depth. In this situation, you would be facing a dot. This version of perspective can be a bit advanced.

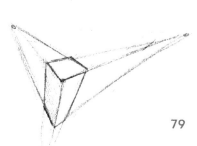

One-Point Perspective

START by making a horizontal line. This is your horizon line. Now make a dot in the center of the line. This is your single vanishing point. Now, let's draw two straight, parallel lines anywhere below our horizon line.

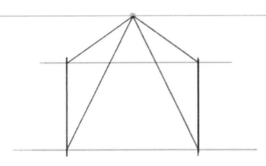

NEXT, make two vertical lines that intersect with our two straight lines. We've now made a square. This will be the front face of our cube. Then, extend a line from each corner of the box to your vanishing point. These are your lines of perspective.

NOW, make a third horizontal line located between the top and bottom lines of your square. Draw a vertical line at each point where the horizontal line intersects with the lines of perspective.

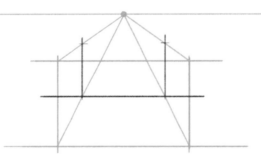

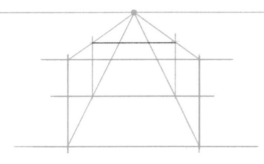

THEN, draw a top line between where the verticals intersect with the lines of perspective. We have now made a second square which is the back face of our cube.

FINALLY, darken the outer lines to define the cube. Finish by knocking back any unnecessary lines of perspective.

You have now drawn a cube in one-point perspective!

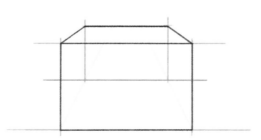

Two-Point Perspective

While there appears to be only one set of vanishing lines in one-point perspective, there is a secret second set; however, they run parallel to your horizon line and thus will never converge into a second point. We can make these lines converge to a vanishing point by rotating our viewing angle, such that the width and depth recede from view.

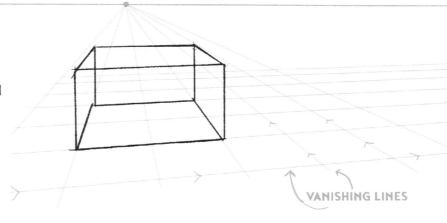

VANISHING LINES

LET'S TRY IT OUT!

FIRST, establish your horizon line. Now place <u>two</u> vanishing points on the line: one on the far <u>left</u> and one on the far <u>right</u>.

NEXT, draw three vertical lines. These are the vertical edges of your cube. Make two marks on the middle line. This will determine the height of your cube.

NOW, draw a line from each height indication to each vanishing point. These <u>vanishing lines</u> will intersect the outer vertical lines. The points where these lines intersect will be the outer corners of your cube.

THEN, from each corner, extend a line to the <u>opposite</u> vanishing point. This shows us the back edges of your cube as if we have x-ray vision to see through our subject.

FINALLY, darken the outer lines to define the cube. You can also erase any extraneous lines.

Check out your two-point perspective cube!

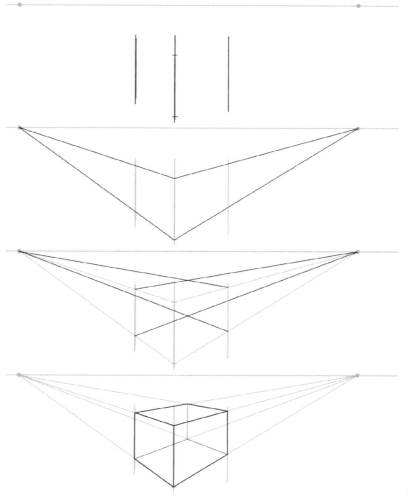

Perspective Tips & Tricks

Perspective can seem like an overwhelming topic, leading many books to ignore the subject or simply to give it a passing glance, but we believe in your abilities! The techniques of using and understanding perspective are obtainable if you approach them with patience and practice. Here are a few helpful tips:

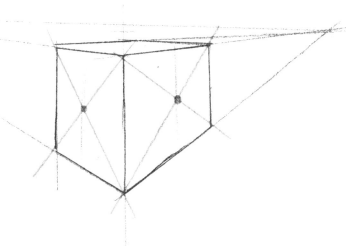

TO FIND THE CENTER OF A CUBE, draw a line to connect the opposite corners of each face. Where the two lines intersect is the line of symmetry. This is very helpful for locating elements of your subject, such as finding the location of a door on a building in two-point perspective.

TO FIND THE CENTER of something that isn't a cube, simply box in your item. Pretend the car, shoe, or other subject has been perfectly contained within a cardboard box, and then draw that imaginary cube around your subject. Then locate the center using the same "X" technique as above.

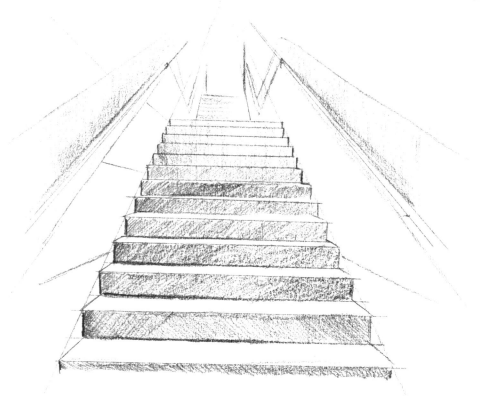

FORESHORTENING is the process of showing depth through an exaggeration of scale, meaning that items closer to our viewpoint will appear larger. For example, if we draw a staircase, the stairs closest to our view take up more of our field of vision than those farther away and will thus be larger than we would otherwise expect.

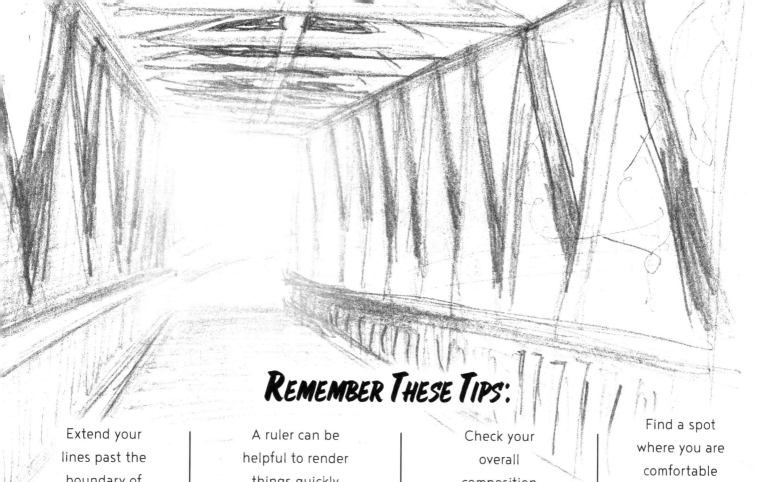

Remember These Tips:

Extend your lines past the boundary of your object and go all the way to the vanishing point.

A ruler can be helpful to render things quickly but try to practice making straight lines freehand. Sketches don't have to be perfect.

Check your overall composition and proportions before figuring out perspective.

Find a spot where you are comfortable and safe. Stay still, as moving will change your angles and horizon line.

Atmospheric Perspective

Allude to the environment by tightly rendering foreground texture but reducing the detail as you develop subjects that are farther in the distance.

Objects that are farther away will move from appearing as individual objects and instead appear as clustered bands.

Objects that are farther away will also appear lighter and paler when compared with subjects close to the viewer. You can allude to distance by gradually reducing the value scale and color saturation of your subjects as they recede in space.

Drawing From Life

You can use the basic principles we just learned to draw all kinds of things! A cityscape, for example, is essentially a series of very large boxes and cubes. Don't be intimidated by the change in scale; just try to simplify the shapes of your subject into basic forms, whether the size of a building or a bumblebee. Let's go step by step and see how perspective can help us with this urban environment.

STEP 1:

Find a spot where you can observe a cityscape, a group of buildings, or a street corner. Establish your horizon line and vanishing points on your page. Don't be nervous if one or both vanishing points extend off the page – that's typical with two-point perspective. Simply extend your horizon line as far as your page allows and approximate the second vanishing point.

1st Outermost Edge of Building

Middle Edge of Building

2nd Outermost Edge of Building

Vanishing Point

Horizon Line

STEP 2:

Outline the visible sides of your buildings by drawing vertical lines to indicate the outer edges. Use your sighting techniques to measure as accurately as possible.

TOPS OF BUILDINGS

Vanishing Point

Horizon Line

STEP 3:

Find the angle of the tops of your buildings using the angle measuring techniques we've reviewed, such as the clock or windshield wiper.

STEP 4:

Find the angle of the bottoms of your buildings. For particularly boxy buildings, both the top and bottom lines of perspective should recede to the same vanishing points.

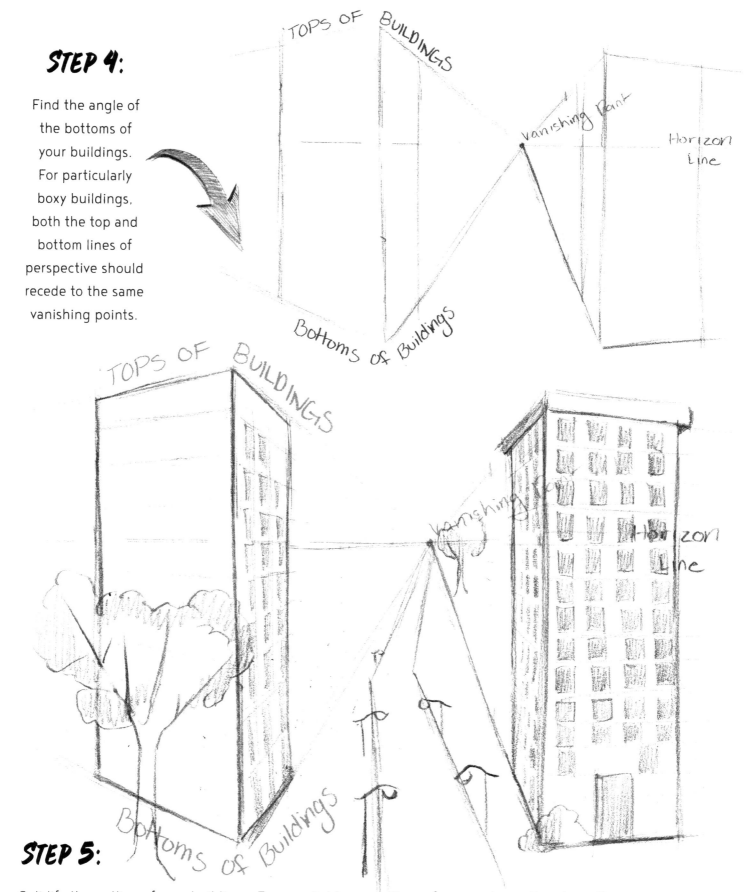

TOPS OF BUILDINGS

Vanishing Point

Horizon Line

Bottoms of Buildings

TOPS OF BUILDINGS

Vanishing Point

Horizon Line

Bottoms of Buildings

STEP 5:

Solidify the outline of your buildings. Erase or lighten your lines of perspective – this clears the page so you can refine any details. Remember that additions like windows and doors will likely follow the same vanishing points as the buildings. Continue to add refinements until your scene feels complete. The most important thing is that you work on achieving believable perspective. If your details are slightly off, it's very unlikely that anyone will notice; however, if the perspective is wrong, it will be very apparent.

Practicing Perspective

Try out your new skills on various subjects, locations, and angles. Start with one-point perspective to practice finding your horizon line from a straight-on approach. Then view the same subject from an angle to work on your two-point perspective. Perspective can take some practice, so don't get frustrated if the journey is a little bumpy at first. Just keep trying!

USE THIS GRID TO TRY OUT ONE-POINT PERSPECTIVE:

HORIZON LINE

USE THIS GRID TO TRY OUT TWO-POINT PERSPECTIVE:

Setting Up a Still Life

The rules of perspective apply to everything, including very small objects. Still lives are compositions made of static objects, usually observed from life. There are many techniques for assembling an interesting still life, the mastery of which can greatly improve your composition skills for subject matter of all kinds.

Vary Values

Different colored objects will each have their own local value scale. For instance, matte metal might not have the brightest highlights, so try to pick subjects that each possess a different value scale.

Power of Threes

An odd number of subjects in a composition is far more visually engaging than an even number. Ideally, aim to have three or five main subjects, or clusters of subjects, in your frame.

Height Angles

Select objects of varying heights. To create a sense of order, arrange subjects from tallest to shortest. For visual interest, break up the subjects into competing sections, with the tallest item off-center.

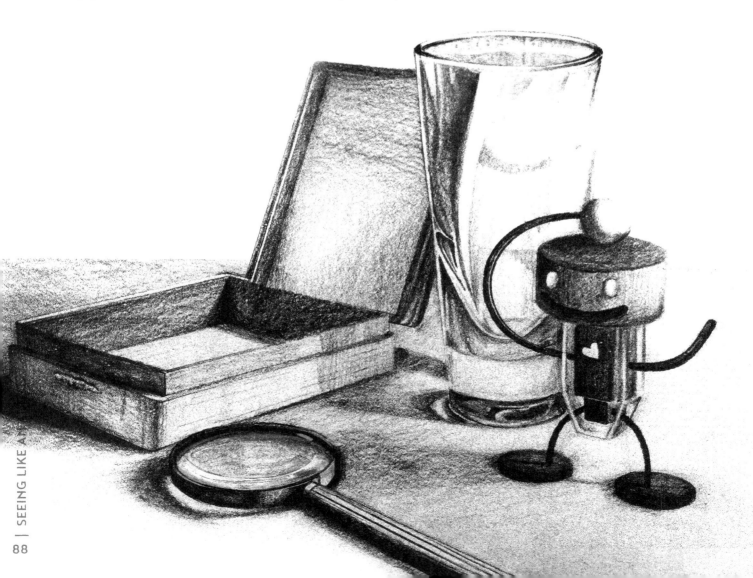

Interesting Arrangements

Negative Space

Negative space, or white space, refers to the areas that are empty, blank, or unexciting. Still, these areas can have big effects on the impression of your artwork. For example, a subject that takes up the whole canvas will feel very different from the isolation caused by large areas of white space.

Curate First

A still life can be a place to show off your unique personality and perspective. Pick objects that are unique to you, unexpected, or tell a compelling story. For a bold vignette, add a "memento mori," or a reminder of death, by including a skull, fruit, or an hourglass.

Dutch Tilt

In filmmaking, a Dutch tilt is when the camera is at an angle instead of being oriented straight up and down, usually creating a sense of emotional unease. Use a viewfinder to find an interesting composition, then tilt your frame to instantly add dynamic diagonals.

Point of View

Position yourself at an interesting angle. A piece can completely change if you lower your eye to the level of an ant versus if you adjust your view for an eagle-eye, top-down approach.

Shadow Play

Carefully considering shadows and reflections can lead to an intriguing still life. You can even conceal hidden words or meanings in these often-overlooked areas, allowing for a bit of mischief.

Implied Angles

There are lines in your work other than those you create with your pencil. Consider the direction objects face, the eye-lines between them, and how this forms subtle relationships.

ARRANGE A STILL LIFE AND SKETCH A FEW THUMBNAILS IN THE SPACE BELOW:

Figuring Out the Figure

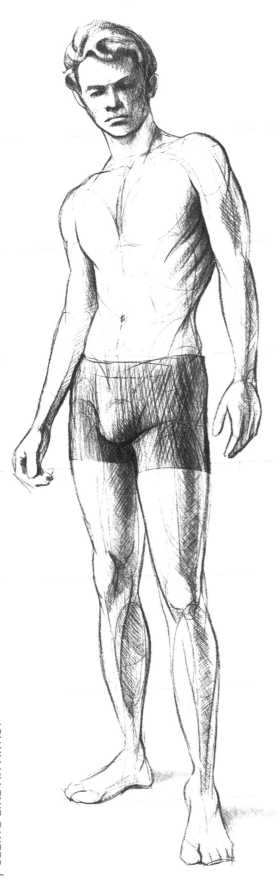

Figure drawing has a long history in artmaking and is the foundation from which gesture studies were born. A body will not stay in a position for long, so prioritize these main components: **GESTURE, SHAPE, AND FORM.** Save value for last.

Whether drawing your subject from life or a reference, starting with a gesture is essential. First, create your **LINE OF ACTION** to define how the body moves in space. Next, add defining lines that use curves to capture the body's weight, motion, and proportion. Avoid stiff, straight lines that can make your subject seem like they are glued to the floor. Instead, a live figure model will balance their weight in real-time, which should be captured with asymmetrical curves.

Next, it can be helpful to add **MEASUREMENT LINES**, helping you to verify distances between key points. Optionally, you can distort true proportion in pursuit of various ideals. For instance, with an academic proportion, a human standing upright will have a height of approximately seven heads. A heroic proportion uses eight heads.

With measurements down, you can move to **SHAPE** to capture the area of the body. Keep the interior skeleton and muscles in mind to capture shape most effectively. These components are vitally important because, while you may only be trying to render the outer surface of the skin or clothing, the movement and volume of the outer are directly affected by the inner.

Now use **FORM** to capture the volume of the body by adding cross-contours to the shapes. This helps to define volume, determine your relation to the individual components in space, and provide a 3D measurement of the concavity of a form.

If time allows for it, you can move on to **VALUE**. While drawing, you should work in a pattern of push and pull with your piece: pushing back values from earlier stages with a kneaded eraser and then pulling out darker values as you add certainty and structure.

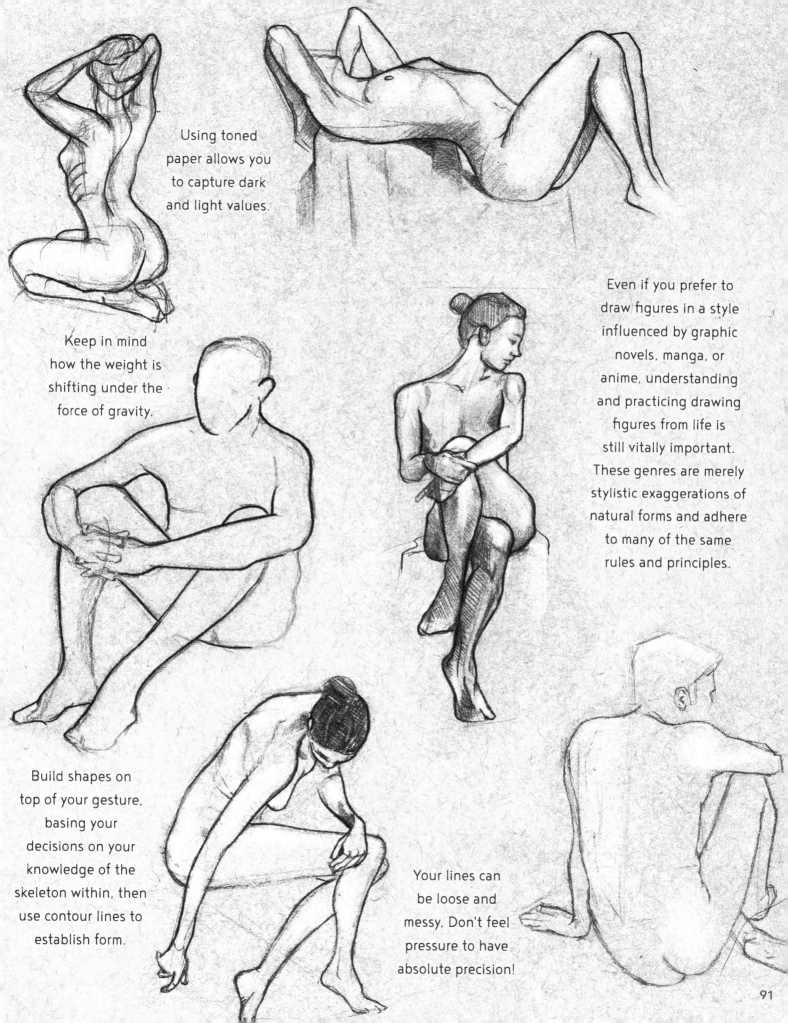

Using toned paper allows you to capture dark and light values.

Keep in mind how the weight is shifting under the force of gravity.

Even if you prefer to draw figures in a style influenced by graphic novels, manga, or anime, understanding and practicing drawing figures from life is still vitally important. These genres are merely stylistic exaggerations of natural forms and adhere to many of the same rules and principles.

Build shapes on top of your gesture, basing your decisions on your knowledge of the skeleton within, then use contour lines to establish form.

Your lines can be loose and messy, Don't feel pressure to have absolute precision!

Portrait Practice

Perfect your portraits by following these simple tips for mastering human faces:

USE YOUR HEAD. Self-portraits give you instant access to a model you can position into whatever pose you need. Set up a camera and take a few photos from different angles, then use these as a reference.

STUDY A SKULL. The forms of flesh are guided by the structure underneath, so familiarizing yourself with the basics of skeletal structure can be an enormous help, whether you're drawing a hand or a head. Anatomical skull models are available online, or view the classic illustrations within the book *Gray's Anatomy* for reference.

FIND FAMILIAR FACES. Consider asking a friend or family member to model for you so that you can gain experience with different proportions. You can also draw strangers in public if you ask permission.

MUSEUM MODELS. Marble busts, statues, and sculptures can make an excellent subject for a classically-inspired portrait study. The pale plaster and marble forms offer a high-contrast view of light and shadow.

BREAK IT DOWN. Like any form, the face can be broken down into its many planes, and familiarizing yourself with these facets, such as by viewing the Asaro or Loomis models, can be enormously helpful.

MAGAZINE MUGS. Using reference photos can expose you to a diverse assortment of subjects. We like to keep cuttings from magazines, family photos, and royalty-free images in our rotation.

MIRROR, MIRROR. An easy way to check your portrait is to flip it with a mirror. By viewing your work transformed this way, you can easily identify if features might be askew.

ISOLATE INDIVIDUAL ITEMS. A sketch of a face may only look as strong as its weakest feature. Practice drawing eyes, noses, mouths, ears, and other elements before diving into a full face.

PORTRAIT PROPORTION. Ensure your facial features are the correct size in relation to each other by learning idealized face proportions.

Now, let's practice portraits. Ask a friend or family member to be a model. Don't be shy; you'll be surprised at how excited they may be about this. Have them sit, stand, or take a pose that seems comfortable for them. Start with a two-minute study. Then take a short break and step back from your work to analyze it. Next, try a five-minute pose. Finally, try a ten-minute pose. Remember to work from large to small and loose to tight.

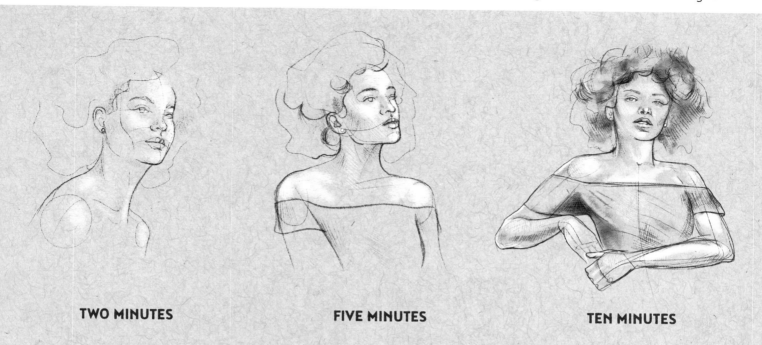

TWO MINUTES **FIVE MINUTES** **TEN MINUTES**

PRACTICE SOME PORTRAITS IN THE SPACE BELOW:

TWO MINUTES **FIVE MINUTES** **TEN MINUTES**

Facial Features

HOW TO DRAW AN EYE

 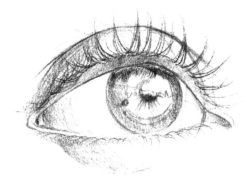

Keep in mind that eyelashes are curved, not straight and rigid.

HOW TO DRAW A NOSE

 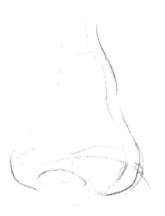 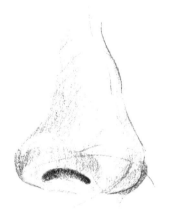

The nose is a series of connecting spheres and prisms.

HOW TO DRAW A MOUTH

Refrain from drawing lines around each tooth; instead, show the tooth line.

We've provided a rough sketch of a head below. Use what you've learned from our lesson on portraits and our step-by-step of eyes, nose, and mouth to add features to this face!

Approaching Animals

Drawing animals can seem incredibly daunting, but when we apply the principles of sketching that we've learned so far, we can approach them just like any other subject – focusing on gesture, shape, form, and value!

Animals are rarely ever still or in the perfect pose for long. This inconvenience can encourage you to capture quick studies from multiple angles, vastly enhancing your knowledge of the three-dimensional form.

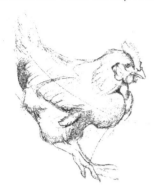 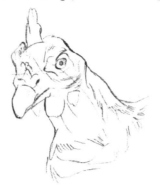 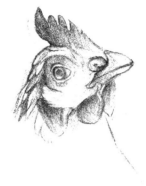

Start by drawing the dorsal stripe. This line of action extends from the tip of the nose, along the spine, to the tip of the tail. Then divide the overall shape into four parts: the head, front, belly, and rear.

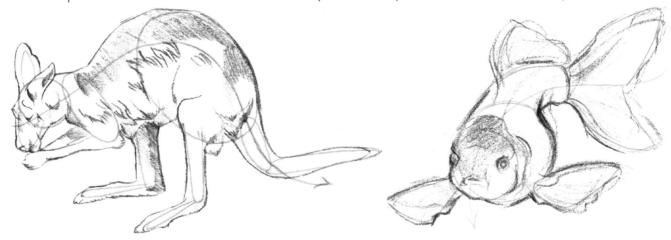

Animals have so many varying textures and points of visual interest. You can be selective in your marks to help to emphasize focal areas. Keep in mind the directionality of the fur, scales, and other textures to follow the surface contours of the animal. Have fun, and don't feel restricted by strict realism!

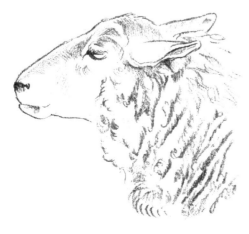

LET'S GO STEP BY STEP TO BREAK DOWN HOW WE APPROACH CREATING ESSENTIAL ANIMAL PARTS:

When creating **WINGS**, imagine them as a curving or curling piece of paper. Start by establishing the gesture to capture the motion of the subject, then use shapes and cross-contour lines to create the broad, curving form. Once that has been created, you can break the subject down into its individual sections. Lastly, you can move on to the final details, such as developing the feathers. Not every feather has to be drawn or detailed for our minds to understand it is there.

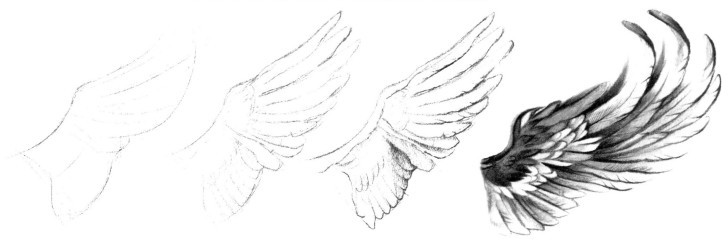

Animal **HEADS** come in all different shapes and sizes, but they are almost always symmetrical, so start by adding a line of symmetry along the front axis. Then add a cross-contour for the placement of the eyes.

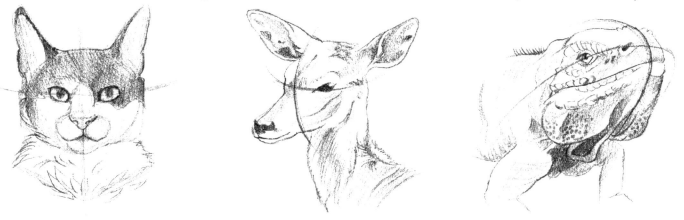

The **FEET** of an animal vary widely in the types that you might find, from hooves to paws to claws. Below, we've broken down two types of feet that you might find:

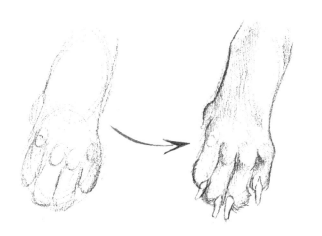
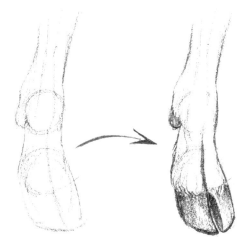

Creating Creatures

Fantasy creatures may come from our imagination, but truly believable creatures will still be grounded in some kind of reality. Try combining different animals or animal features to create a hyperreal hybrid!

RABBIT + **STAG** = **JACKALOPE**

Sampled animal forms can also be used subtly. Rather than recreating exact elements from an animal, you can use their general features or anatomy to inform the form or textures that make up a creature.

CREATURE INFORMED BY BIRD ANATOMY

CREATURE INFORMED BY REPTILE ANATOMY

Fantasy creatures can be a completely unique concept or combination, but many are pulled from various cultures, myths, or histories. Try to research the mythology surrounding a creature to respect its meaning and origins, enhancing your creation and adding authenticity. However, you should not adopt venerated symbols or reduce a culture to stereotypes, which would cause your appreciation to turn into appropriation.

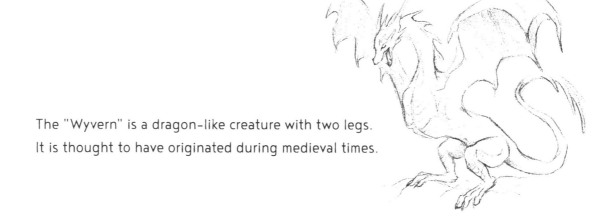

The "Wyvern" is a dragon-like creature with two legs.
It is thought to have originated during medieval times.

LET'S BREAK DOWN HOW WE CREATE DYNAMIC FANTASTICAL CREATURES:

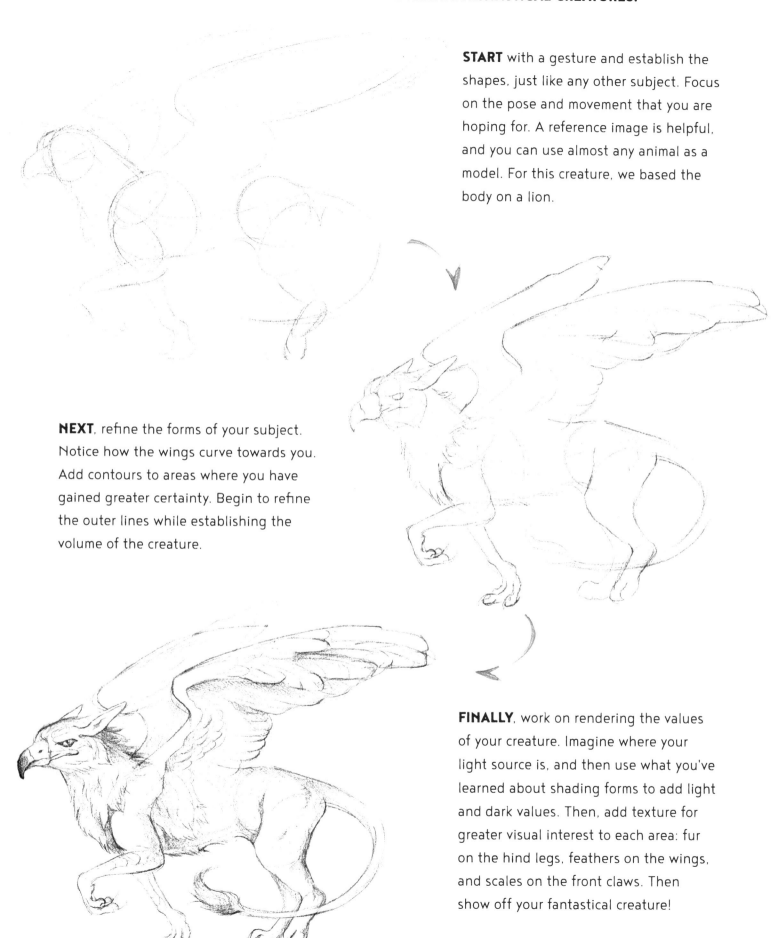

START with a gesture and establish the shapes, just like any other subject. Focus on the pose and movement that you are hoping for. A reference image is helpful, and you can use almost any animal as a model. For this creature, we based the body on a lion.

NEXT, refine the forms of your subject. Notice how the wings curve towards you. Add contours to areas where you have gained greater certainty. Begin to refine the outer lines while establishing the volume of the creature.

FINALLY, work on rendering the values of your creature. Imagine where your light source is, and then use what you've learned about shading forms to add light and dark values. Then, add texture for greater visual interest to each area: fur on the hind legs, feathers on the wings, and scales on the front claws. Then show off your fantastical creature!

Controlling Emotions

Facial features can express so many different emotions, no matter the subject. Whether a friend, a fox, or a fire truck, flex your creative muscles on the next page to test out different expressions. You can exaggerate features using caricatures or study how the subtle lift of an eyebrow can express confusion.

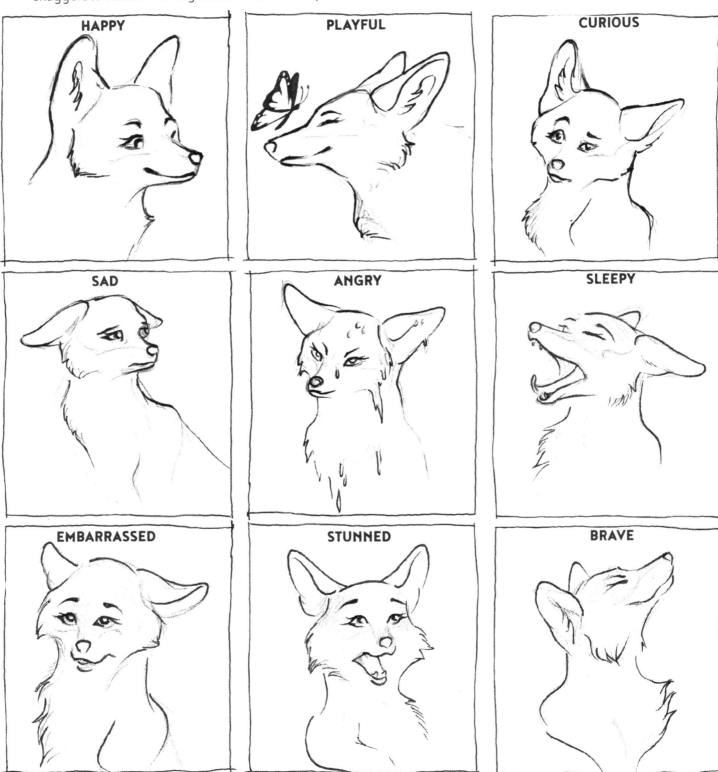

HAPPY

PLAYFUL

CURIOUS

SAD

ANGRY

SLEEPY

EMBARRASSED

STUNNED

BRAVE

"Expression" Yourself

Fill each of the squares below with your interpretation of each emotion. You can use almost any subject for this exercise: look at your own face, imagine a creature, or even try smiley faces!

HAPPY	**PLAYFUL**	**CURIOUS**
SAD	**ANGRY**	**SLEEPY**
EMBARRASSED	**STUNNED**	**BRAVE**

CHALLENGE – For even more practice, draw as many faces as possible in your sketchbook with no repeats. These can be fully realized expressions, adorable animals, or even just smiley faces.

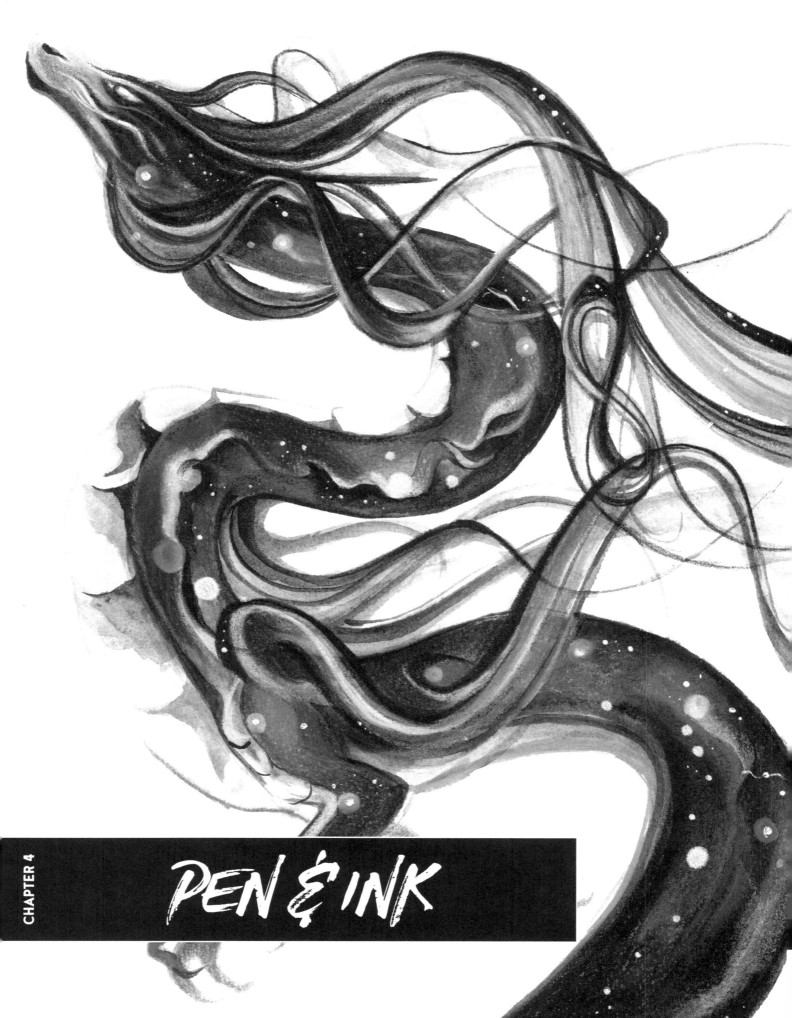

PEN & INK

In this Chapter:

Essential Elements of Line
–
Intro to Pen and Ink
–
Shading and Value
–
Line Tips and Tricks
–
Pen Types and Techniques
–
Pen Drawing Activities

Materials Required:

Ballpoint Pens

A few ballpoint pens in different colors.

Fineliner Pens

A set of fineliner pens in a variety of tip sizes.

Gel Pens

Gel pens in any color, but at least one white.

Sketchbook

As always, have your sketchbook on hand to practice as we go.

Importance of Line

When two dots connect, they create a line. This line can tell us so much about our subjects.

Line Variation

Lines can extend in a multitude of **DIRECTIONS**:
VERTICAL LINES represent rising, falling, and growth.
HORIZONTAL LINES represent stability, order, and neutrality.
DIAGONAL LINES represent movement, conflict, chaos, and nature.

A line's **WEIGHT** can be thick or thin, dense or sparse.
A line's **TEXTURE** can be rough, smooth, patterned, or wavy.
A line's **SIZE** is determined by its length, width, and height.
A line's **PROXIMITY** is the spacing of marks in relation to one another.

Lines can be **ACTUAL** in that they are physically present on the page.
Lines can be **IMPLIED** by using negative space to infer connections.

The erratic line directions and weights in this sketch convey the organic cluster of leaves.

Line Directions

Direction can affect how our mind perceives a subject's movement, energy, or liveliness. In nature, very rarely will a line be perfectly up and down. Instead, lines slant at various angles and bend into and out of each other. Because of this, avoid using a ruler when drawing natural elements and instead curve your lines to follow the contour of each form. Whether your subject is a tree-filled forest, a study of crystals, or a figure in action, straight lines can break the sense of organic flow vital to natural matter.

Line Weights

Since opacity cannot be controlled with pen in the same way as with other materials, line weight and density must be used to control the value of your drawing. Line weight can make an image more dynamic by helping to convey light and shadow, as well as depth or mass.

Line Texture

A line's texture may refer to a line's roughness, smoothness, or spacing. This can be determined by the material used to make it or by the artist's intention. For example, a ballpoint pen produces a rough line, while a fineliner usually produces a smooth line.

Pen & Ink

Pens can be a surprisingly excellent artistic medium, but the permanence of their marks can be intimidating at first. However, by employing a good use of line, along with the lessons on perspective and form that we learned earlier, you should be able to easily create exciting pen illustrations.

Why use pen?

GRAPHIC EMPHASIS – Because inks rely less on controlled opacity than many other mediums, they can capture high contrast, resulting in a more graphic quality with emphatic use of varying line qualities.

UNFILTERED – The permanence of pen drawings can result in drawings with a raw, spontaneous quality.

PERMANENCE – Pen can turn transient marks into permanent strokes through the lining process when ink is added over a preliminary sketch,

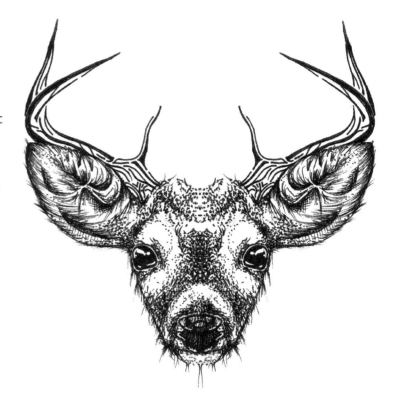

Key Pen Qualities:

There are a few essential characteristics that you should consider when selecting your pen.

BLEED-PROOF – Inks are formulated to either rest on top of your surface to absorb into the paper's pores. This absorption is known as "bleed" and is usually best avoided due to its messy nature.

SMUDGE-PROOF – An ideal ink will be resistant to smudging such that you would not need to overly worry about destroying your artwork with an accidental swipe of the hand.

WATERPROOF – This component of an ink's permanence allows you to go over the top of an inked image with watercolor without disturbing the ink underneath.

LIGHTFASTNESS – This refers to an ink's resistance to fading or discoloration over a given period, assuming the artwork is stored in the proper conditions (away from harsh lighting or other elements).

DARKNESS / COLOR – An ink's perceived darkness and coloration can vary widely between brands and affect your final image's impact. You may wish to compare swatches before working on a piece.

Shading in Pen

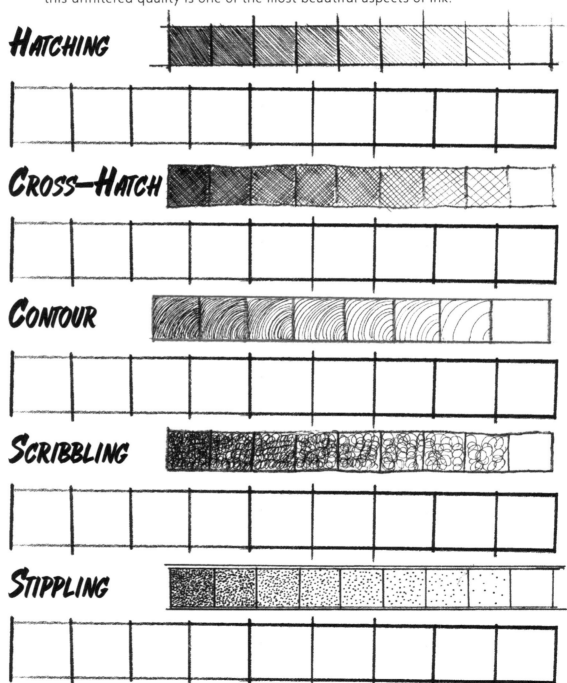

With graphite, pressure can be used alongside pigment density to control value. For most pen drawings, pressure plays far less of a role in controlling value, as all marks will result in the same ink value being applied. Instead, stroke spacing and density, like those in the shading techniques below, can add a range of values to your pen drawings while implying movement, direction, and texture. Remember that you cannot erase with most pen, but this unfiltered quality is one of the most beautiful aspects of ink!

Hatching can be long, short, uneven, woven, or curved to the contours of your subject. Each of these conveys a different texture of the surface you are rendering.

HATCHING

CROSS-HATCH

Flowing contour lines can look like a topographical map of your subject or can trick our eyes into optical illusions.

CONTOUR

SCRIBBLING

Stippling can be random, creating a "five o'clock shadow" effect, or it can be regular, like the halftone pattern seen in comics.

STIPPLING

While these are the most common strokes for shading, don't be afraid to experiment and find your own!

Mixing Methods

Mixing and matching your shading techniques within a single composition allows you to express a range of values and a wide variety of textures and surface types, such as this scene of potted plants. Here, hatching follows the contours of the pots to emphasize the curved surface, scribbling creates the trailing forms, and stippling adds textures and pores.

Each shading method can be combined and modified to create unexpected textures, patterns, and effects. We've provided a few samples below. Try mixing and matching your own combinations in your sketchbook!

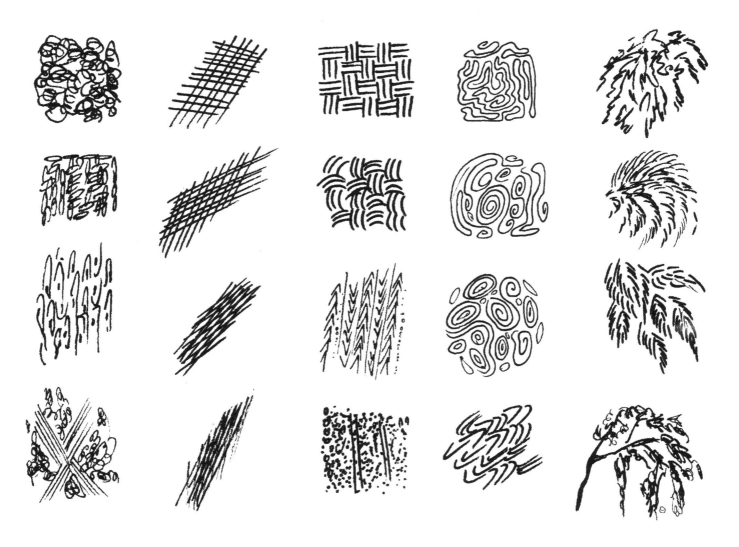

Curve to Contours

As we've learned in previous sections, subjects are made up of various forms. You can use line direction to help convey volume by alternating the angles you use or by curving lines to match the contours.

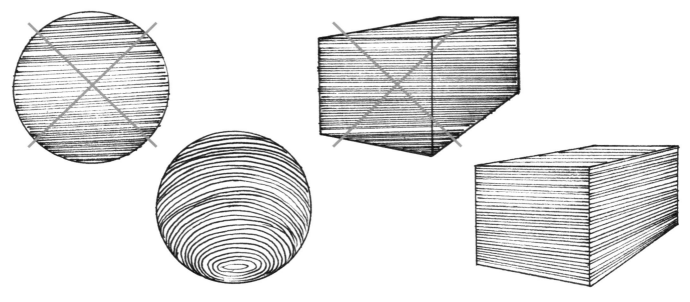

You can use line directions, as well as proximity, weight, and other variables, to trick our eye into seeing illusions of ripples, angles, and valleys.

PRACTICE VARYING LINE PROXIMITY AND DIRECTIONS IN THE SPACE BELOW:

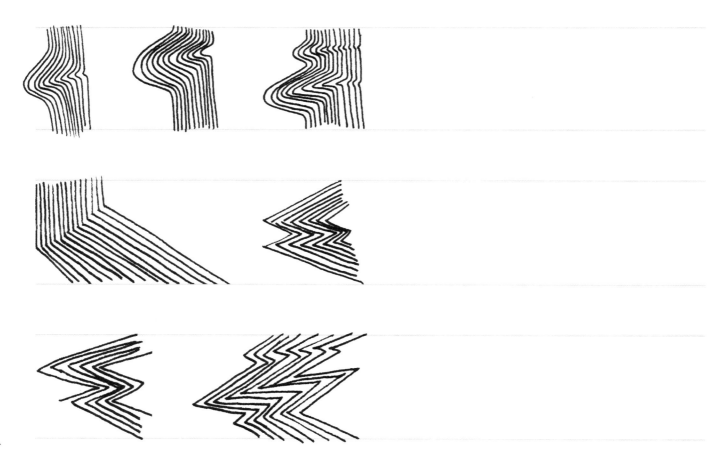

Line Effects

When working in pen and ink, a single line will often have to simultaneously convey a variety of purposes, from defining contours and outlines to establishing value and texture through shading.

You can **VARY YOUR LINE WEIGHT** either during the creation of your work by varying your pressure, or afterwards by making your lines and then selectively making some bolder.

Lines can have **VISUAL EFFECTS**. In general, thin lines will recede in space, while thicker lines will seem to jump out at the viewer.

Lines can communicate a subject's **LOCAL COLOR VALUE**, meaning its true value in relation to other objects within the same scene. You may draw some subjects very dark and others very light.

Our minds are great at making connections. This principle is known as **GESTALT** and refers to how our minds can unify separate elements through similarity, proximity, and spacing. This means that you don't need to render everything in your work because your viewer's imaginations will fill in the rest! For example, you can show hair using a few simple strokes instead of drawing each individual strand. We can use this principle to suggest the existence of objects, motion, and space through the strategic use of positive and negative space. This is known as **IMPLIED LINE.**

Line Tips

PERMANENT PEN – While you can use a pencil for preliminary work before using pen, alternatively, you can skip the pencil stage to practice your observation skills. To do this, try to change your mindset from recreating your idea of the subject and instead strictly focus on the shapes of the different values. Similar to using a pencil, start light and loose and gradually add more layers to create shadow and depth.

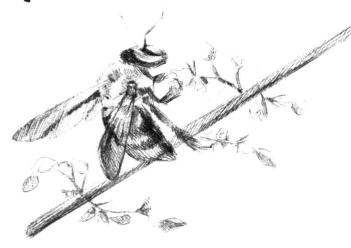

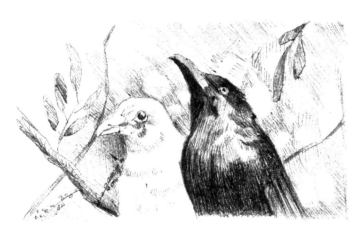

LOCAL VALUE – A black bird likely won't have a range of values from 0-100%, but instead may be made up of values from 80-100%, while a white dove may only have values from 0-20%. Remember that this value scale may be created with pen through line weight, density, or pressure. The lightest values are captured through negative space and the absence of line.

BROKEN OUTLINE – An outline can be used selectively, with the line broken to infer lighting or atmosphere, such as the lit side of a building losing part of its outline or a cloud being shown best when not all edges are defined. For example, notice how the top of this flower seems to fade away as if illuminated by a harsh light due to a broken outline.

Streamline Your Story

As an artist, you are not a copier but a storyteller. It is your creative interpretation whether to omit or modify an item in your composition. **LINE ECONOMY** refers to the minimal amount you can draw to establish a subject or concept for your viewer. Each line you add to your scene should help craft a tale in one way or another, with the most care given to developing your desired protagonists. Start minimally to see how far you can reduce a subject and how a scene's story might change with some parts emphasized and others faded. Use this to clarify your narrative, emphasize a focal point, or streamline your subject.

OPTION ONE **OPTION TWO**

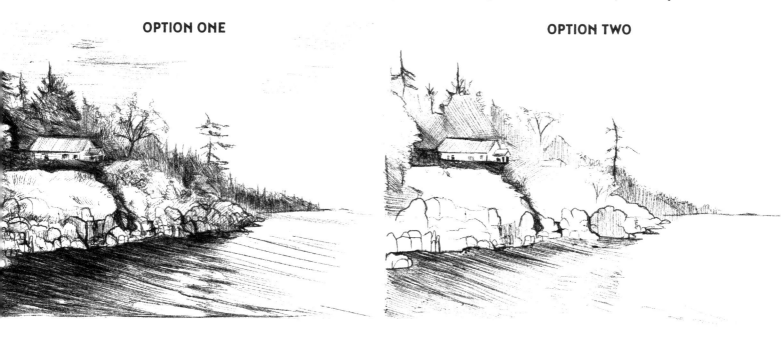

While this drawing of an ocean-side cottage could be made with many different lines, all overly worried about the textures of each surface, the same scene could be captured with minimal lines to better focus our viewers' attention. It's up to you to determine the ideal line economy for your subject.

TRY MAKING TWO SKETCHES BELOW, ONE WITH A LARGE
NUMBER OF LINES AND THE OTHER WITH MINIMAL LINES.

Types of Pens

Ballpoint Pens

Ballpoint pens are a surprisingly beautiful medium for creating dynamic illustrations and sketches. With a ballpoint pen, you can control the amount of ink applied to the page by varying the pressure of your application - light pressure will release less ink, and full force will provide more ink onto the page. This allows better control over opacity than other pen types. However, the ball tip can cause subtle variations, resulting in a sketchy quality. In addition, because these are made for writing rather than creating artwork, their inks might fade quickly.

Gel Pens

Gel pens use a unique matte and opaque ink, similar to paint, allowing them to be used on paper of any color or tone. This quality and their fine-tipped points make them excellent for final details at the end of a drawing. Gel pens are available in various colors and specialty finishes; however, our absolute favorite is a matte white for adding whiskers, highlights, and other finishing touches.

Fineliner Pens

Fineliner pens come with different-sized nibs or tips. They are typically tailored toward calligraphy, comics, illustrations, and other technical processes that require a fine point and a graphic finish. The tip size is indicated by a number, such as 005 for the thinnest tip to 08 for the thickest tip. It's important to have and use fineliners of varying sizes to maintain precision when needed or to place bold emphasis where desired.

Try the Types

BALLPOINT PENS

Break out your ballpoint pens and test them as an artistic medium. Try different brands, types, and tip sizes to see what you're most comfortable with.

GEL PENS

Give your gel pens a try in the space to the left. Try layering different colors together or adding emphatic lines around your sketch

FINELINER PENS

Figure out your fineliners in the space to the right. Test different tip sizes and check how pressure and angle can affect your line.

Build with Ballpoint

Creating an image in ballpoint pen alone can feel very different from starting with graphite since you can't easily remove your initial marks. Yet, by observing the dimension of the form and the values, it can be done!

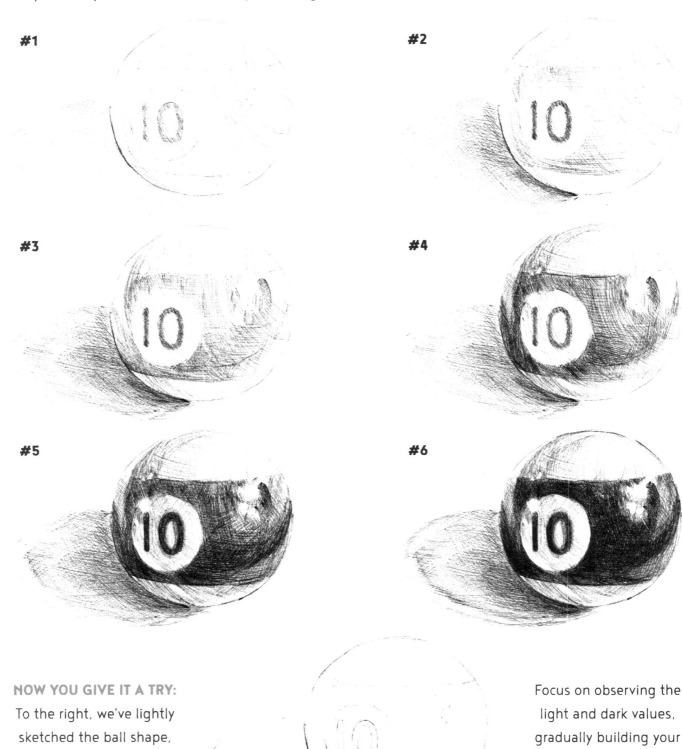

#1 #2 #3 #4 #5 #6

NOW YOU GIVE IT A TRY:
To the right, we've lightly sketched the ball shape, and it's up to you to shade it using a ballpoint pen.

Focus on observing the light and dark values, gradually building your tone by using various shading techniques.

Layering Pigments

It's possible to build up quite a bit of color and tone with ballpoint pens. You can create rich drawings that feel rendered and complete by layering different hues. It may seem strange to elevate such a common office supply staple, but ballpoint is a tool that many professional artists prefer to use to render sketches.

Begin with your lightest colors, such as red or yellow. Then, add a complementary tone, layering areas to combine and build upon values and hues. Pay close attention to the shadows and highlights, emphasizing the texture and directionality of these natural forms. Save any black for the very last to render shadows, add emphasis, and capture the finishing details.

For something like the fox sketch below, we start with light blue before moving to amber orange and then finish with black. The layered pigments make a denser tone than any one color could. It also allows us to refine our image over time, as any light mistakes get covered in later steps.

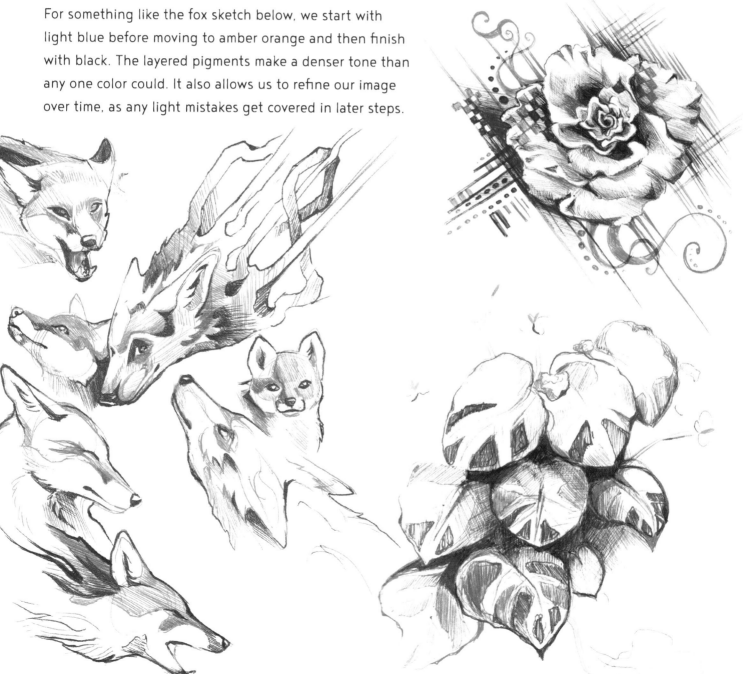

Step by Step Success

Let's go step by step to create a dynamic ballpoint drawing. First, we start by blocking out the major shapes. Next, add hatching and contour shading with contrasting tones. Finally, remember the textures and angles of the surfaces you render and choose shading techniques to best display those characteristics.

Once the base is beginning to gain dimensions, add in details. You are the artist and ultimately decide how a subject will appear. Is the neck scaly or made of stone? Is the fin feathered or translucent? Continue alternating between colors until you achieve a look that excites you!

Show us your Style!

Now that you've seen our step-by-step approach for a ballpoint sketch, we would love to see how you would complete this creature! Use the principles you've learned so far to define this ballpoint beast's shape, textures, and tones! You can even continue the image in every dimension to explore the wings, body, and environment. We can't wait to see what you create!

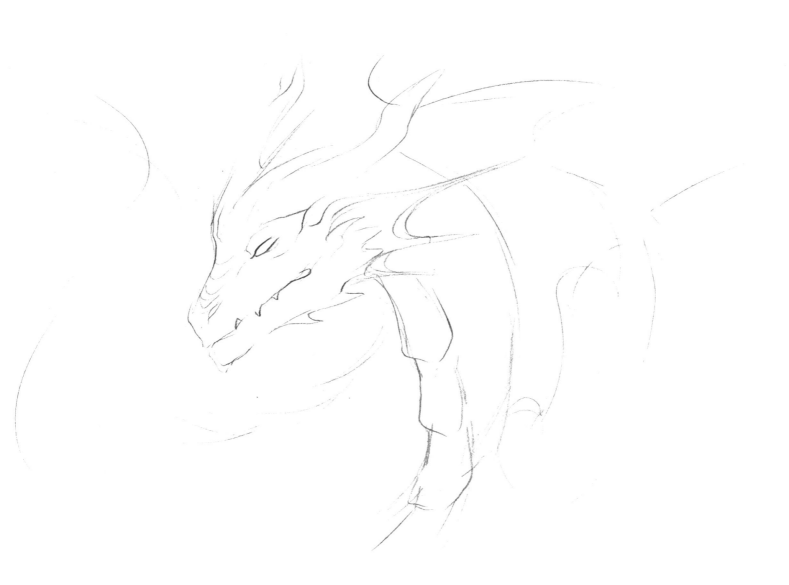

Art of Darkness

For this exercise, we will test the capabilities of a white gel pen. The opaque ink of a white gel pen makes it the perfect tool for drawing eye-catching designs on dark papers or adding detail over other mediums.

Using your white gel pen, add value, definition, and details to the subject below. You can add realism by adding pores, textures, and value or focus on graphic elements like creative patterns. When working reductively with pencil we reduce by using an eraser but with pen we reduce by using light-colored pens.

Tone it Up!

Working on mid-toned paper allows you to add light and dark values to your image. You can use a fineliner or a dark gel pen for the dark side of your value scale, a white gel pen for the light side of your value scale, and the paper tone as your middle point. Check it out in this example value scale below:

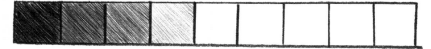

To start, make a sketch in pencil, then ink your image with a black pen. Next, focus on the lightest areas of your subject with a white gel pen. Use your shading techniques, like hatching, with both light and dark pigments to achieve a full range of values. You can even add pops of color for additional visual flair!

TONED PAPERS COME IN A WIDE VARIETY OF COLORS. TEST OUT A FEW SAMPLES BELOW:

Fineliner for Fine Lines

Textures can help communicate the quality of an object's surface: transforming an egg into a geode, defining an object's weight, and helping to craft a compelling narrative. Remember that any texture will follow form. Lines conveying texture should recede along the planes of the subject or curve to match the contours to help us understand the structure and surface. Now, let's use a fineliner to add texture to various objects by controlling our line weight, direction, and quality:

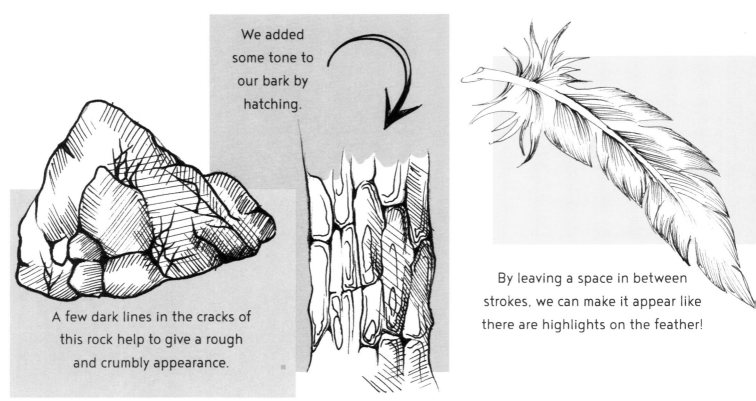

We added some tone to our bark by hatching.

A few dark lines in the cracks of this rock help to give a rough and crumbly appearance.

By leaving a space in between strokes, we can make it appear like there are highlights on the feather!

NOW YOU TRY ADDING DEFINITION TO THESE SURFACES:

Add Some Definition

ROCK – Using the techniques from previous lessons, apply your first layer of ink. Next, apply more ink in the crevasses to imply depth. This makes the rock begin to look craggy. Build up the final tones using hatching and cross-hatching.

BARK – Bark is typically layered, flaky, and chunky, with deep crevasses. Sketch in a layer of ink, avoiding harsh lines but filling in deeper crevasses. To emphasize the flakiness of the bark, add some delicate layers of lines. Notice how it looks like you could almost peel the bark off the tree.

FEATHER – Apply your first outline in ink. Use a delicate pen combined with light pressure. This is a soft object, so we don't want it to feel too structured. Start by adding definition to the feather by following the curves, similar to hatching but with rounded strokes. The darkest areas may be near the feather's rachis, with lines tapering off towards the end.

TRY MAKING YOUR OWN SURFACES FROM SCRATCH IN THE SPACE BELOW:

Mixing Pen Types

You don't have to stick to only one pen or ink type when making a drawing. As long as you choose your materials intentionally, you can make the most of each to create a mixed-media masterpiece.

STEP ONE

STEP TWO

STEP THREE

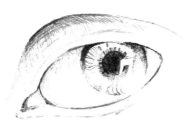

STEP FOUR

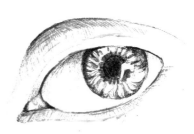

STEP FIVE

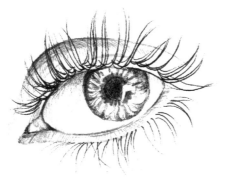

STEP SIX

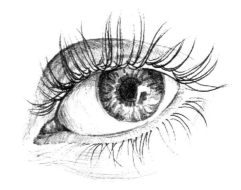

For this sketch, we used colored ballpoint pens to create a base of tone. Then, we worked on top with fineliner for the black accents like the eyelashes and iris. Finally, we used a white gel pen to create the highlights in the eye. The end result is a quick and colorful sketch bursting with personality!

FINAL SKETCH **NOW YOU TRY!**

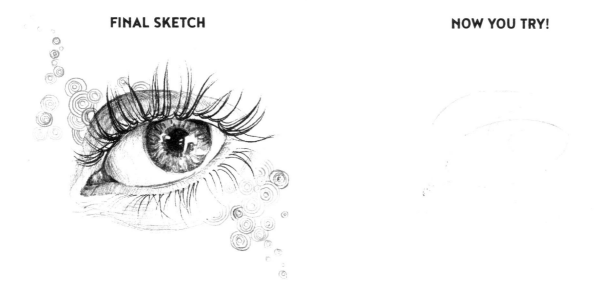

USE THE SPACE BELOW TO CREATE YOUR OWN MIXED-PEN MASTERPIECE!

Pen and line can be used to make quick sketches or entire compositions – the only limit is your imagination!

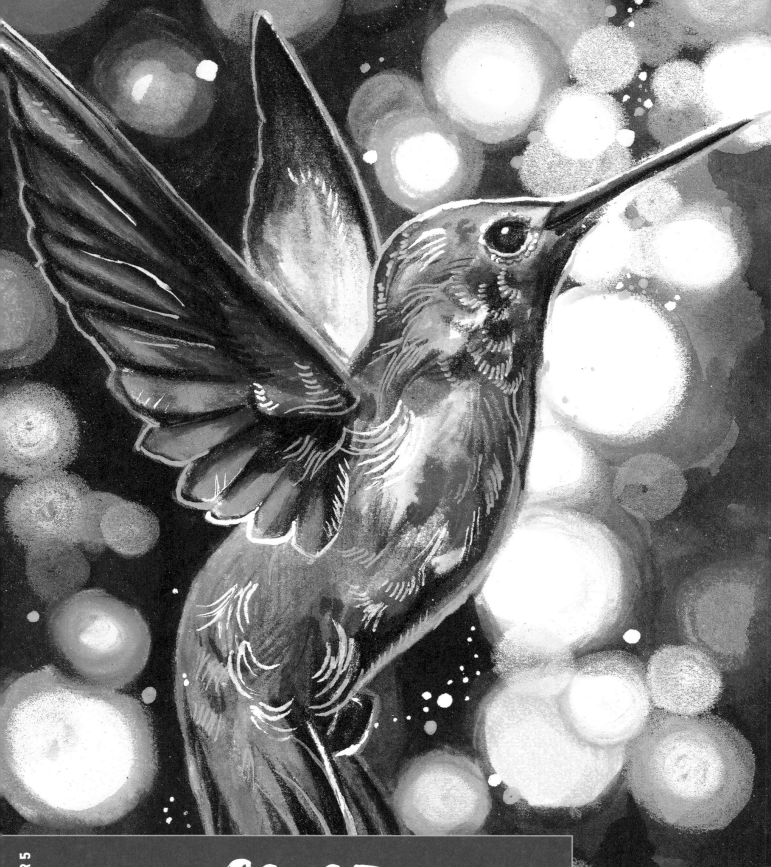

COLOR

In this Chapter:

Intro To Colored Pencil

–

Layering, Blending, and Burnishing

–

Color Theory

–

Color Mixing

–

Shades, Tints, and Tones

–

Color Schemes

Materials Required:

Colored Pencils

A set of at least 12 colored pencils in various colors, including black and white.

Eraser

Helpful to erase any mistakes or to work reductively.

Sharpener

A pencil sharpener will ensure you're always on point.

Sketchbook

Have your sketchbook on hand to take notes and practice as we go.

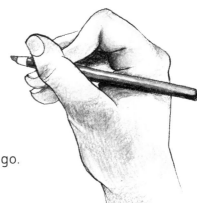

Intro to Colored Pencil

COLOR is another essential element of design. It makes use of all our previous elements of line, shape, form, value, and texture, expanding on each through a lens of hue and saturation.

WHAT ARE COLORED PENCILS?

Colored pencils consist of a pigmented core encased in an outer protective shell, typically made of wood. These are an easy medium to learn once you've practiced the principles covered in our graphite section. They are an excellent option for any artist who wants to experiment with color while maintaining control.

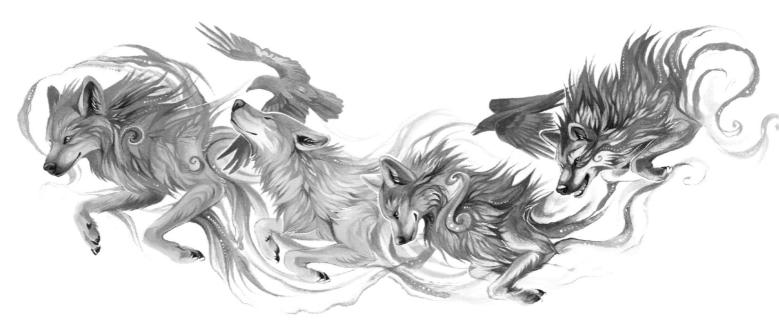

WHY USE COLORED PENCILS?

PRECISE – Due to their sharpen-able tip, colored pencils offer far more precision than similar mediums like pastels, crayons, and paints, making them excellent for detailed work or for finishing touches.

RELATIVELY MESS-FREE – Besides a few pencil shavings or the occasional broken tip, colored pencils are far less messy than other coloring materials, making them easy to use and low maintenance.

VERSATILE – Colored pencils are available in a wide range of types, colors, finishes, and features, which can be used to create anything from a sketch to a photo-realistic "pencil painting."

ACCESSIBLE – For a small upfront cost, you can have a material that can last for quite a while.

COLORED PENCIL COMPONENTS

The colored pencil core contains three components: a pigment, a binding agent, and a filler. These components and the ratios in which they are mixed give different colored pencils their unique properties. Let's break down each of these components to understand their purpose:

PIGMENTS are colors in their raw state. There are many different types of pigments, with the source and quality determining how vibrant and lightfast the colors may be over time.

BINDING AGENTS determine how the pigments will apply to a surface. There are three binding agents typically used in colored pencils, which determine the pencil type: wax, oil, and gum arabic.

FILLERS are used to control the composition of a pencil and help extend the life/use of a pencil. The more filler is used the less soft and vibrant the pencil. Cheaper pencils tend to contain more filler.

TYPES

WAX PENCILS use wax as a binder and tend to be the most affordable and commonly available type of colored pencil.

OIL PENCILS use oil as a binder, are typically less prone to breakage, and are the most expensive pencil type.

WATER SOLUBLE PENCILS use gum arabic as a binder, which can dissolve when water is applied. For the purposes of this section, we will focus on the other types, but these can be fun to try!

PROPERTIES

HARDNESS determines how smoothly the pencil will apply to the surface and how long the tip will stay sharp when used. Typically pencils with less binder or filler and more pigment feel softer and more "buttery."

LIGHTFASTNESS refers to the resistance of a color from fading over time, which is determined by the quality of pigment used in the pencil lead. More lightfast pencils are preferred for their archival quality but are more expensive.

VIBRANCY refers to the strength of the color saturation and is determined by the pencil's core composition. Vibrant pencils contain a high saturation of pigment and are more expensive. Cheap pencils are less vibrant.

Choosing Your Pencil

When choosing which colored pencils to use, there is a vast world of options.
Here's a little info to help you make the best choice for your artwork:

TWO MAIN COLORED PENCIL TYPES:

Wax-Based

POSITIVES:

Wax-based pencils are typically the softest lead, making them easier to blend. They are usually somewhat erasable and more affordable than oil-based.

NEGATIVES:

Wax can be prone to "bloom," causing a white haze. The softer lead can break more easily. Cheaper options may have a duller appearance due to lower pigment quality and concentration.

Oil-Based

POSITIVES:

Oil-based pencils are semi-hard, making them less prone to breakage and able to hold a fine point. They often use the highest quality pigments, which can be more vibrant and lightfast.

NEGATIVES:

These are usually more expensive due to the higher-quality materials. Their semi-hard lead means the application isn't quite as smooth. They can be difficult to erase.

TWO MAIN COLORED PENCIL CLASSIFICATIONS:

Student Grade

Student-grade pencils tend to be more affordable than artist-grade pencils, which results in them almost always being wax-based. Student-grade pencils use more fillers and less pigment to extend a pencil's life. The resulting harder lead tends to provide more control; however, lightfastness, vibrancy, and application smoothness are often compromised. Student-grade pencils should perform better than those you used in kindergarten, but they are not the best quality, so your art may suffer.

Artist Grade

Artist-grade pencils are a more premium, and thus more expensive, option than student-grade. They tend to use less filler, more premium pigments, and a better binding agent. The higher concentration of pigment results in a more vibrant color, while the higher quality of the pigment usually results in better lightfastness. Oil binding agents can be used, resulting in a semi-hard lead with less breakage and a smooth application. These are considered the best colored pencils available, but are not always obtainable for every artist.

Tips and Tricks

Here are a few simple techniques to remember when working with colored pencil:

Sharpening Colored Pencils

A common misconception is that colored pencils need to be sharpened every time the pencil gets dull (which can happen really quickly). In fact, blunt pencil tips are better than sharp tips for shading, layering, or burnishing, as the larger surface area prevents the drawing from having prevalent streaks.

When you do sharpen your pencils, be sure to use the proper technique. Carefully rotate the sharpener without quick or jerky movements, keep the blade sharp, and check the tip often. If sharpening seems overly frustrating, you can use a scalpel or even fine-grit sandpaper to sharpen your pencils by hand. That way, you can shave the lead to the exact point you need, such as a fine point for detail or a blunt end for shading in large areas.

Filling Up Your Page

One of the most intimidating things about using colored pencils is that it can take a long time to complete a large, intensive drawing. To speed up the process, try using the side of the pencil to shade large, flat areas. Alternatively, consider using a base of watercolor or marker underneath your colored pencil so that you can skip right to the detailed step.

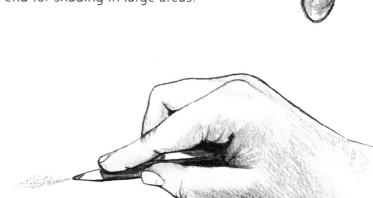
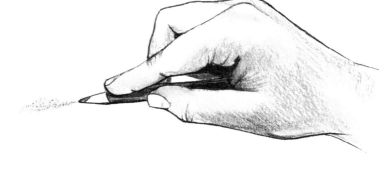

Prevent Breakage

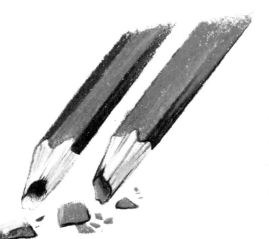

Soft-core pencil lead can break easily if it is not cared for properly. If you accidentally drop one of these pencils or use a dull sharpener, you might be cursed with perpetually broken lead. If this happens, you can try slowly heating the pencil to reset the binding agent. Lay the pencil flat on a baking tray and place it in an oven set at 200 degrees Fahrenheit for approximately 20 minutes.

Layering Colors

Like with the other mediums that we have discussed, pencil pigment can be applied to a surface using various shading techniques:

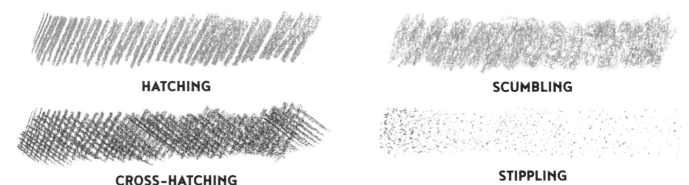

HATCHING

SCUMBLING

CROSS-HATCHING

STIPPLING

Your pencil type can influence which shading technique you use for a drawing. For example, a pencil with harder lead may be more conducive to hatching or cross-hatching. Scumbling or scrubbing in a circular motion can be an excellent technique for a softer-leaded pencil with a blunt tip.

Layering

The secret to a great colored pencil drawing is working in layers. Colored pencils are semi-opaque, meaning that when a new color is layered on top of an old color, some of the previous layers will be visible. This quality requires a few things to be taken into consideration:

WORK FROM LIGHT TO DARK – Because our darkest colors will always be visible, these should typically be added last. We can also make a pencil drawing darker, but we can't make it lighter!

CONSIDER INTERACTIONS – A new color is created when two colors are layered on top of one another. For instance, when yellow is layered on top of blue, you will produce a green color.

THE MORE PIGMENT, THE RICHER THE DRAWING – Colored pencil drawings benefit from many layers. Build up layers slowly and methodically for the richest and most opaque color application. Use smooth, even pressure to form a soft patch of light color, then gradually apply harder pressure.

BE MINDFUL OF BLOOM – Wax bloom is a white haze that can occur over top of wax-based colored pencil drawings. Sometimes bloom can be removed by gently wiping or blotting with a soft piece of fabric. Bloom can usually be avoided by using a spray fixative over your drawing as soon as it has been completed.

Blending & Burnishing

Two of the most essential colored pencil techniques to learn are blending and burnishing. These layering techniques will help you create illustrations with smooth, rich, and dynamic hues.

BLENDING is the act of combining two or more layers of colors to create a new color or smooth gradient. You can layer pigmented colors together or use a colorless blender, a special pencil with a soft, translucent core, to achieve beautiful blends. The more time you take to lay down a consistent application of color, the smoother your blending and the more dynamic your finished product will be.

BURNISHING is the act of polishing the pigment until the paper is completely saturated with color. Once your work has been burnished, no additional pencil can be added, as the surface pores are no longer receptive. Some beginners inadvertently burnish their work by going too hard with early layers, preventing them from building up any more tone later in the drawing. When done correctly, this technique is used as the final step in a pencil drawing to achieve an ultra-smooth finish with few visible marks

TOOLS FOR BLENDING & BURNISHING:

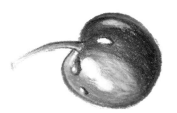

A **LIGHT-COLORED PENCIL**, such as white or a tan tone, can blend and burnish a colored pencil drawing; however, it can potentially obscure your art with a milky haze due to the pigment found in these pencils.

A **BURNISHER** is a hard, translucent, colorless pencil made specifically for burnishing layers of pencils together to achieve a rich and glossy surface. You can use a colorless blender for burnishing, but the result may be less desirable.

SOLVENTS can be used to break down the binder of the colored pencil, allowing for an almost paint-like appearance. Each pencil type will use its own solvent, such as alcohol or odorless mineral spirits for wax-based pencils, Sansodor™ for oil-based pencils, and water for watercolor pencils. Be aware that some solvents can be toxic and must be used with safety precautions. Additionally, because they are a wet process, they should only be attempted when working on thick paper.

PHYSICAL BLENDING can be used to manually smudge layers of pencil together using a paper towel, tortillon, or a blending stump. However, this process can be rougher on the artwork and less precise, so other methods are usually preferable.

What is Color Theory?

COLOR THEORY is scientific understanding how different hues relate to and function with each other. Understanding these principles allows you to mix and match a few pigments into just about any hue imaginable. Color uses all the elements of art - line, shape, form, and value - within a more vibrant lens.

PRIMARY COLORS are pure hues that can't be created by mixing any other colors. In traditional color theory, red, blue, and yellow are the fundamental colors for mixing all other colors.

RED

BLUE

YELLOW

SECONDARY COLORS are hues that result from mixing two primary colors. Because of this, they are spaced in-between their corresponding primary colors on the color wheel. Secondary colors include:

VIOLET

GREEN

ORANGE

TERTIARY COLORS are created by mixing a primary color with a secondary color. Each tertiary color is placed directly in-between the corresponding primary and secondary colors on the color wheel. These include:

RED-VIOLET BLUE-GREEN YELLOW-ORANGE

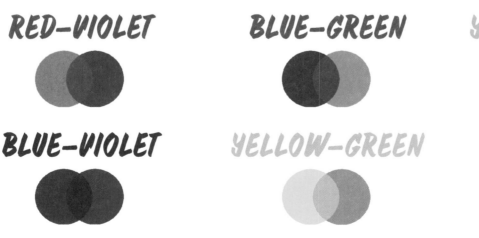
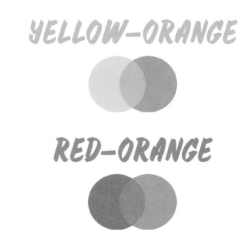

BLUE-VIOLET YELLOW-GREEN RED-ORANGE

PRO TIP – Always refer to the names of the tertiary colors starting with the primary color first, followed by the modifying secondary color, such as "red-violet", not "violet-red".

The Color Wheel

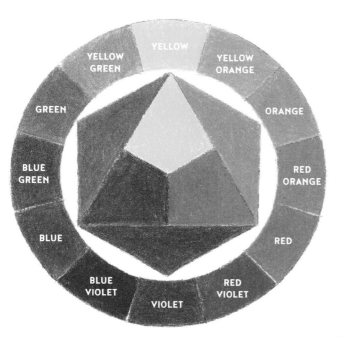

The **COLOR WHEEL** is a tool to visualize how primary, secondary, and tertiary colors connect and relate to one another.

You can make your own color wheel by filling in the template below. All you need are red, blue, and yellow colored pencils. Mixing these three colors, you can make each of the secondary and tertiary colors.

Adjust your colors by adding more or less of each to get a balanced tone. It can take a few tries to mix the correct hue.

FILL IN THE COLOR WHEEL BELOW:

COLOR TERMS

HUE refers to the pure pigment or color, such as red or violet, and is determined by its location on the color wheel.

SATURATION, also referred to as chroma, is the intensity, purity, or dilution of a color.

VALUE is the lightness or darkness of a color, either determined by the pure hue or by the mixture of that color with white, black, or gray.

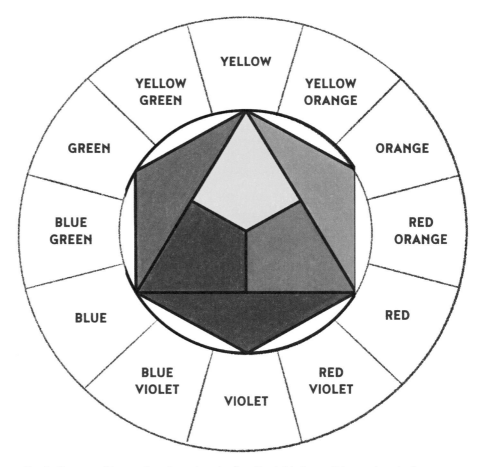

PRO TIP – Digital artists use a Red-Green-Blue wheel instead of a Red-Yellow-Blue wheel. Since we primarily discuss traditional processes, we will use an RYB wheel in these demonstrations.

Mixing Made Simple

The color wheel is great for showing color relationships, but there's much more than just pure color! The world is full of colors of every hue and saturation, but that doesn't mean you need a pencil for each. Using our layering and blending techniques, we can combine pigments to make just about any hue imaginable!

This chart might look confusing initially, but filling each row and column with different colors allows us to magically view every possible mixing combination of primary and secondary colors.

STEP ONE – Start with the left-most column. Take a yellow colored pencil and shade the first box with half hardness, then continue to fill each box in that vertical column with a base of yellow. Continue in the next column with orange, then red, and so on. Once each column has been half-shaded, move to step two.

STEP TWO – Starting with the top row, shade each square with green at about half hardness. Continue with the next row to add blue to the base colors. Once all rows and columns have been filled, you may want to go over certain colors to blend an even mixture. Once finished, you will have made all of the possible combinations of any two colors!

This is what the chart will look like after the first step:

	YELLOW	ORANGE	RED	VIOLET	BLUE	GREEN	BLACK	GRAY	WHITE
GREEN	YELLOW + GREEN	ORANGE + GREEN	RED + GREEN	VIOLET + GREEN	BLUE + GREEN	GREEN + GREEN	BLACK + GREEN	GRAY + GREEN	WHITE + GREEN
BLUE	YELLOW + BLUE	ORANGE + BLUE	RED + BLUE	VIOLET + BLUE	BLUE + BLUE		BLACK + BLUE	GRAY + BLUE	WHITE + BLUE
VIOLET	YELLOW + VIOLET	ORANGE + VIOLET	RED + VIOLET	VIOLET + VIOLET			BLACK + VIOLET	GRAY + VIOLET	WHITE + VIOLET
RED	YELLOW + RED	ORANGE + RED	RED + RED				BLACK + RED	GRAY + RED	WHITE + RED
ORANGE	YELLOW + ORANGE	ORANGE + ORANGE					BLACK + ORANGE	GRAY + ORANGE	WHITE + ORANGE
YELLOW	YELLOW + YELLOW						BLACK + YELLOW	GRAY + YELLOW	WHITE + YELLOW

This is what our chart looks like after coloring all of the columns <u>before</u> moving onto the second step. Next you'll layer colors in each row!

Once finished, you should have something that looks similar to this:

	YELLOW	ORANGE	RED	VIOLET	BLUE	GREEN	BLACK	GRAY	WHITE
GREEN	YELLOW + GREEN	ORANGE + GREEN	RED + GREEN	VIOLET + GREEN	BLUE + GREEN	GREEN + GREEN	BLACK + GREEN	GRAY + GREEN	WHITE + GREEN
BLUE	YELLOW + BLUE	ORANGE + BLUE	RED + BLUE	VIOLET + BLUE	BLUE + BLUE		BLACK + BLUE	GRAY + BLUE	WHITE + BLUE
VIOLET	YELLOW + VIOLET	ORANGE + VIOLET	RED + VIOLET	VIOLET + VIOLET			BLACK + VIOLET	GRAY + VIOLET	WHITE + VIOLET
RED	YELLOW + RED	ORANGE + RED	RED + RED				BLACK + RED	GRAY + RED	WHITE + RED
ORANGE	YELLOW + ORANGE	ORANGE + ORANGE					BLACK + ORANGE	GRAY + ORANGE	WHITE + ORANGE
YELLOW	YELLOW + YELLOW						BLACK + YELLOW	GRAY + YELLOW	WHITE + YELLOW

By layering your pigments together, you create tertiary colors (such as yellow-green), mixed colors (such as yellow-violet), or a burnished colors (such as yellow-yellow)

CREATE YOUR OWN COLOR MIXING CHART IN THE SPACE BELOW:

	YELLOW	ORANGE	RED	VIOLET	BLUE	GREEN	BLACK	GRAY	WHITE
GREEN	YELLOW + GREEN	ORANGE + GREEN	RED + GREEN	VIOLET + GREEN	BLUE + GREEN	GREEN + GREEN	BLACK + GREEN	GRAY + GREEN	WHITE + GREEN
BLUE	YELLOW + BLUE	ORANGE + BLUE	RED + BLUE	VIOLET + BLUE	BLUE + BLUE		BLACK + BLUE	GRAY + BLUE	WHITE + BLUE
VIOLET	YELLOW + VIOLET	ORANGE + VIOLET	RED + VIOLET	VIOLET + VIOLET			BLACK + VIOLET	GRAY + VIOLET	WHITE + VIOLET
RED	YELLOW + RED	ORANGE + RED	RED + RED				BLACK + RED	GRAY + RED	WHITE + RED
ORANGE	YELLOW + ORANGE	ORANGE + ORANGE					BLACK + ORANGE	GRAY + ORANGE	WHITE + ORANGE
YELLOW	YELLOW + YELLOW						BLACK + YELLOW	GRAY + YELLOW	WHITE + YELLOW

When mixing colors that are opposites on the color wheel, you neutralize both colors, resulting in a brownish hue.

135

Hue Potential

We have started to show the wide range of colors possible by mixing primary and secondary colors, but there are so many more than could possibly be shown with one grid. Each main hue can be made into so many different unique colors. Let's explore the potential of a single hue.

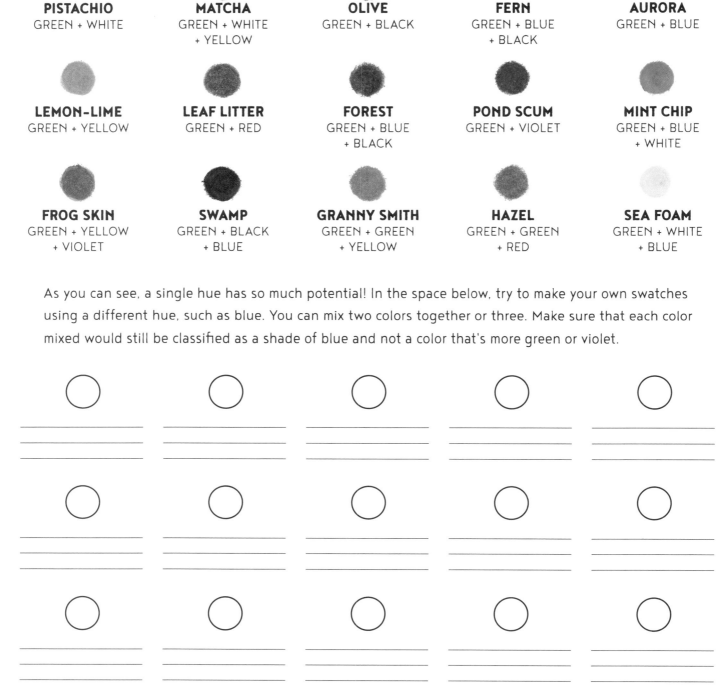

PISTACHIO
GREEN + WHITE

MATCHA
GREEN + WHITE
+ YELLOW

OLIVE
GREEN + BLACK

FERN
GREEN + BLUE
+ BLACK

AURORA
GREEN + BLUE

LEMON-LIME
GREEN + YELLOW

LEAF LITTER
GREEN + RED

FOREST
GREEN + BLUE
+ BLACK

POND SCUM
GREEN + VIOLET

MINT CHIP
GREEN + BLUE
+ WHITE

FROG SKIN
GREEN + YELLOW
+ VIOLET

SWAMP
GREEN + BLACK
+ BLUE

GRANNY SMITH
GREEN + GREEN
+ YELLOW

HAZEL
GREEN + GREEN
+ RED

SEA FOAM
GREEN + WHITE
+ BLUE

As you can see, a single hue has so much potential! In the space below, try to make your own swatches using a different hue, such as blue. You can mix two colors together or three. Make sure that each color mixed would still be classified as a shade of blue and not a color that's more green or violet.

You can continue this practice with every hue in your sketchbook if you'd like.

Good Gradient

The color wheel is a round representation of the color spectrum. While we have separated it into manageable blocks in our wheel, the colors can shift and blend to display the full range of possible hues. Test the potential of your colors by mixing and blending to make a perfect rainbow.

FIRST, ROUGH IN THE PLACEMENT OF YOUR COLORS ALONG THE SCALE.

THEN, LAYER AND BLEND THE COLORS TO MAKE SMOOTH TRANSITIONS.

NOW, YOU TRY MAKING AS SMOOTH OF A GRADIENT AS POSSIBLE:

As you can see, mixing colors smoothly from one to another requires practice and control but unlocks an enormous range of colorful potential. Now put your color blending to the test by filling the sky in the scene below with a smooth sunset gradient.

Saturation

SATURATION refers to how pure the hue of a color may be. This vital element of any color can be especially important for capturing realistic subjects, as these are rarely fully saturated.

Typically, the colors of your pencils will come close to full saturation, so you may have to desaturate or neutralize them to achieve natural tones. **NEUTRAL** colors are made by mixing any two complementary colors. The resulting shades can be beautiful and complex, with browns and grays having an enormous range of potential hues, perfect for capturing the nuance of skin tone.

MAKE A GRADIENT FROM ONE COLOR TO ITS COMPLEMENT IN THE SPACE BELOW:

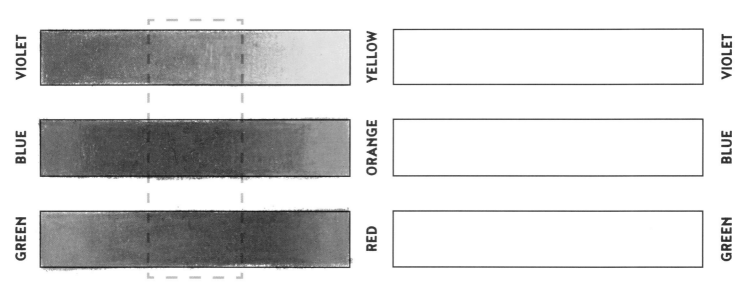

The neutral colors will be in the middle of each of these scales. In the space below, make a few swatches of the neutrals that you've created. We've given each color mixture a name to better identify them.

"VILLOW" **"BLUNGE"** **"GRED"**

Color Matching

By utilizing the methods we have discussed, you can mix colors to match the true hues of your subjects. Pay attention to the main colors that make up the hue, along with the underlying tone and warmth.

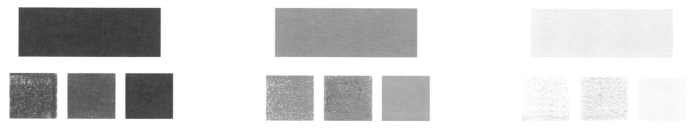

BLUE
+ GREEN
+ LIGHT LAYER OF BLACK
+ BURNISH WITH GREEN

ORANGE
+ LIGHT LAYER OF BROWN
+ BURNISH WITH YELLOW

+ GRAY
+ LIGHT LAYER OF BROWN
+ LIGHT LAYER OF YELLOW
+ BURNISH WITH WHITE

We've provided a few color swatches in the space below. Use your color-mixing skills to match these colors as closely as possible. Start by lightly shading and build the color over time to get the perfect tone.

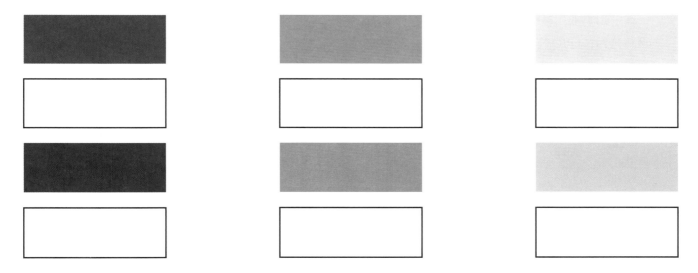

Now, get a paint swatch from a hardware store or find a piece of colored paper and tape it to the space below. Try your best to match the color as closely as possible. Keep your saturation in mind!

Shade, Tint, and Tone

SHADES, **TINTS**, and **TONES** are the next steps in creating variations of hues and values. Shades are darker variations of a hue created when black is added to a color. Tints are lighter variations of a hue made when white is added, reducing the value. Tones are the middle of these, created when gray is added to a color.

SHADES: ADDING BLACK

A shade will create a darker value of your color and can be blended to create just about any value. To test creating a shade, use a black colored pencil with any primary colored pencil, such as Red, Blue, or Yellow. Fill in the boxes below to create a value scale with all of the shades possible with your color,

USE ONLY BLACK HERE.

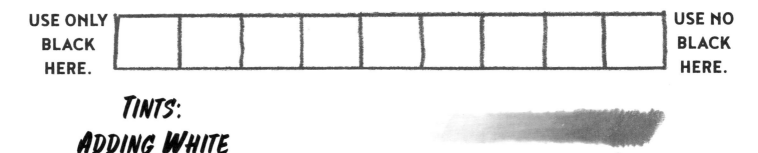

USE NO BLACK HERE.

TINTS: ADDING WHITE

White colored pencils can be used for blending, creating tints, or for lighter values on toned paper. To test creating a tint, use a white colored pencil with any primary colored pencil, such as Red, Blue, or Yellow. Fill in the boxes below to create a value scale with all of the tints possible with your color,

USE ONLY WHITE HERE.

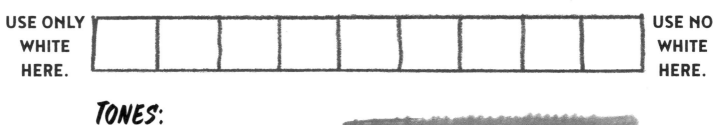

USE NO WHITE HERE.

TONES: ADDING GRAY

Adding gray will dull whatever color it is that you are working with. Try to use a gray colored pencil that is right in the middle of your value scale. Alternatively, you can mix your own gray by using an even mix of black and white colored pencils. Fill in the boxes below to create a value scale with all of the tones possible with any primary colored pencil, such as Red, Blue, or Yellow.

USE ONLY GRAY HERE.

USE NO GRAY HERE.

Color Value Chart

This chart is a good way of analyzing and understanding how a color can change using tints, tones, and shades. What we are making is a full value scale with color. This can be done with any hue of colored pencil, but for our demonstration, we have shown it with yellow.

In the blank chart below, use a single-hued colored pencil, such as yellow, as well as black and white. Start along the far right column. From top to bottom, make a value scale by using 100% black in the top square, 100% white in the bottom square, and then blending the two in the middle. Then mix each with your chosen hue. Starting with the top row, blend from 100% color over to 100% black. In the next row, blend from color to dark gray. In the next, blend from color to middle gray. In the next, blend from color to light gray. Then, in the last row, blend from color to white. This shows the range of one color's tints, tones, and shades.

PURE COLOR		50% - 50%		BLACK
PURE COLOR		50% - 50%		DARK GRAY
PURE COLOR		50% - 50%		GRAY
PURE COLOR		50% - 50%		LIGHT GRAY
PURE COLOR		50% - 50%		WHITE

PURE COLOR		50% - 50%		BLACK
PURE COLOR		50% - 50%		DARK GRAY
PURE COLOR		50% - 50%		GRAY
PURE COLOR		50% - 50%		LIGHT GRAY
PURE COLOR		50% - 50%		WHITE

Toned Paper

Use what you've learned about tints, tones, and shades to test drawing on a few different tones of paper. First, make a sketch with a pencil in a color that is close to your base tone so that you can rough in your subjects without it being super visible. Next, use a white or light-colored pencil to begin adding your subject's highlights. Then use a black or dark-colored pencil to add your darker values. You can use the tone of the paper as the middle of the value scale. Just be sure to keep the hue of each paper type in mind.

FILL IN THE VALUE SCALE AND THEN CREATES SOME SKETCHES IN THE SPACES BELOW:

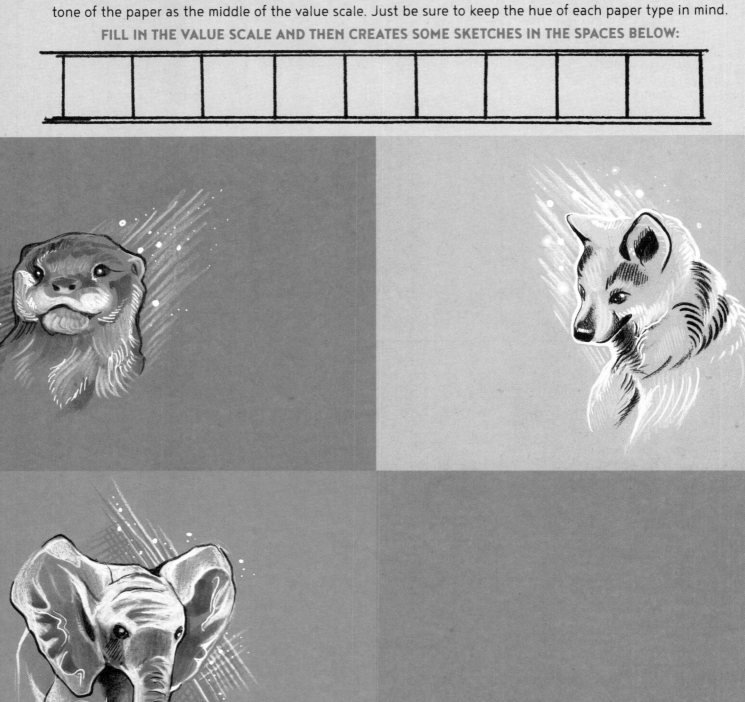

Build on Black

Don't be afraid of working on a dark surface! You can actually use many of the materials we've discussed on dark paper, such as gel pens and colored pencils. Even graphite can work on certain black surfaces due to its shiny quality. On this page, we'll work step by step to create an image in reverse.

#1

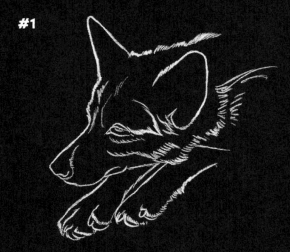

Start with a sketch using a light colored pencil that will be visible on your black paper. **WORK ON TOP OF OUR SKETCH AS YOU CONTINUE THE REMAINING STEPS.**

#2

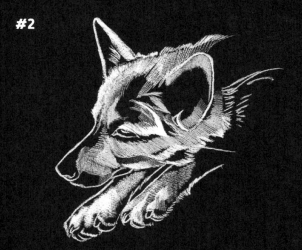

Then, lay down base tones to establish your forms. Unlike when shading on white paper, you will leave the shadows black and work on building up light areas and highlights.

#3

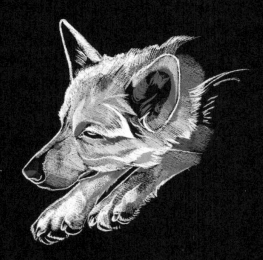

Next, add mid-tones by identifying the primary local color of your subject. For example, this dog is a light cream color. Leaving the shadowed areas black will maintain a full range of values.

#4

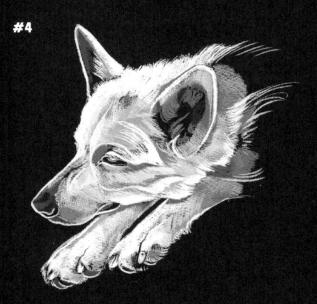

In the final stages of the drawing, add white to the highlights so that the subject will really jump off the page. Define the darkest values to allow your subject to really pop!

Value of Color

In art, there is a saying that "values do all the work, but color gets all the credit." As we've just learned, you can use black and white to create tints, tones, and shades of each color; however, every pigment has a true value as well. Using these values, you can swap any color in your work for one with the same value to add instant intrigue.

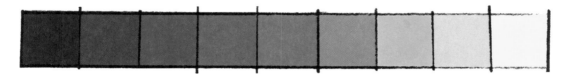

It may not look like it initially, but each of the colors in the scale above has a value that is close to the one shown below in grayscale. Don't believe us? You can use your phone's camera to check - simply view it through a black and white filter or take a photo and reduce the saturation.

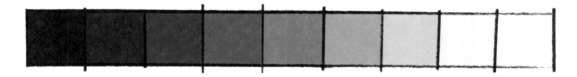

A great starting point to explore this principle is to work in a two-color system with violet as your darkest value and yellow as your lightest value. If we blended violet and yellow together, we would neutralize the two colors, resulting in a desaturated brown hue.

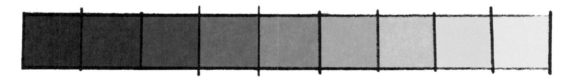

Alternatively, we can pick a color between violet and yellow on the color wheel to use for the middle values on the sketch, such as red-orange. Now, instead of blending <u>across</u> the wheel, you can blend <u>with</u> the wheel moving from violet to red to orange to yellow. Doing this lets you maintain your saturation, resulting in a far more dynamic creation.

TRY BLENDING FROM VIOLET TO ORANGE TO YELLOW BELOW:

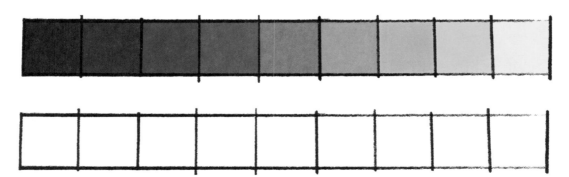

Try it Out!

Below, one sketch uses the desaturated two-color system while the other blends with the color wheel. We used violet for the shadows, yellow for the highlights, and then blended with red-orange to create a vibrant illustration!

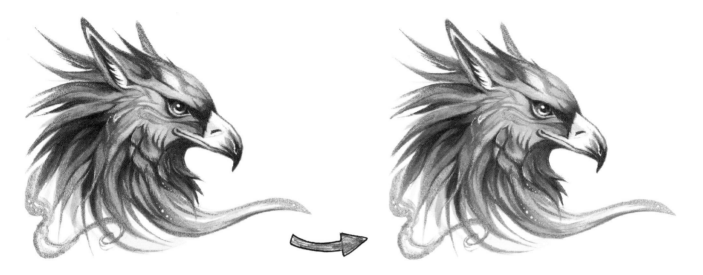

Now try it out! We've made a sketch below so that you can experiment with color. Start by using violet for the darkest areas and yellow for the lightest areas. Next, use a red-orange for the mid-tones. You can then blend from violet to orange and from orange to yellow to have beautiful, vibrant colors.

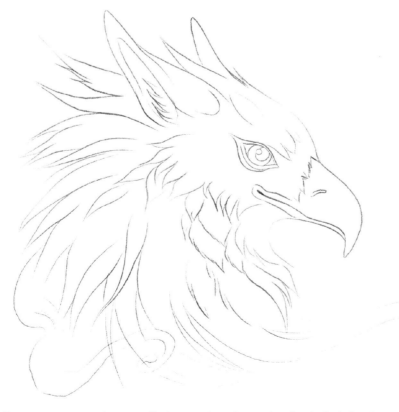

You can do this with your own work as well. Any subject can be first sketched in grayscale before planning out your color choices. There's a whole lot more to explore so stick with us as we learn more color theory!

Imperfect Perception

Visual Spectrum

Color is an expression of the light spectrum, which means that it can be understood in two distinct ways:

ADDITIVE color means viewing white as the combination of every color and black as the absence of color. To think of this, imagine a ray of light. This ray appears white to us and can light up a room. If we remove that ray of sunshine, we are left with total blackness. We can also split this ray of light to view the individual colors, such as when we view a rainbow in the sky or use an optical prism.

SUBTRACTIVE color is the kind of mixing that physical, as opposed to digital, artists rely on. This is because we start with a white sheet of paper and then add pigment to create color, meaning that black would be the combination of every color and that white would mean no color at all. Mixing physical pigments relies on the subtractive process because we are controlling which light waves are absorbed or reflected when viewing a work.

This emphasizes the dilemma of an artist. By mixing pigments, we use <u>subtractive</u> color processes to match our perception of the colors around us; however, the way we perceive the world relies on light, which operates on an <u>additive</u> color process. Let's discuss another way your brain is tricking your eyes:

False Perception

How we perceive color is not perfect; instead, it is experiential, meaning that our perception changes depending on the colors and values surrounding it. When artists try to capture the world around us, they attempt to replicate our perception and experience of the world, not the actual physical conditions.

RELATIVE CONTRAST refers to the effect that color values have on each other. For example, placing a dark color next to a light one will make them both look more extreme, with the light seeming lighter and the dark seeming darker. Two colors of similar value will look as if they have less contrast when put next to each other.

SIMULTANEOUS CONTRAST refers to the effect that colors have on each other and how these relationships can change our perception. For example, warm colors will look warmer if placed next to cool ones, and cool colors will look cooler if placed next to warm ones. Similarly, a bright color next to a muted color makes the muted one look duller. Artists can use this principle to their advantage, to either exaggerate the effect (creating our perceived color instead of the actual color) or by utilizing the effect (using an actual color knowing it will shift our perception of other items).

ON THE OPPOSITE PAGE, FILL IN EACH CIRCLE WITH THE INDICATED COLORS:

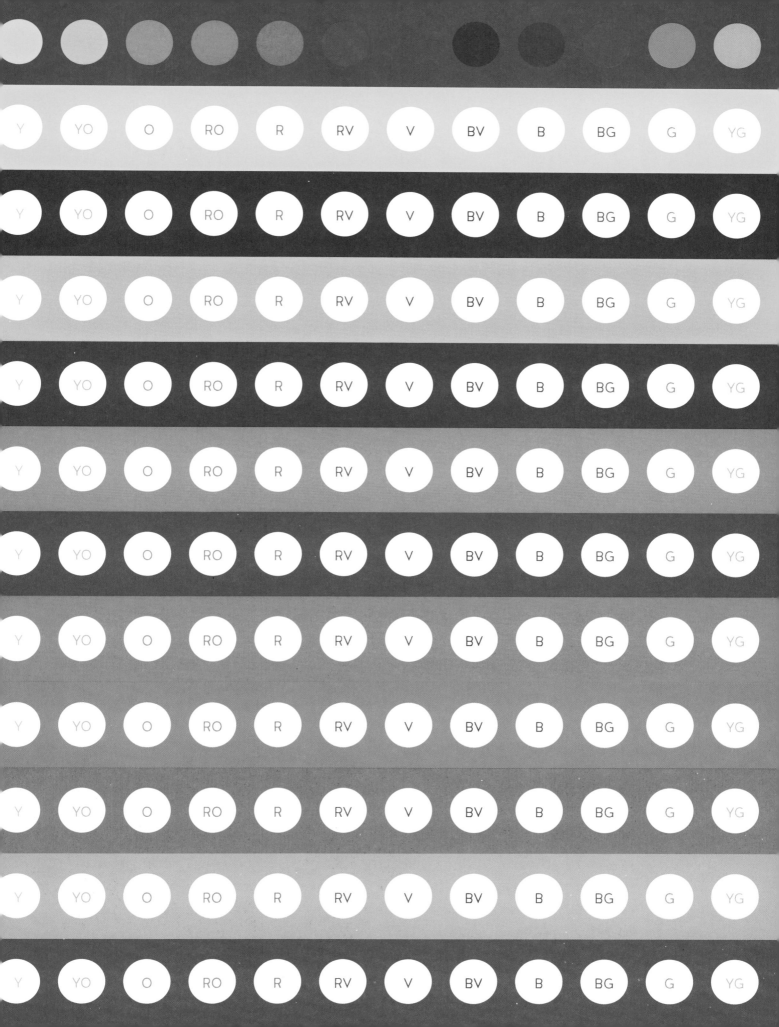

Color Schemes

Now that you understand the color wheel, you can learn how to use these colors for dynamic creations!

WHAT ARE COLOR SCHEMES?

The combination of colors in an intentional way is known as a color scheme or a color harmony. These hue relationships are essential to creating dynamic artworks and can enhance or imitate our natural experience of color.

WHY DO THEY MATTER?

If you know how to use color schemes, you can tell your audience how you want them to feel and what you want them to pay attention to. For instance, a cool color scheme of blues and violets may indicate a relaxed or somber mood.

HOW DO YOU USE THEM?

Using our knowledge of the color wheel and the different types of hues, we can begin to understand how different combinations of color work together to form harmonious schemes. When different sets of colors are combined in a single composition, we can begin to tell more complex visual narratives. The visual on the right identifies some of the most common types of color schemes.

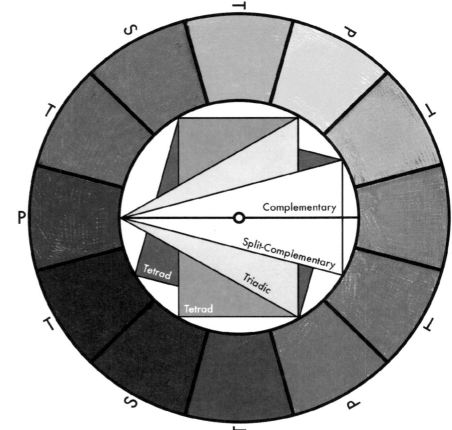

Complementary

Split-Complementary

Triadic

Tetrad

Tetrad

Schemes & Themes

Let's define the most common color schemes:

ONE-COLOR

A **MONOCHROMATIC** color scheme uses only one color, along with the tints, tones, and shades of that color.

TWO-COLOR

A **COMPLEMENTARY** color scheme uses two colors that are directly opposite each other on the color wheel, such as blue and orange.

A **DYADIC** color scheme uses two colors separated by only one or two colors on the color wheel, such as green and yellow.

THREE-COLOR

An **ANALOGOUS** color scheme uses at least three colors that touch on the color wheel, such as yellow, yellow-orange, and orange.

A **SPLIT-COMPLEMENTARY** color scheme uses two dyadic colors with the complement of the color between them, such as yellow, orange, and blue-violet.

A **TRIADIC** color scheme uses three equally spaced colors on the color wheel, such as the primary colors yellow, red, and blue.

FOUR-COLOR

A **TETRAD** color scheme uses four colors that can be connected by a square or rectangle on the color wheel, such as red, green, yellow, and violet.

Monochromatic

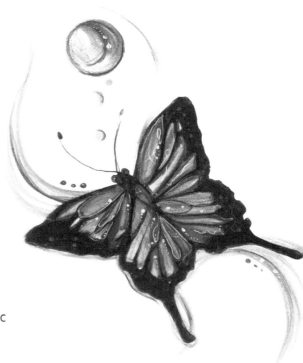

A **MONOCHROMATIC** scheme uses only one color and includes tints and shades of that color. This is one of the most straightforward color schemes, making it a great place to start.

To find all of the possible colors that can be used in a monochromatic scheme, it can be helpful to create a tint, tone, and shade scale to identify the range of possibilities within this color scheme, like the one that we have done below:

PURE COLOR		50% - 50%		BLACK
PURE COLOR		50% - 50%		GRAY
PURE COLOR		50% - 50%		WHITE

Create a value scale in the space below using your monochromatic color scheme. Then, choose an ordinary object and try rendering with just one color and all of that color's tints, tones, and shades.

Dyadic & Analogous

Dyadic and analogous color schemes use colors in close proximity on the color wheel to create color compositions that easily harmonize with one another.

A **DYADIC** color scheme is a simple scheme that uses two colors on the color wheel that are only separated by one color.

This type of scheme is an effective, easy way to use multiple colors that will easily harmonize with one another.

CREATE A SKETCH USING A DYADIC COLOR SCHEME:

An **ANALOGOUS** color scheme uses three or more colors directly next to each other on the color wheel, such as yellow, yellow-orange, and orange.

CREATE A SKETCH USING AN ANALOGOUS COLOR SCHEME:

Two of the most common types of analogous color schemes are warm and cool color schemes. Warm color schemes use red, yellow, and orange and often convey the feeling of a hot day, fire, or high energy. Cool color schemes use blue, violet, and green and often convey the feel of ice, a cool breeze, or a relaxed atmosphere.

Complementary

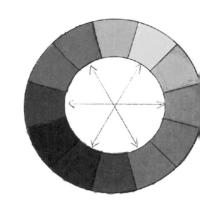

COMPLEMENTARY colors are located directly across from each other on the color wheel. The most common complementary color schemes are blue and orange, red and green, and yellow and violet. When these colors are used directly next to each other, the look of each hue is intensified. These color schemes are commonly used in movies or posters to increase visual interest. Here are a few handy uses for a complementary scheme:

Create dynamic creatures with features that pop.

Emphasize the dual nature of two subjects.

Contrast subjects with their environment.

PICK TWO COMPLEMENTARY COLORS TO SKETCH YOUR OWN COLORFUL MASTERPIECE BELOW:

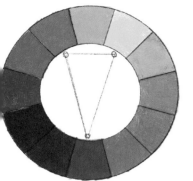

Split-Complementary

SPLIT-COMPLIMENTARY color schemes use three colors to create a similar but slightly more dynamic color system. This color scheme is created by choosing two dyadic colors and the complement of the color between those two dyadic colors.

For example, you could choose yellow and green as your dyadic colors. As the color between those two is yellow-green, the corresponding complement color would be red-violet. So, for this color scheme, our colors are green, yellow, and red-violet. These colors do not need to be used in equal amounts. Often, choosing one color to act as your focal color and using the other two colors to inform that color can create a pleasing final result.

PICK THREE COLORS IN A SPLIT-COMPLEMENTARY SCHEME FOR A SKETCH BELOW:

Triadic & Tetradic

Triadic and tetradic color schemes are the last two schemes we will cover, but there is an entire world of color schemes waiting to be researched, explored, and utilized in your own art!

TRIADIC schemes use three evenly spaced colors on the color wheel. The most common triadic color scheme uses the primary colors: blue, yellow, and red. This type of scheme is very loud making it not ideal for more subtle works, creating a contemporary, bold, or modern feel in your artwork.

TEST YOUR OWN TRIADIC SCHEME BELOW:

TETRADIC color schemes use two sets of complementary colors on the color wheel, such as yellow, violet, red, and green. A tetrad, meaning a group of four, can be found by making a square or rectangle to connect colors on the color wheel. With so many colors playing off one another, this type of scheme is a favorite amongst graphic novelists and concept artists due to the resulting heightened visual interest and contrast. Often in a tetradic color scheme, one set of complementary colors dominates while the other set plays a supporting role.

TRY OUT A TETRADIC COLOR SCHEME IN SOME THUMBNAILS BELOW:

Test the Schemes

Now that you know each of the schemes, let's try and apply each one. We've provided a sketch along with a scheme and suggested color palette. Test your schematic shading skills on the sketches below:

ACHROMATIC
No hue, only value.

MONOCHROMATIC
One color and its values.

DYADIC
Two harmonious colors.

ANALOGOUS
Three touching colors.

COMPLEMENTARY
Two opposite colors.

SPLIT-COMPLEMENTARY
A dyadic and their complement.

TRIADIC
Three equidistant colors.

TETRADIC
Two complementary color sets.

POLYCHROMATIC
All primary and secondary colors.

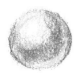

Colorful Characters

Individuals and cultures have their own ideas of what certain colors or schemes may represent. Let's explore these ingrained interpretations by making some colorful characters!

Colors

Read this list of colors and then think of a character trait that might fit each color. Is blue bashful? Is yellow energetic? Write or draw your interpretations next to each.

YELLOW –

YELLOW-ORANGE –

ORANGE –

RED-ORANGE –

RED –

RED-VIOLET –

VIOLET –

BLUE-VIOLET –

BLUE –

BLUE-GREEN –

GREEN –

YELLOW-GREEN –

Color Schemes

Now look at the list of color schemes. What kind of character do you imagine would be monochromatic? How do they differ in emotion or attributes from a character with a complementary scheme? Write or draw out your interpretations.

MONOCHROME –

ANALOGOUS –

DYADIC –

COMPLEMENTARY –

SPLIT-COMPL. –

TRIADIC –

TETRADIC –

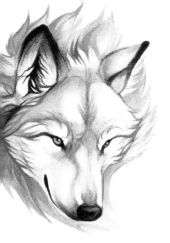

RENDER A FEW OF YOUR CHARACTERS IN THE SPACE BELOW:

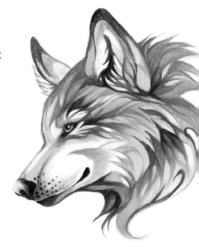

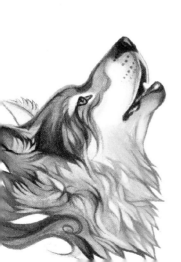

Keep these common character types in mind: protagonist, antagonist, sidekick, wise elder, child, trickster, leader.

Color Theory from Life

Modeling images from life is a great way to build fundamental skills and to learn how objects, people, and animals exist in space. Begin by observing the objects around you. Even a simple piece of fruit or a toy model can be used to understand basic forms and colors. Let's try an example together, step-by-step.

We've provided a sketch of an apple in the space below. Develop the subject by using what you've learned about layering and color theory to build up rich, dynamic hues.

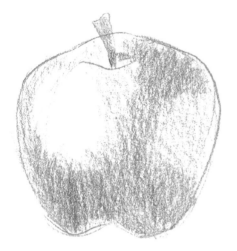 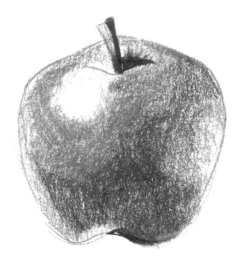 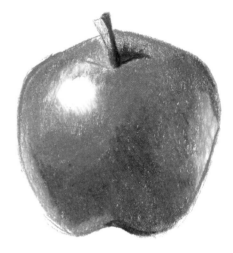

We're using a crimson red for our base tone. Leave the highlight spots white.

For lighter colors, we used bright orange. For shadows, we used a dark violet.

Using white and a blender, we burnished the colors together in the final layer.

TEST YOUR SKILLS BY FINISHING THE SKETCH IN THE SPACE BELOW:

Imagine a Dragon

While modeling from life is crucial to strengthen core technical abilities, drawing from imagination helps free your mind and foster stress-free sketching habits. Just remember that even if you're sketching a fantastical object, you can still base it on reality! For instance, if you're drawing a dragon egg, use an egg from the grocery store to draw from life. The drawing of the dragon's wing below mimics a bat's wing. Use what we've learned from color theory to expand and enhance reality.

TRY SAMPLING REAL-WORLD COLORS TO FINISH DRAWING THE DRAGON BELOW:

Color Theory Plan

When creating a colored image, planning your design around a color scheme can be incredibly helpful. This can create artwork that looks cohesive, well-researched, and informed. When colors are working harmoniously with one another, the viewer notices!

SELECT THE COLOR SCHEME. As we've covered, there are many different color schemes that your artwork can utilize, each with its own characteristics. Will you be making a piece with a complementary or analogous approach? This doesn't have to be a strict rule, as you can use additional colors for accents or even have multiple color schemes in one work of art. Still, it is helpful as a guide in blocking out the major hues.

BUILD YOUR COLOR PALETTE. Once your scheme has been chosen, make swatches to test out a few different colors to expand your scheme. Create a quick value scale with each, test layering each pigment over one another, and stay flexible enough to swap out colors that seem ineffective.

TEST YOUR SCHEME. Make a thumbnail drawing to work out your hues' placement, dominance, and values. Which color or colors do you believe will play the most prominent role? Which do you imagine will be the most minor? Rarely will your first attempt with a new scheme be your best, so take the time to test during this preliminary stage.

By selecting a scheme, building a palette, and creating color tests, you should have a solid foundation for your final artwork. Applying your new knowledge of color theory can take a lot of practice, so repeat these steps with each new piece to become a confident color master!

SPLIT-COMPLEMENTARY SCHEME

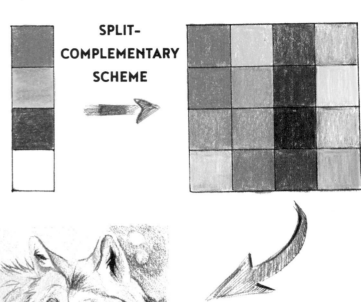

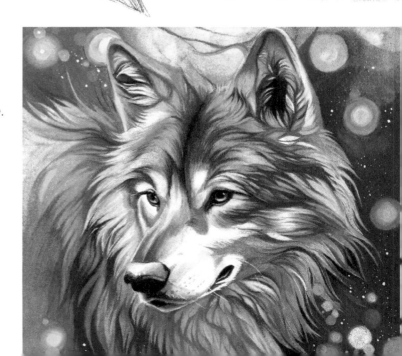

Color Planning Page

Let's go step-by-step through the process of using your newfound knowledge of color theory.

IDENTIFY YOUR SCHEME. Make a swatch in the grid to the side to isolate what colors you would use in each color scheme for your artwork. Monochrome would only be one color in many shades, while tetradic would be four unique colors.

MONOCHROME

ANALOGOUS

DYADIC

COMPLEMENTARY

SPLIT-COMPL.

TRIADIC

TETRADIC

BUILD YOUR PALETTE. Use this space to test a few color combinations you imagine using in your drawing.

TEST YOUR SCHEME. Create a thumbnail in the space below and test out how your color scheme might be implemented in your piece. We recommend making more than one before moving on to the real thing.

Consider using the "60-30-10 rule," in which one color takes up approximately 60% of your piece, another color takes up approximately 30%, and an accent color takes up approximately 10%. This can create balance.

Colored Pencil Process

STEP #1 – Start by lightly sketching your subject. You can use a graphite pencil, or you can even use a light-colored pencil. Keep your sketch very light so you can work over it with colored pencil.

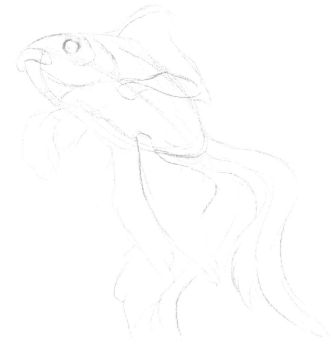

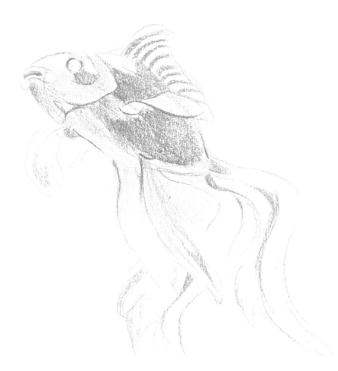

STEP #2 – Lightly apply a base of tone to your subject, focusing on broad shapes rather than tight details. Identify your light source so you can keep highlights light, and carefully lay down pigment in areas of shadow. In later stages, shadows, highlights, and reflective light will make the object's tone more complex.

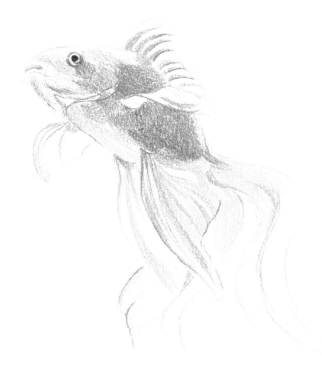

STEP #3 – Continue to build up layers of pencil to create a more richly pigmented drawing. You can use layering techniques such as scumbling to add additional areas of color on top of one another.

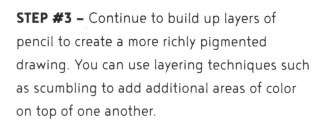

STEP #4 – At this stage, refine areas of shadow and light. For darker areas, choose a darker color, such as purple or blue, to create the illusion of shadow. Use the layering techniques learned earlier but resist applying full pressure to any area until you are happy with the overall look and color.

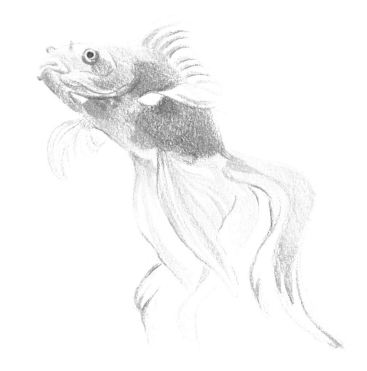

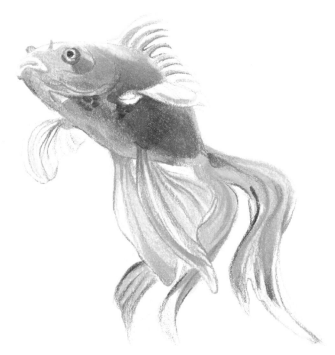

STEP #5 – After adding multiple layers and capturing the essence of your subject, begin the burnishing process. If using oil-based pencils, it is best to use a solvent for burnishing, while a colorless blender should be used for burnishing wax-based pencils.

STEP #6 – Lastly, take a very sharp pencil and add any final details. It can be difficult to add pigment over a burnished area. Still, details such as whiskers, cracks, or fine lines are best if added last so they aren't muddied from the burnishing process.

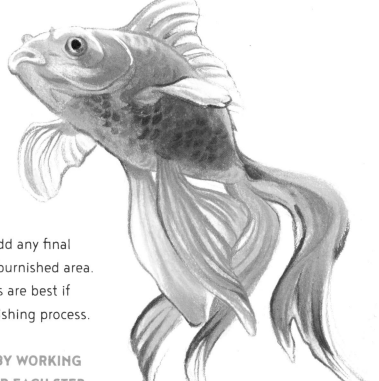

FOLLOW ALONG IN YOUR SKETCHBOOK OR BY WORKING OVER TOP OF THE SKETCHES WE'VE MADE FOR EACH STEP.

FINDING INSPIRATION

In this Chapter:

"Creativity is a rhizomatic process, meaning that it grows and spreads unpredictably in all directions. Try to stay open and excited by every avenue of creative expression."

Identifying Obstacles
–
Encouraging Inspiration
–
Mixing Mediums
–
Interesting Ideas
–
Typography and Filigree
–
Sharing Your Art

Materials Required:

Everything Used So Far
Keep your graphite pencils, pens, and colored pencils beside you.

Your Ideas and Imagination
Prepare to expand your creative potential.

Scissors, Glue, and Other Supplies
We might get a little crafty in this chapter.

Sketchbook
As always, have your sketchbook ready for when inspiration strikes.

Creative Block

Even seasoned artists occasionally get into a rut. Suppose you find yourself devoid of new images to create, stories to tell, or concepts to explore. There are so many ways that this feeling can occur. Sometimes it will creep up on you, gradually feeling like you have less and less inspiration, while other times, you'll be at the height of your creative potential only to find that you wake up and can't tap back into that mindset. If this is the case, it may be a good idea to mix things up and spark some creative inspiration.

COMMON EXAMPLES OF CREATIVE BLOCK:

FEAR can take many forms, whether fear of wasting materials, rejection, or failure. Each of these can affect different people in different ways, but they can each be overcome with the appropriate change in mindset. If you're afraid of wasting time, materials, or money, remember that your art is important, and you are the only one who can create it. Consider whether there are cheaper ways to make the piece you want or calculate the potential payoff if you take the leap and make what you imagine. If you're afraid of rejection, remember that if your work is important to you, it would also be important to others with a similar mindset. You'll only know how much your work could mean to someone else once you make it and show it off. For fear of failure, remember that you are your only limitation. On the risk scale, most art is very low risk and has a very high payoff. If you accidentally mess up a piece of paper, the world will not stop turning; however, if you make the right marks, your work can truly change the world.

HESITATION can be insanely detrimental to one's creative process. We've discussed a few strategies to overcome "blank page syndrome" at the beginning of the book, but the main takeaway is not to let perfection be the enemy of the good. Don't over-analyze your creation before you've even started; instead, allow yourself to dive right in. Identify any obstacles and do whatever you can to start creating.

REPETITION can be a difficult form of creative block, often because you might not feel like you're being blocked at all. Maybe you've made a piece that was received especially well by critics or your peers, or maybe you made a piece that you really enjoyed creating, so you start to make similar work. Over and over, you explore the same subject, concept, or theme, eventually to where it seems you can't imagine making anything else. Believe it or not, this can be a form of creative block. You've formed tunnel vision and are unable to make anything outside your comfort zone. In times like this, it can be enormously refreshing for you and your audience to try expanding your creative field of view.

OVERLOAD is another unexpected form of creative block. Sometimes artists can feel a million different ideas pulling them in a million different directions. While having many concepts can be a good thing, occasionally, this overload can cause paralysis as you struggle to identify which piece should take top priority. Keeping a sketchbook is one of the best ways to avoid this feeling of overload. If you think of an exciting idea, jot it down. If you imagine an innovative image, do a few quick thumbnails. Your sketchbook can be the net where all ideas can be caught while fresh. Then, when you have time to work on a larger piece, you can pull out your sketchbook, flip through it, and see what provides the most significant impact.

Identify Obstacles

Battling your creative block starts by identifying what types of causes are most common for you and your work. Once you determine what causes your creative block, you can develop strategies and techniques to move past it in <u>hours</u> rather than days or <u>weeks</u>! Start by identifying three distinct times in recent memory that you have personally experienced creative block. Then try to identify the creative block's underlying cause in each situation. For example, were you afraid of failure? Did you not know how to get started? Were you distracted by housework? If you can pinpoint the causes, you can begin to develop solutions! Use the space below to work it out:

Instance	Causes
	O **FEAR** – rejection, failure, etc. O **HESITATION** – blank page syndrome O **REPETITION** – playing it safe O **OVERLOAD** – too many ideas O **OTHER** – explain below: _____ _____ _____
	O **FEAR** – rejection, failure, etc. O **HESITATION** – blank page syndrome O **REPETITION** – playing it safe O **OVERLOAD** – too many ideas O **OTHER** – explain below: _____ _____ _____
	O **FEAR** – rejection, failure, etc. O **HESITATION** – blank page syndrome O **REPETITION** – playing it safe O **OVERLOAD** – too many ideas O **OTHER** – explain below: _____ _____ _____

THIS CHAPTER WILL DISCUSS SOME OF OUR FAVORITE WAYS TO PUSH PAST CREATIVE BLOCK AND MOVE ON TO MAKING!

So Many Mediums

By breaking out of your comfort zone and getting experimental, you might discover your new favorite process or a new way to communicate with your audience. We recommend paying attention to what excites you most about art making. For example: if you love color, you can delve deeper into color theory and mixing. Expanding your knowledge of the processes you love will make your art stronger and more engaging!

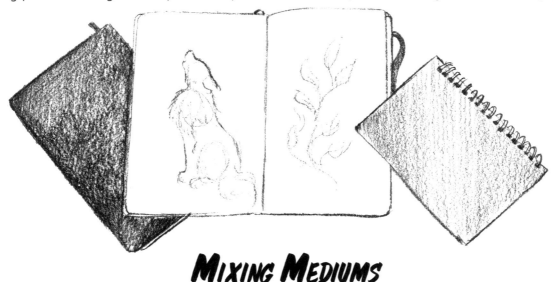

Mixing Mediums

While some purists still insist on making work exclusively with one medium, mixing and matching materials within a work can allow you to arrive at surprising innovations through unconventional combinations

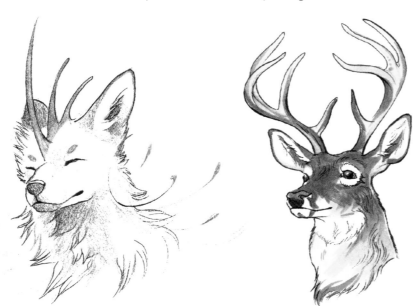

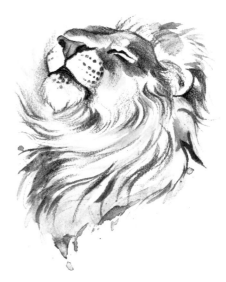

Graphite can gain tons of drama by adding metallic pigments or gold leaf over top for a traditional yet bold look.

Fineliner pens can be combined with marker to create bold, graphic illustrations like those commonly found in comic books.

Colored pencils can add moments of sharp detail when used over top loose watercolor to create mesmerizing images.

Advanced Mediums

The materials in this book were strategically chosen as ideal starting points for your development. If you wish to continue your growth, here are a few processes that we recommend giving a shot.

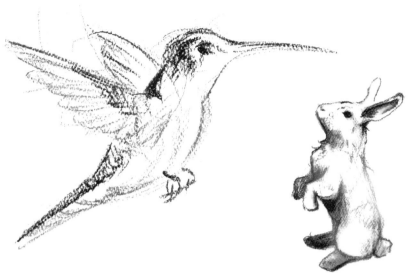

If you enjoyed exploring graphite's tonality and gestural qualities, you might enjoy working with **CONTÉ**. Conté are bars of graphite or charcoal compressed with clay for stability. This material can help you explore a broader range of colors and values, such as reds, browns, and grays. While the process will use many of the same techniques we explored in the graphite section, conté will be a looser process resulting in a more raw, visceral, and tonal finished result.

If the permanence of pen was particularly provocative, you might enjoy pursuing ink with a quill or **DIP PEN**. Using these more traditional ink applicators, you must constantly refill your pen from a reservoir that allows you to consider diluting your ink for beautiful washes. Additionally, these mediums allow the line width to be controlled by a user's pressure and direction in a way that other pen types cannot replicate.

If colored pencils have intrigued you, **MARKERS** might be your next medium of choice. Available in an enormous range of types, colors, and styles, markers are a world of their own. They can be used for everything from graphic emphasis to fully hyper-realistic creations. Just like with colored pencils, you can mix and layer colors for beautifully dynamic results or combine markers with many other mediums very easily

Mix Mediums

Using colored pencils and gel pens, you can add detail, definition, and vibrant color to watercolor or marker designs. Let's practice this technique by refining this watercolor wolf!

FIRST, follow our formula to create a quick sketch of your subject.

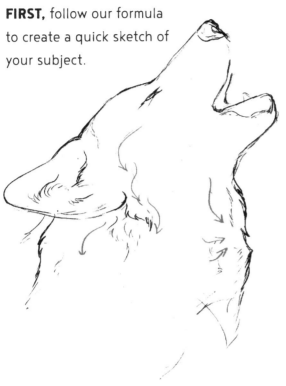

NEXT, add volume, value, and color with a watercolor base.

THEN, use colored pencils to add tufts of fur that cascade along the volume of your form.

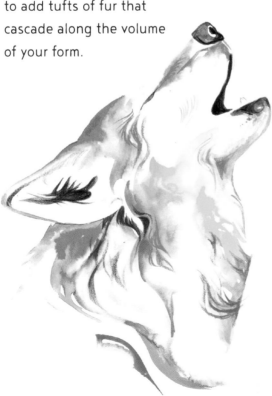

FINALLY, use fineliner and gel pen to add crisp outlines and highlights.

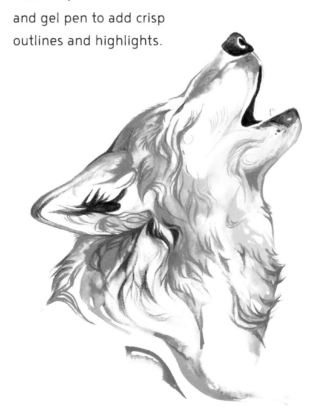

Bring this wolf to life and add
definition using colored pencils,
gel pens, or any medium.

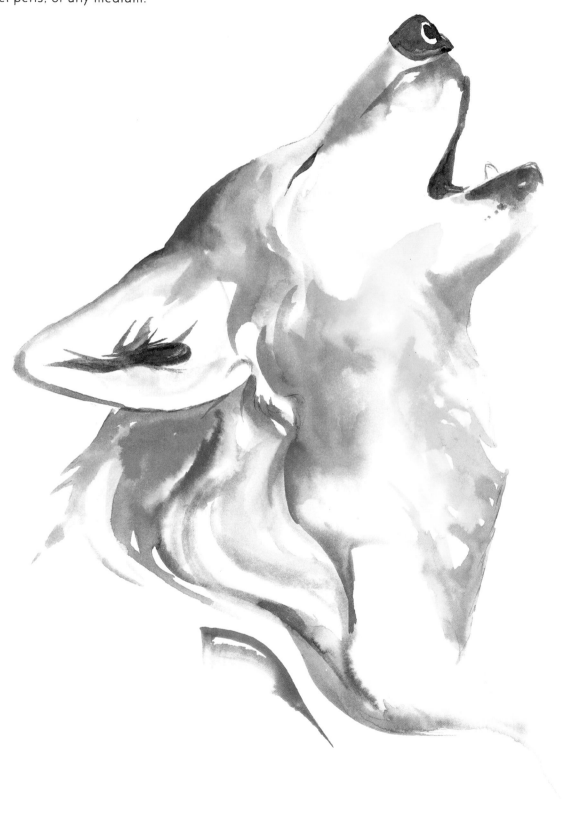

Work with Mistakes!

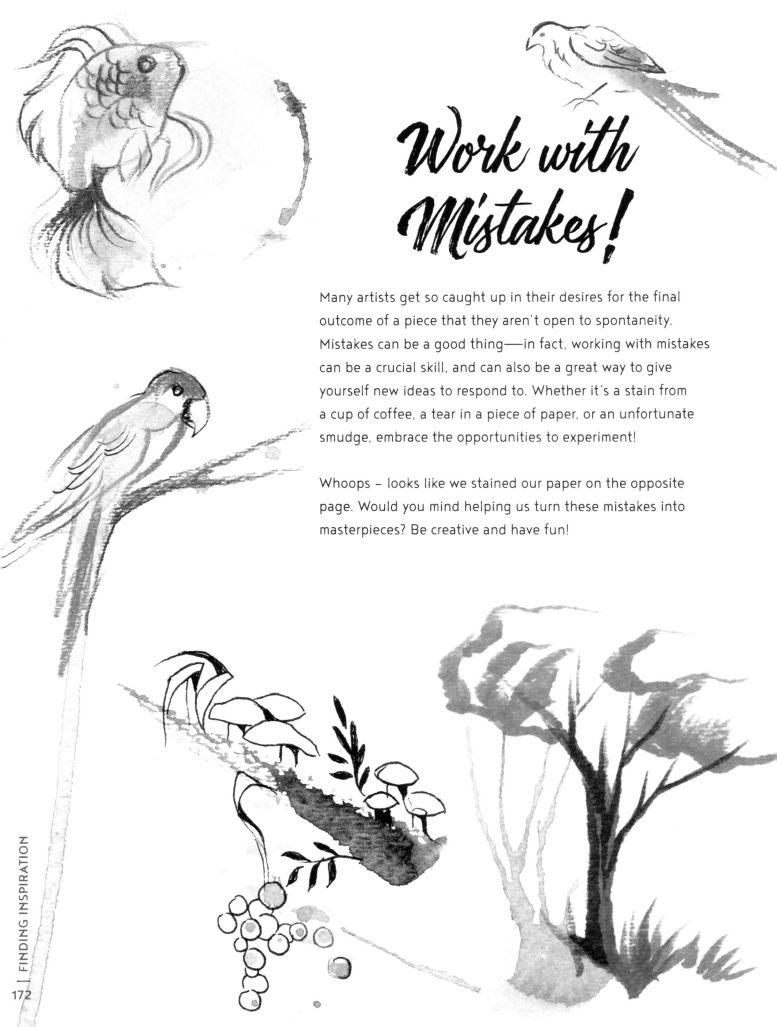

Many artists get so caught up in their desires for the final outcome of a piece that they aren't open to spontaneity. Mistakes can be a good thing—in fact, working with mistakes can be a crucial skill, and can also be a great way to give yourself new ideas to respond to. Whether it's a stain from a cup of coffee, a tear in a piece of paper, or an unfortunate smudge, embrace the opportunities to experiment!

Whoops – looks like we stained our paper on the opposite page. Would you mind helping us turn these mistakes into masterpieces? Be creative and have fun!

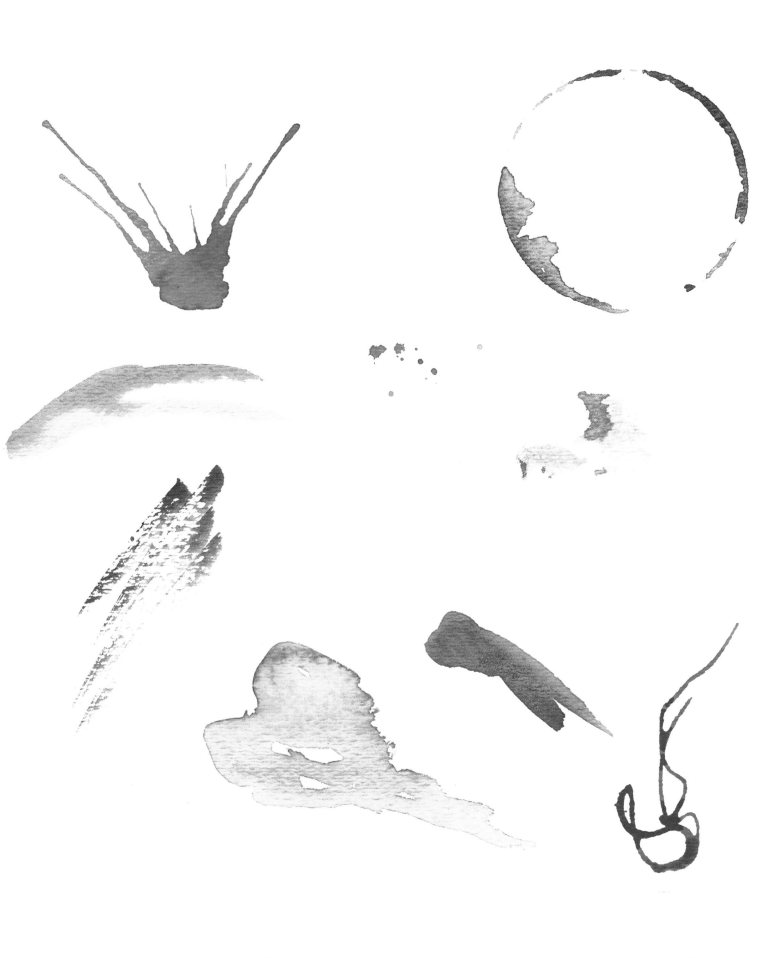

Kintsugi is the Japanese process of responding to cracked pottery with a glaze of precious metals, treating cracks as assets of the piece rather than as accidents. You see, mistakes really can be as good as gold!

173

Embrace the Absurd

Living logically can sometimes be such a bore! The art movement of Surrealism embraces dreamlike constructions where logic isn't the priority. Some of the absurd games and activities that came out of this movement can really help to unlock your creativity.

Automatism

Automatism means spilling out whatever is on your mind without allowing your brain to filter it. You can try automatic writing, automatic speaking, or our favorite, automatic drawing! How do you do it? Just grab a drawing utensil and let yourself go! Combine materials, get weird, and try new things!

Radical Randomness

Flip through a magazine, put your finger down on a page, and draw what you're touching. Play with a friend and trade prompts, try using a random prompt generator, or have someone give you both prompts so you can compete.

Make a Manifesto

A manifesto is a rule book that verbalizes your priorities, restrictions, and core principles. It can be quite a lot of fun to make a rule book and then only create work that strictly abides by these rules. For example, a rule could be to always start in the center of your paper and work outward. A rule could be that your work needs to be decoded to be understood! Whatever you choose to do, you should also decide whether your rules are public or private: Are these internal restrictions or something you want to let others in on?

Exquisite Corpse

Exquisite Corpse is an excellent game to collaborate with others, and it is not nearly as grotesque as it sounds. In fact, we played one of these games on our very first date! The game is about collaborative exploration and seeing what you can create when unaware of the context.

Grab a piece of paper and fold it into an accordion. One person draws anything they want to on the first flap. We tend to draw a head first, but you can do almost anything. The first person then folds the flap over and slightly extends the lines so their partner can continue the form without knowing what was drawn on the first flap. The second person may draw whatever they want on the second flap, slightly extending their lines onto the third flap. They can create shoulders, arms, or whatever they wish so long as it connects to the first person's extended lines and so long as they don't peek at what was on the first flap. Repeat the process until the last section of the accordion is complete. When all the folds have been finished, unfold the paper to reveal the beast you have collaboratively constructed!

Exquisite Corpse can be played with as many people as you want, taking on many different forms! Try the game with two people first, and then see what results you get by adding more and more contributors or by adding more and more accordion folds!

Creative Collaboration

Do the activities on this spread with another person, whether a family member, friend, or fellow artist. These will challenge your imagination while allowing you both to respond to the unexpected nature of collaborative creation. Don't worry - there's no right or wrong way to go about this and it's not a contest.

COLLABORATOR #1

COLLABORATOR #2

In the space below, use about one minute to have each person start a drawing. Feel free to leave it open-ended and expressive. Then, switch drawings and spend a few minutes refining the sketch that the other had started. Turn their squiggles into snakes, their shapes into ships, or their words into poetry. After about five minutes of development, give the drawing back to the original creator for them to add final refinements.

NEED INSPIRATION?

- Have each person draw the head of a character and the other person draw the rest of the body.
- Draw a few shapes and then trade off adding new additions to create a cityscape or forest.
- Make a collaborative creature. Have one person start with an eye, then trade off making each feature.

Collaborative Comic

Now collaborate to create a narrative. In the boxes below, have one person start the first frame of a comic strip, then trade off making each frame after that. If you'd like, you can include text bubbles or leave it purely visual, make it humorous or deathly serious. You never know where collaboration might lead!

COMIC #1 – **STARTED BY** _____ – **FINISHED BY** _____

COMIC #2 – **STARTED BY** _____ – **FINISHED BY** _____

Prompts & Limitations

You would think that having zero limitations would be the most exciting thing for a creative mind, but many artists find that nothing good comes when anything is possible. Creativity is one's ability to think in alternative ways, adapt to situations, and fill voids with magic moments. Limitations have a way of encouraging this creative thinking in ways you might never have imagined!

To be open and excited by these simple sparks is vital, as it can help simulate the demands of working for clients. Consider making a custom deck of inspiration cards or a set of dice with corresponding limitations to help shuffle up your concepts and reveal unexpected combinations.

TRY MAKING A FEW SKETCHES BELOW WITH THE PROMPTS THAT WE'VE PROVIDED:

Make a composition that relies on a round frame.

Combine two or more mediums in a tiny drawing.

Spill some tea and incorporate the stain into a sketch.

Make a white gel pen illustration.

Flex Your Flexibility

PICK ONE OR MORE OF THESE PROMPTS TO INFLUENCE YOUR NEXT PIECE:

- Bear
- Deer
- Bunny
- Fox
- Taco
- Tornado
- Sugar
- Truck
- Rocket
- Plane
- Skull
- Magician
- Astronaut
- Robot

- Eye
- Mouth
- Hand
- Octopus
- Tree
- Space / Galaxy
- Ghost
- Shadow
- Gemstone
- Enchanted
- Cottage
- Serpent
- Butterfly
- Hoard

- Phoenix
- Seaweed
- Garden
- Mushroom
- Hybrid
- Lightning
- Ancient
- Camouflaged
- Antlers
- Insect
- Fire
- Opalescent
- Golden
- Double / Duo

- Symmetry
- Poisoned
- Skeleton
- Feathered
- Alien
- Mechanical
- Death
- Life
- Smoke
- Glass
- Iron
- Lunar
- Jungle
- Pastel

NEED INSPIRATION? CHOOSE ONE OF THE LIMITATIONS BELOW AND STICK TO IT FOR A SHORT PERIOD OF TIME.

- Only make work using prompts or ideas as provided to you by someone else.
- Every subject you make has to incorporate a triangle, lightning bolt, or hexagon.
- Use your non-dominant hand for the first ten minutes of every piece you make.
- Every piece you make has to have been partially started by another person.
- Only make work on top of paint samples from a hardware store.
- Every piece you make has to visually incorporate the color neon pink.
- Make a piece with the goal to change you viewer's sense of time.
- Make a drawing on top of a photograph.
- Make a piece that incorporates two truths about yourself along with one lie.

- Make as rendered of a drawing as possible without lifting your pencil off the page.
- Make something from an animal's point of view.
- Make something from your shoe's point of view.
- Only make art of subjects that scare people.
- Only make art based on items you find in trash, recycle, or donation bins.
- Only make art based on groan-worthy jokes.
- Only make artwork of translucent objects.
- Only create art of completely impossible things.
- Only make art on things you can find from a thrift store as your canvas.
- Only make art using supplies from a grocery store.
- Only make art on blank t-shirts.
- Make art that convinces your viewer to photograph it, perfecting until everyone does.
- Draw or paint art without moving your arm.

There's truly an unlimited number of limitations that you can try, and each one can expand your creativity!

Encouraging Inspiration

EXPERIMENT WITH A NEW MATERIAL – Test out something completely new, even if it doesn't relate to your typical way of creating! Try embroidery, origami, or anything else that intrigues you.

FOCUS ON OPPOSITES – Whatever your subject or concept is, brainstorm as many opposites of it as possible. Knowing the counterforce to your subject is good, as you can use this to create tension in your work. This also helps you better understand what is true about your subject by focusing on what isn't.

HOST A GET-TOGETHER FOR FELLOW CREATORS – Surround yourself with people who work in other fields for an evening of fun. This can power up your passion and be a great way to share skills and experiences!

TURN TO YOUR FORMER SELF FOR INSPIRATION – Select an old drawing or sketch – maybe one that you are particularly proud of or even one that you can't stand. Then, try redrawing it with a fresh new twist. This may help you notice stylistic changes in your work and find the motivation to create a new piece. One great thing about keeping a sketchbook is that you are preparing yourself to battle creative block by consistently logging new ideas.

RESEARCH ART MOVEMENTS – Over the years, there have been so many art movements from different periods, cultures, and creators. Your work can be vastly improved by understanding the problems these artists were trying to solve along with the solutions they arose to. You're likely familiar with the Renaissance, but what about Cubism, Bauhaus, or the Fluxus movements?

TAKE IN THE WORLD AROUND YOU – Here are a few places you can turn to for inspiration:

> **WATCH / LISTEN –** Listen to podcasts, audiobooks, TED Talks®, or comedians. Take a day to tune in to new music, films, or photographers. Hearing or watching something new can be very inspiring.

> **FRIENDS AND FAMILY –** The stories and experiences of those close to us can be excellent sources for new narratives. Keep an open mind, and actively invite discussion and dialogue with others who may have different views.

> **ADVENTURE –** Whether traveling somewhere on the other side of the globe or taking a hike through your neighborhood, you never know what you'll find on an exciting outing!

> **OTHER ARTISTS –** There are so many artists, writers, and researchers working today and in the past, so there is no excuse not to see, read, or learn something new! Check out art magazines, blogs, or videos. See if there are exhibitions happening around you, and then go check them out!

Combat Your Block!

Ways to Find Inspiration:

- Sleep
- Run
- Read
- Sing
- Cook
- Collaborate
- Travel

- Sculpt
- Map
- Tinker
- Code
- Knit
- Build
- Guide

- Climb
- Paint
- Clean
- Curate
- Collect
- Hike
- Swim

- Doodle
- Decorate
- Debate
- Shower
- Learn
- Dig
- Bury

- _____
- _____
- _____
- _____
- _____
- _____
- _____

Mood Board

A "mood board" is a great way to gather and reference the images you enjoy. Dig out old sketches, collect old catalogs, or snag paint swatches from your local hardware store. Curate imagery and tones that may inspire your next series! This can help refine your palette and create rules or constraints for your work to adhere to. Try this: Take a magazine you don't care about, comb through, and remove any images that inspire you, whether subjects, environments, or textures. Put these together into a mood board and use it as a guide for what you create today.

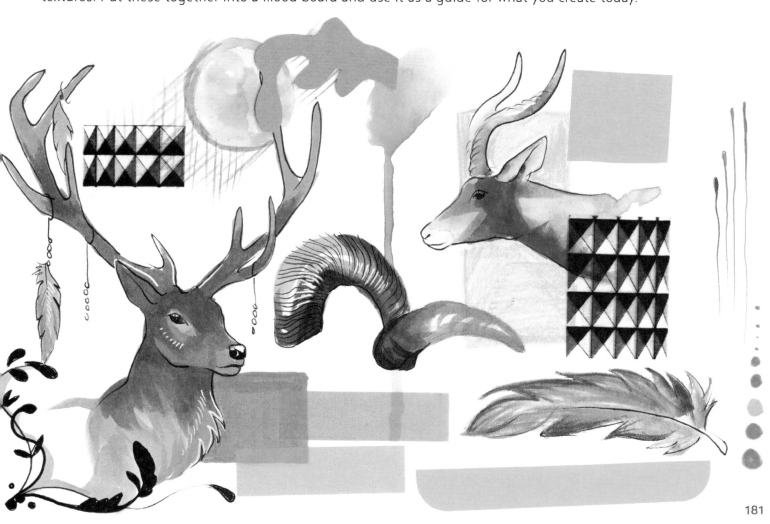

Interesting Ideas

Over the years, we've found quite a few simple experiments that can result in easier and more exciting connections with your audience. While you can create incredible work without using these "cheat codes," assembling a list of interesting ideas or techniques can easily push a piece to the next level.

TRY A TRIPTYCH

Polyptychs are works that use multiple panels to display visually or thematically connected subjects, the most common of which are diptychs (two panels) or triptychs (three panels).

BREAK THE BORDER

As most compositions are rectangular, it can be a fun trick to imply a standard border and then selectively have a subject break out of this box, resulting in an almost 3D effect.

GORGEOUS GILDING

Use gold leaf or try metallic pigments in a wide range of colors and finishes. Even multicolored, holographic, and iridescent pigments are possible for your work.

ATTEMPT ANAMORPHOSIS

This technique, which dates back to the Renaissance, purposefully distorts images so that they must be viewed from a particular angle or with a specific tool to properly register the subject. It can use a lens, a mirror, or a particular vantage point to create an optical illusion.

USE UV

Try utilizing special pigments to make some elements of your work visible under normal lighting conditions and others that are only visible with an accessory, such as a UV light, 3D glasses, or other tools.

FIND YOUR RESOLUTION

Not all images are best at full resolution. Some can be better conveyed with minimal information or details limited to the most critical areas. Try your hand at photorealism. Then give abstraction a go. You only know what you'll love once you try it.

FINDING INSPIRATION

182

TIME IS RELATIVE

Be bold and play with time in your work. For example, you can freeze a moment and overlay another pose from a different point in time. Sometimes the best stories jump from point to point, allowing them to form connections that would otherwise be lost in a strictly chronological interpretation.

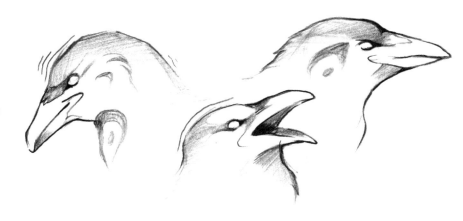

BE MISCHIEVOUS

While most viewers will view your piece only briefly, you will likely spend significantly more time and energy focusing on the content, layout, and concept. This can be grounds for quite a bit of mischief. You can view your work like a puzzle, adding subtle clues around a piece that might hint at a pun or a hidden meaning. Art can and should be fun, so we encourage you to explore every avenue you can to keep it that way!

MAKE IT 3D

Translating a two-dimensional piece into a sculptural form can be fascinating for you and your audience. We suggest you first make a "maquette" out of wire, clay, or paper to model your ideas in three dimensions. These preliminary creations can be a fantastic way to work out problems or approximate aesthetics before diving into an entire piece.

Gallery Goals

While many artists focus on making visually appealing or commercially marketable work, another faction of the art world focuses on carefully curated exhibitions. If this is your goal, here are a few suggestions:

MAKE IT SITE-SPECIFIC

Site-specific work relates or responds to a unique location, usually relying on a specific material, subject, or size integral to the space. For example, try creating a series of drawings of a gallery's restroom signs. How does the piece change once shown within the same room as the original?

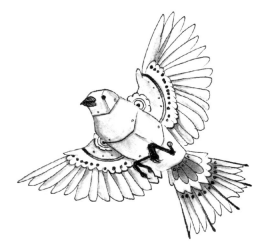

TINKER WITH TECHNOLOGY

Break out a projector, mess around with motors, sync up some speakers, and test the limits of what you can create by incorporating tech into your work. This can be a way to make your work move on its own, react to certain variables, or work towards a goal. There is so much potential.

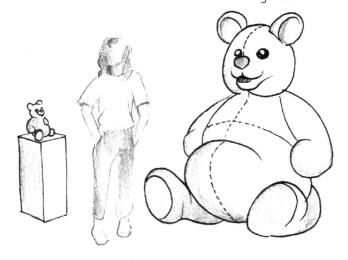

SHIFT THE SCALE

During a critique, it's common to hear the demand to "make it bigger" or even to "make it microscopic." When your work occupies a surprising scale, it demands that your audience react a certain way. This implied order to retreat or approach can be potently powerful.

MAKE IT INTERACTIVE OR PERFORMATIVE

Artwork can have a physical or even human presence. Interactive work calls upon the viewer to participate, blurring the line between artist and viewer. Performative work can be more theatrical or confrontational as viewers witness the action as artwork.

BE INTERDISCIPLINARY

We've often found that boring artists look at other <u>artists</u> while exciting artists look at other <u>disciplines</u>. We encourage you to reach out to researchers, mingle with musicians, and network with neurosurgeons. Cross-pollination will not only help you make better art, but it should also help your new collaborators to expand their own viewpoints. After all, creativity is a two-way street!

KNOW WHEN TO DELEGATE.

Delegation is the act of assigning tasks to others. It's important to remember that you don't have to personally know how to do everything to make art. Instead, draw on the expertise of others. For instance, if you want to make a bronze statue, consider asking someone specializing in that craft to help. There's no reason to put yourself in harm's way by hastily attempting something that takes years of practice.

FOCUS ON CONCEPT MORE THAN MASS APPEAL

Some artists believe that the intention of a piece can mean far more and have a grander effect than mere aesthetics ever could. This philosophical approach to artmaking is usually respected in fine art galleries as it's seen to be more intellectual. You can try by focusing on how you can share an idea with a viewer without a sellable item being the goal. Who knows – that balloon filled with car exhaust might be your best piece ever.

BE SURPRISING

The common thread between all these suggestions is to play with the expectations of your audience. The art that sticks in your mind the longest tends to be the most surprising in one way or another. Like a song that changes tempo halfway through, your work can make someone stop in their tracks if you can play with the expectations of your audience. Strip back what is formal, prop up what is informal, make us second-guess our senses, and push yourself.

Where to Sketch

You can (and should) sketch just about anywhere, so long as you are observant and considerate! Packing a small sketchbook and a pencil before you leave the studio will prepare you for whenever the inspiration strikes. So, whether you're at your favorite coffee shop or headed off on a grand adventure, try to look around and soak up the inspiration. Don't be shy about sketching in public. No one will judge you, and most people won't even notice. Here are a few locations you could try:

LOCAL PARK — Go get some fresh air and create "en plein air!" Find a location with an interesting view or background, then selectively add in people, animals, and scenery to tell a scenic story.

NEIGHBORHOOD — Take a walk around your neighborhood and sketch what you see. Discovering the magic in the seemingly mundane can be life changing

ZOO OR NATURE PRESERVE — Animals can provide lots of inspiration for all kinds of creatures. Just be sure that you observe from a safe and respectful distance.

LOCAL MUSEUM — Did you know that most museums allow and even encourage sketching? Marble busts make great models for you to practice drawing faces & poses.

BUS / TRAIN / AIRPLANE — If you're sitting, you could be sketching! Try using the quick-moving subjects visible out of the window as practice for gesture studies!

FILL THE SPACE BELOW WITH SOME SKETCHING (NOT SKETCHY) LOCATIONS:

FINDING INSPIRATION

Sketching Anywhere + EVERYWHERE!

Let's stretch your creative muscles and expand your possibilities. We challenge you to complete each of the prompts below as best as possible!

DRAW YOUR VIEW FROM OUT OF A WINDOW

DRAW FROM A MOVING CAR / BUS / TRAIN

DRAW AN ANIMAL FROM LIFE

DRAW A BUILDING THAT YOU'RE FOND OF

MAKE A SKETCH OUTSIDE AT NIGHT

Sketch loosely, and don't be afraid to make mistakes! You grow your skills by taking risks and practicing your craft. Remember: This book is a place for experimentation!

Repetition Repetition Repetition

Here's an easy trick to help you make an interesting composition: Repeat your subject. Turn a single bee into a swarm (multiplicity), show a person over a period of time (simultaneity), or copy and paste your subject to make an exciting image (serialism). Not only can the many forms of repetition be visually compelling, but the act of creating something many times or in many ways is a great way to practice a new subject!

MULTIPLICITY refers to the use of multiples in a work of art. This technique can crowd a subject to convey feelings of claustrophobia or repeat an element in an innovative way.

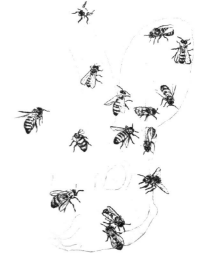

SIMULTANEITY refers to the visual depiction of numerous moments of time within a single work of art. Like a photograph with multiple exposures, these works can blur our perception of time or our agency within a universe with a constantly ticking clock.

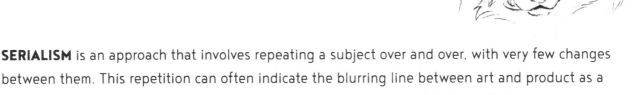

SERIALISM is an approach that involves repeating a subject over and over, with very few changes between them. This repetition can often indicate the blurring line between art and product as a result of consumerism or the overcrowding caused by our growing global population.

Pitter—Patterns

Pattern is a phenomenon that exists all around us. From the natural patterns found on organic objects like feathers or flower petals to the intricate details of modern materials like tile and textiles, learning to make repeating patterns unlocks a world of creative potential. Let's break down how to make a repeat:

#1

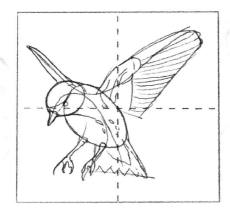

First, start with a square work surface and sketch whatever you like, whether abstract or representational. The only rule is that your subject shouldn't extend over the edge.

#2

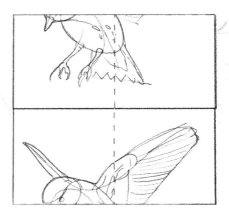

Next, cut your piece in half horizontally and join the two halves together on opposite ends. You could work on the pattern at this point, and it would repeat in only one direction.

#3

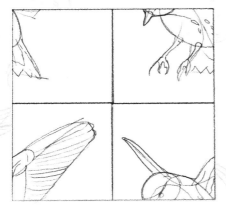

Cut vertically and rejoin. This moves the areas that were initially along the edges into the middle and has driven the subject to the corners of the piece.

#4

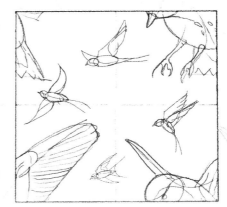

Now, add drawings to fill in the openings of your pattern, placing content over the gaps of your cuts but not modifying the original subject along the outer edges.

Now trace your sketch onto your work surface several times, carefully lining up the edges of your pattern. From there, you can render the components to complete your seamlessly repeating pattern.

Collage Barrage

Derived from the French word "coller," meaning "to glue," collage is the process of gathering, assembling, and adhering together compositions with images and textures pulled from various sources. Similar to how a musician might sample an audio clip to gain texture or to call upon previous references, collage can be a way to add meaningful material to your work from many different sources of inspiration.

Begin your collage process by looking through magazines, catalogs, photographs, and comics, isolating any graphics that speak to your creative aesthetic. Then, carefully cut them out with scissors or a scalpel. Once you have amassed a small collection, play with the pieces to form interesting associations, combine two subjects into one strange hybrid, or layer the pieces together like a surreal quilt or jigsaw puzzle.

Try making your own collage using the instructions on the opposite page as a guide. Once created, use the compilation as a creative starting point. You can paste pieces directly to the surface below and then draw around it to create an interesting environment or use the collage as a draft to be redrawn entirely.

Typography

Typography refers to any use, arrangement, and style of letters, words, or symbols within a work of art. We can only begin to describe the vast universe of type and lettering. Still, it can be helpful to understand the basics, such as the difference between serif, sans serif, and script, as well as essential calligraphic elements like adding filigree to your font.

SERIF **SANS-SERIF** **SCRIPT**

Type and text are important tools in your creative process. While some images are best without the specificity of type being added, others can be incredibly enhanced by its thoughtful addition. If adding text to your design, it is best to first consider your goal in adding it, the mood you want to establish, and the forms you wish to utilize. Let's discuss each of these below:

GOALS – What are you hoping to achieve by adding type? Do you want to use text to inform the viewer, to add humor, or is your concern purely aesthetic? How can mood and form help to achieve this goal?

MOOD – Text can be expressive, and a font can help to achieve this expression. Serif fonts have accents on the letters to add a sense of formality, while sans serif are more minimal. Script fonts can look like sophisticated cursive or like childish handwriting. Consider not only what your words will say but how they will be shown. For example, shadow lines can create a sense of vibration, while an ombré can add whimsy.

FORM – When composing your text on the page, adding guides can help to ensure elements are lined up as you desire. First, add a light mark to the vertical and horizontal center of the page to aid in aligning your elements. Then, create a baseline on which your type will rest. Next, measure and divide the space for each letter or word so that everything will fit as intended. Then, lightly sketch your letters before making your marks permanent. Once finished, erase your guides to leave only your type behind.

CHALLENGES AND ACTIVITIES:

– Choose a word and turn it into a cityscape, using lessons from the Perspective section to add depth.

– Find inspiration from historical uses of type, ranging from illuminated manuscripts to modern murals.

– Transform your name into a symbolic self-portrait, making each letter the epitome of your personality.

Alphabet Worksheet

The modern English alphabet has 26 letters, each with an uppercase and lowercase variation.
Let's make our own custom alphabet, with each letter exhibiting a different creative style!

A a	B b	C c	D d	E e
F f	G g	H h	I i	J j
K k	L l	M m	N n	O o
P p	Q q	R r	S s	T t
U u	V v	W w	X x	Y y
Z z				

Some people believe each letter corresponds to unique colors, moods, and styles. Maybe A is red and shiny like an apple while B is blue and bubbly. This blurring line between perception and sensation is known as synesthesia. You can play with this concept as you make your own creative interpretation of each letter.

Fun with Filigree

Including filigree and flourishes can add so much fun to your creations. These elements can frame your subjects, enhance your story, or elevate your art in unexpected ways. We recommend experimenting to create your own style of headers, footers, and borders, giving your pieces a unique flair. Check out a few of our examples below and then try your own:

STACKED BANNER
Implies informational significance or emphasis

SIGNATURE FLOURISH
A cascading series of loops to add a fanciful twist

OVERLAPPED LINES
A more regal look can be made by clustering your flourishes

PRACTICE FLOURISHES IN THE SPACE BELOW:

GEOMETRIC BORDER
Frames a piece to convey a more serious tone.

FLOWY FILIGREE
Conveys a playful, sketchy feeling

NARRATIVE FOOTER
Can incorporate imagery from your main subjects

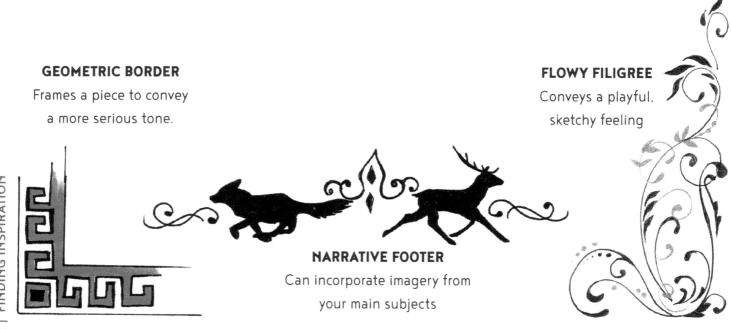

Tufted Flycatcher
Mitrephanes
phaeocercus

Three~Wattled Bellbird
Procnias tricarunculatus

Emotion and information can be portrayed in any design component! Just be sure to keep the purpose of your sketch in mind. A playful mood can be made using lots of curves and quirky accents. A starkly informative tone can be established with blunt geometric borders and traditional accents.

CREATE A SKETCH THAT INCORPORATES FLOURISHES BELOW:

Quetzal
Pharomachrus
Euptilotis

MAKE THE MOST OF THIS MOUNTAIN SCENE BY ADDING
CREATURES, A VILLAGE, OR ANYTHING ELSE YOU IMAGINE:

Artist Trading Cards

We love collaborating with artists in our community by making and collecting art trading cards. These miniature masterpieces are a great way to loosen up and share your work with the broader art community. Miniatures have a rich and complicated history within the arts, gradually moving from an art form of necessity to one of collectibles, keepsakes, and memorabilia. Today, artists of all kinds continue to create artwork at intimate scales through ACEOs, which stands for Artist Cards, Editions, and Originals. This term refers to a work of art that measures exactly 2.5 x 3.5 inches (the size of a standard trading card or poker card). This size encourages greater experimentation, quicker creation, and for the cards to be easily traded and sold to fellow artists and collectors.

An **EDITION** refers to a reproduction, or copy, of a work. Any edition should be clearly stated as such on the back, should be numbered so that people know how many copies of the item there are in existence, and should be signed by the artist on the back.

An **ORIGINAL** refers to an authentic, one-of-a-kind work of art. An original is the most expensive and sought-after kind of ACEO due to its unique, irreplaceable nature. An original ACEO should have the artist's name, the date the piece was completed, and a signature on the back of the card.

You can make or draw anything on an artist trading card so long as the size doesn't change. That slight limitation opens up a world of creative possibilities. We encourage you to cut some paper down to size and try making miniatures yourself! They can be especially enjoyable to produce with friends, family, and fellow artists, as not only will that allow you to see how other people approach the medium, but it will also instantly provide a group of people you can trade with!

Try it for yourself! Cut down a few different kinds of paper into 2.5" x 3.5" cards, then create sketches, collages, and paintings on these tiny canvases. You'll be surprised how fun this can be!

Art Interpretation

Everyone has art that they like and art that they don't. Usually, this affinity is proportionate to how much we relate to and understand a piece or a creator. When young and naive, we'll often speak freely and openly, basing our opinions on first reactions. While these unfiltered opinions can be incredibly enlightening for certain art styles, approaching other people's work with an open mind is often preferred, allowing you to empathize with the viewpoint, story, and processes that formed it. The way that artwork is discussed is called critique. This process is truly an art of its own, with a myriad of strategies, techniques, and methodologies. We'll provide a few tips on how to properly critique a work, but first, it's helpful to understand how different people interpret and value artworks.

THERE ARE TWO MAJOR IDEALS OF ARTISTIC INTERPRETATION:

FORMALISM is viewing art from an aesthetic perspective, prioritizing a piece's appearance over the concept intended. For formalists, a work of art's success depends on how well it utilizes the principles of line, color, and composition to create something which is visually pleasing or displays technical achievement.

CONCEPTUALISM is viewing art from a thematic perspective, prioritizing the concept behind a piece, the intentions of the artist, or what a work of art accomplishes. In a far more modern approach, conceptual artists are less concerned with how a piece looks and may be more excited by what the piece communicates.

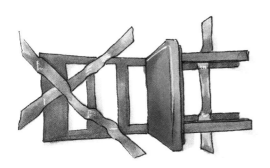

Both of these approaches to creating and viewing artwork can elicit intense emotional responses, and the separation between these viewpoints can often become blurred. While formalist artists are often considered more commercial since their creations are typically easier to sell or reproduce, within the fine art world, many conceptual artists can achieve enormous financial success through the reverence of their creations. Your artmaking approach might lean more toward one approach or lie somewhere in the middle.

Critical Practice

START BY SIMPLY OBSERVING – Before discussing a work of art, you must first experience it. Barring any stints of amnesia, you will never be given a chance to view a work for the first time more than once. You would only judge a song after hearing it, a movie after watching it, or a meal after tasting it. Art is no different – it deserves your attention, and if you are not in the right head space to give it the time it needs, then you are cheating yourself and the artwork out of a fair shot.

MAKE NOTES – After initially observing a work, jot down your first impressions. Begin by describing literally what you see in front of you, even if it seems obvious or mundane. You are a detective on the hunt for clues, and every element of the scene has significance. Then, begin to write what you feel. Does the size make you feel small? Does the pattern overwhelm your senses? Does the color make you feel warm? Write or sketch these observations in a sketchbook so that you can revisit the work later with the same mindset.

FORM CONNECTIONS – Once you have experienced a work and captured the clues, you can form connections between your experience, observations, and interpretations. What do you believe the piece is trying to say? What was the artist hoping for? What has this art achieved? Extrapolate and form conclusions.

USE THE WORKSHEET BELOW TO CRITIQUE A WORK OF ART:

DESCRIBE – Write as many observations as possible. What mediums or colors were used, how was it presented, what genre is the piece?	
ANALYZE – How do the elements of the piece guide your experience? What emotions does the work of art cause? What relationships can you uncover?	
INTERPRET – Use what you've described & analyzed to determine what the meaning of the piece may be. What do you believe the artist is trying to do or say?	
QUESTION – What questions does the piece bring to mind? What questions do you have for the artist? Why do you believe these questions are relevant?	
EVALUATE – Finally, use all your observations to determine your opinion of the piece's success. What worked well? What could have been improved?	

Art in an Elevator

Imagine you've just walked onto an elevator while holding one of your pieces when a stranger asks you about your work. You're both traveling up to the top floor, so you know you have about 60 seconds. How would you describe your process, creations, or ideas verbally in this situation? This is called the **ELEVATOR PITCH** and is excellent practice for learning to talk concisely and convincingly about yourself or your work. Let's take a moment to practice this pitch, starting by breaking down the key elements.

First, think about your process. What do you create and how would you describe it to someone who has never seen your work? What category of art do you believe that you fit in? How do you choose your materials?

MY PROCESS – _____

Next, focus on the subjects or ideas you are most prominently drawn to and list them in a few words.

MY SUBJECTS – _____

Now, try to think about what inspires you to make art. Who or what influences you and drives you to create?

MY INSPIRATION – _____

Then, try to think about why you make art. What do you hope someone will notice within your work or will take away from it when they leave? What emotion do you hope to cause in viewers of your work?

MY MOTIVATION – _____

These prompts should help to clarify what you do and why you do it. Now, try to imagine yourself back in that elevator. What information from your key points is the most essential to communicate to this stranger?

TRY TO STRING YOUR THOUGHTS TOGETHER INTO A SHORT STATEMENT BELOW:

Now imagine that you actually recognize that this stranger is a very important museum curator who specializes in the kind of artwork you create. How would you change your pitch if this were the case? This practice can prepare you for meeting new clients and is worth repeating over time as your work changes and evolves.

Sharing Your Art

For some, creating art can be incredibly personal, making sharing the work a bit of a challenge. It's common to think, "What if people don't like what I'm making? What if my art isn't good enough to share?" These are questions that every artist wrestles with initially. Still, these fears should gradually fade as you discover the value in your unique artistic perspective. The best way to feel more confident about your work is to share it with others, providing you with an expanded perspective and broader clientele.

To start, ask a group of trusted friends or family to view your artwork. This preliminary viewing can provide you with some initial reactions, helpful feedback, and practice at showing and discussing the work that you make. Don't get discouraged if the process feels awkward or if they have some feedback you aren't expecting. Everyone will have their own opinions. The most important thing is to use your experiences to grow as an artist. Filter what you hear based on how helpful it is to your creative process.

FIND WHAT YOU LOVE

Finding the things you love will help guide your creativity while keeping yourself open to new ideas. Identify the artists, stories, or experiences that motivate you to create. Recognize the pieces you have created which make you feel the proudest. This discovery is an integral part of creative development as, often, the artworks we feel most confident in sharing are the ones we connect to the most. Remember the things you love so that you can use them as a lightning rod for creative inspiration.

FIND WHAT OTHERS LOVE

Once you know what you love, learning the things that other people connect with can be beneficial. What do they see and feel in your work? What are their passions that overlap with your own? While you shouldn't devote your artistic career to conforming to other people's wishes, this process can help you branch out into areas that you might not have previously considered, or it can focus your attention on subjects or mediums that seem to connect with your audience best. Use this knowledge to help your art grow.

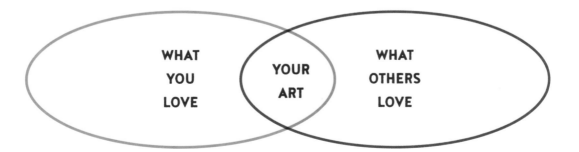

BE WARNED – It can be tempting to recognize trends and hop on board. While this can be an exciting way to explore new avenues, remember that "what is trendy may soon be out of trend." On the other hand, if you try to create work about the things you truly love, your work will connect for years to come.

Branching Out

Once you feel comfortable sharing your art with friends, family, and other artists in your community, you may wish to branch out to an even wider audience. There is a vast world of possibilities if you open yourself to the opportunities. You may wish to show your work in a gallery, sell your work, or license it for a larger distribution. Let's introduce each of these below before going more in-depth.

SHOWING YOUR WORK:

Online
Exhibitions
Publications
Alternative Venues

Showing your work can be an exhilarating process. Your work means a lot to you, but you'll never know how much it could mean to someone else until you take the brave step of releasing it into the wild. There are so many options for how to show your work: You can share it online on any number of social media sites, submit a piece to a call for entry to be shown in a gallery or publication, or pursue alternative means of display, like asking your local coffee shop if they need some new art on their wall. So, push aside your inner introvert and consider sharing your work with the world.

SELLING YOUR WORK:

Online Sales
In-Person Markets
Clients & Patrons
Commissions

Selling your work means physically transferring work to another individual for their enjoyment. This can be difficult for many beginners, akin to selling a piece of themselves or a pet. If you price your work appropriately, you shouldn't regret the sale, and the profit should allow you to create even more new pieces. You can sell your work online through a site like Etsy™ or your own digital store. You can sell your work in person at a craft fair or by showing your work in a gallery. As you grow your fan base, you can sell directly to individual clients, patrons, or collectors.

PROFITING OFF YOUR WORK:

Licensing the Rights
Reproductions
Wholesale
Leases / Exhibitions

Another option is to profit from the image of your creation, which can be done whether you still own the original piece or not, as long as you get a high-resolution scan or photo beforehand. You can license the work to a company to use on anything from apparel to packaging; reproduce the design yourself to sell as prints or merchandise; or venture into the world of wholesale, selling reproductions at a large scale to other stores and websites to carry on their shelves. Alternatively, if you still have the piece, you can lease the artwork to an exhibit that will pay just to display the work.

PROFITING OFF YOUR WORK: *Midas Touch*

As an artist, you can gain the magical ability to turn everything you touch into cold hard cash if you hone your skills the right way. Let's break down a few easy ways to help your passion to turn a profit.

SELL AT LOCAL CRAFT SHOWS, MARKETS, OR VENUES. Selling locally helps to connect with your nearby clients, which can help to establish regular patrons. For many artists, this is how they first get their start as they test the waters to see what items sell and what the going rate for pieces seems to be.

OPEN AN ETSY OR ONLINE STORE. If your work can be easily shipped, an online store is a great option. This can exponentially broaden your audience and allow you to make sales from the comfort of home.

MASS PRODUCE. By taking a work of art and turning it into products and reproductions, such as posters, stickers, or t-shirts, you can profit off and increase the spread of an artwork for as long as possible. If you can reliably make larger quantities of reproductions, you may want to offer your products in bulk to retailers, commonly called wholesale. This is when a reseller will purchase many units of your work at one time with a major discount. While you don't make as much per item, the scale of the order provides a larger payout, and you don't have to take care of fulfilling and shipping individual orders.

LICENSE YOUR ART. Licensing is when a company or individual pays you for the ability to use your work for their own purposes. Because this income does not typically rely on the sale of the physical artwork, you can license an image many times and for long after its initial creation. A limited-use license is preferred so that you can simultaneously license the image to noncompeting industries. This can provide you with ongoing **PASSIVE INCOME** that helps to sustain your craft without any additional work required.

QUICK TIPS FOR MAKING AND SELLING YOUR WORK:

DOCUMENT IT. Get good scans and photographs of everything you make, ideally during the process of making it and once it's finished. It doesn't matter whether it was a sketch done in 30 seconds or a piece that took weeks, document it in as high of a resolution as possible. Each new piece you make has real value, sometimes you just don't know when the value will become apparent.

SOURCE YOUR STUFF. Find a local, high-quality printer that offers good rates. Work with them to help you to set up your files and get a few test prints made with different paper stocks, finishes, and settings to find what's right for you.

BUILD CONNECTIONS. You never know who might be your next big client, who might want a commission, or whose business needs a mural, so try to build strong connections with anyone and everyone you meet. Own your identity as an artist and make it work for you.

Passion to Action

Your success is in your own hands. Whether you want to create a collection of new work, get accepted into a gallery, or launch your website, let's work out how to turn your passions into a plan of action.

LET'S BUILD A ROAD MAP FOR YOUR SUCCESS:

IMAGINE what you would achieve if you had no limits. Feel free to dream big and shoot for the stars, this can help to guide your short-term goals.	
WHY are you working towards these goals? What things are motivating and inspiring you? What are your creative values, and how do your goals fit?	
PRIORITIZE to determine your main goals for the short term. Be aspirational but also realistic as you consider what is truly possible.	
WHEN do you believe that you could realistically achieve these goals? What do you hope to achieve in six months? A year? Five years from now?	
HOW are you going to achieve your goals? What can you set in place to help you along the way? What roadblocks do you anticipate?	
WHO do you imagine might help you to achieve these goals? Who should you reach out to that could assist? Who do you think you'll need to know?	
START now by planning your next steps. Your goals are on the horizon, and there's no time to waste. What actions, small or large, can you take right now?	

Conclusion

You have come so far already! Let's take a moment to review and reflect on what we've created, learned, and accomplished so far. We've provided a few prompts below; give each one thoughtful consideration and then fill them in with your answers. No need to feel self-conscious – we swear to keep these between us.

WHAT SKILLS AND LESSONS WERE THE MOST INSPIRING?

WHAT SURPRISED YOU THE MOST ABOUT THIS PROCESS?

WHERE DO YOU HAVE THE MOST ROOM FOR IMPROVEMENT?

WHAT DO YOU WANT TO LEARN NEXT? HOW SHOULD YOU START?

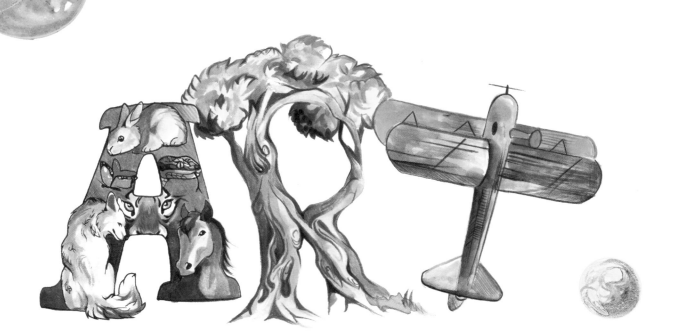

Key Takeaways

We've had such a blast creating with you throughout this book! From the basics of sketching perspective in pencil, learning line with pen and ink, mixing our own colors with colored pencil, tackling creative block, and so much more, we hope that you have not only learned a lot but have gotten excited about all the possibilities for your new creations. There's no way that any single book can teach you everything about art, but we hope this broad overview has helped, no matter where you are on your artistic journey. We hope you can return to this book often and remember to:

BE CURIOUS

Stay open to new perspectives!
You'll learn the most from trying new things.

BE PERSISTENT

Do not let anything stop you from pursuing your passion.
Only you can make your art!

BE CONFIDENT

Your view of the world is unique, and your creations are important!

ENJOY YOURSELF

Have fun as much as possible. Your joy will be contagious!

GET STARTED

Don't hesitate. Just create!

We are so proud of you for taking the initiative to approach your creative practice in a new and exciting way. We are beyond honored to have joined you on this journey, and we cannot wait to see what's in store for you next!

OTHER BOOKS BY KATY LIPSCOMB AND TYLER FISHER

SKETCH YOUR ART OUT: A SKILL AND STYLE ACTIVITY GUIDE

HOWL: STRESS RELIEVING ADULT COLORING BOOK

CATS: STRESS RELIEVING ADULT COLORING BOOK

If you enjoyed this book, we would love for you to return to it often so that you can constantly be inspired. We'd also be insanely appreciative if you would consider reviewing our book online so that more artists can find, use, and share in our creative endeavor. We can't tell you how much an honest review can help.

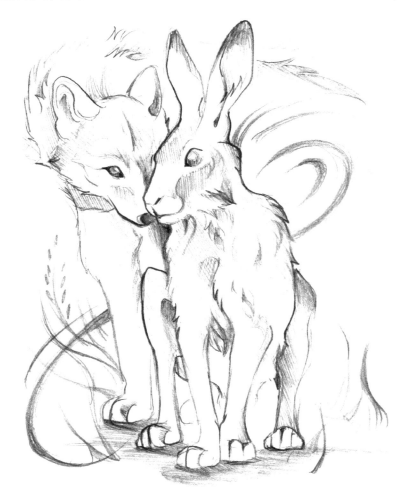

Answer to the puzzle on page 77.

FOR MORE INFORMATION AND BONUS CONTENT, VISIT ARTISTSDRAWINGBOOK.COM